Think of us as a blue plate special with a slice o' pie to boot. Meaty, dependable, and affordable for all. We thought to ourselves: take a big helping of thoughtful guidance and add a side of straightforward instruction and you'd have a start on a pretty good book. Offer it all for less than the price of a couple of movie tickets, and you'd have a great book. In fact, you've got that book in your hands.

Each book in this series of introductory guides isolates one application or topic and aims to get you exploring it quickly and effectively. They're action-based, non-comprehensive, and not filled with a lot of idle chat because our goal is to get users using. Our books are for those who do not accept the premise that if you don't already know, you must be a dummy or an idiot. We believe in using computers to *do* things, not doing things to use computers. Your computer should make your life better, not more complicated. And the truth is, despite the ease of use offered by today's computers, users often need a bridge to help them navigate the digital world. They need a real-world guide and they need it with no nonsense.

You'll be surprised how far you can go in 200 or so pages. Take a look at the Table of Contents to see what we mean. Simple and straightforward—the way using a computer should be. And that's the way each book in this series works. Inside each of these handy books are the essentials of each topic—everything you need to know to get up and running.

Thanks for picking up our books, and drop us a line with your comments.

Click!

the *no nonsense* guide to

Digital Cameras

Ron White

McGraw-Hill/Osborne
New York Chicago San Francisco
Lisbon London Madrid Mexico City
Milan New Delhi San Juan
Seoul Singapore Sydney Toronto

The *McGraw·Hill* Companies

McGraw-Hill/Osborne
2600 Tenth Street
Berkeley, California 94710
U.S.A.

To arrange bulk purchase discounts for sales promotions, premiums, or fund-raisers, please contact **McGraw-Hill**/Osborne at the above address. For information on translations or book distributors outside the U.S.A., please see the International Contact Information preceding the Acknowledgments.

Click! The No Nonsense Guide to Digital Cameras

1234567890 DOC DOC 019876543

ISBN 0-07-222740-0

Publisher Brandon A. Nordin	**Indexer** Irv Hershman
Vice President & Associate Publisher Scott Rogers	**Computer Designers** Lucie Ericksen, John Patrus
Acquisitions Editor Marjorie McAneny	**Illustrators** Melinda Lytle, Michael Mueller, Lyssa Wald
Project Editor Katie Conley	**Series Developers** Katy Bodenmiller, Greg Simsic
Acquisitions Coordinator Tana Allen	**Series Interior Design** Katy Bodenmiller, Greg Simsic, Dick Schwartz
Technical Editor Jennifer Ackerman Kettell	**Series Cover Design** Katy Bodenmiller, Greg Simsic
Copy Editor Peggy Gannon	**Cover Photograph** Photonica
Proofreader Susie Elkind	

This book was composed with Corel VENTURA™ Publisher.

About the Author

Ron White has been a photojournalist since his college days and throughout his career as an editor at computer magazines and author of books. The former executive editor of *PC Computing* magazine, White is also the author of the million-copy best seller and award-winning book *How Computers Work*, which has been on lists of top computer books. As a photographer, he specializes in portraits; his latest interest is digital darkroom software, such as what he describes in this book. He's using it to restore a large collection of neglected family photos dating back four generations. His writing has been called "lucid" by the *New York Times*; he explains complex topics in simple terms so that they become common sense to the reader. To accompany this book, he has added information about digital photography to his web site, www.howcomputerswork.net. He can be reached by e-mail at ron@ronwhite.com.

About the Technical Editor

Jennifer Ackerman Kettell has written and contributed to several books about web design and graphics, including the use of digital photography on the Web. She's filled dozens of smart cards with panoramas from her travels, portraits, and figure skating photos. Jenn lives with her family in Arizona.

INTERNATIONAL CONTACT INFORMATION

AUSTRALIA
McGraw-Hill Book Company Australia Pty. Ltd.
TEL +61-2-9900-1800
FAX +61-2-9878-8881
http://www.mcgraw-hill.com.au
books-it_sydney@mcgraw-hill.com

CANADA
McGraw-Hill Ryerson Ltd.
TEL +905-430-5000
FAX +905-430-5020
http://www.mcgraw-hill.ca

**GREECE, MIDDLE EAST, & AFRICA
(Excluding South Africa)**
McGraw-Hill Hellas
TEL +30-210-6560-990
TEL +30-210-6560-993
TEL +30-210-6560-994
FAX +30-210-6545-525

MEXICO (Also serving Latin America)
McGraw-Hill Interamericana Editores S.A. de C.V.
TEL +525-117-1583
FAX +525-117-1589
http://www.mcgraw-hill.com.mx
fernando_castellanos@mcgraw-hill.com

SINGAPORE (Serving Asia)
McGraw-Hill Book Company
TEL +65-863-1580
FAX +65-862-3354
http://www.mcgraw-hill.com.sg
mghasia@mcgraw-hill.com

SOUTH AFRICA
McGraw-Hill South Africa
TEL +27-11-622-7512
FAX +27-11-622-9045
robyn_swanepoel@mcgraw-hill.com

SPAIN
McGraw-Hill/Interamericana de España, S.A.U.
TEL +34-91-180-3000
FAX +34-91-372-8513
http://www.mcgraw-hill.es
professional@mcgraw-hill.es

**UNITED KINGDOM, NORTHERN,
EASTERN, & CENTRAL EUROPE**
McGraw-Hill Education Europe
TEL +44-1-628-502500
FAX +44-1-628-770224
http://www.mcgraw-hill.co.uk
computing_europe@mcgraw-hill.com

ALL OTHER INQUIRIES Contact:
Osborne/McGraw-Hill
TEL +1-510-549-6600
FAX +1-510-883-7600
http://www.osborne.com
omg_international@mcgraw-hill.com

Thanks

This is dedicated to my friends and family who have endured without complaint (for the most part anyway) my merciless invasion of their privacy, their space, and their wishes by poking various cameras in their faces without warning.

Thanks to my new extended family at McGraw-Hill/Osborne, particularly Margie McAneny for suggesting this project and, along with Tana Allen, for easing my way into this new series. Katie Conley and Peggy Gannon did a wonderful job of keeping me on track and correcting my lapses into unknown tongues. Jennifer Ackerman Kettell was invaluable as a technical editor and in helping compile the book's Buyer's Guide section.

I'm personally and professionally grateful to Greg Simsic and Katy Bodenmiller for conceiving the much-needed *No Nonsense* series and for welcoming me onboard for its launch.

I could not have done this book, literally, without the cooperation of photographers who are more talented than I and who gave me permission to use their photos: Wayne Reed, Shannon Cogen, Doug Burgess, Mike Berceanu, Digital Photography Review, Klaus Schraeder, Arthur Rosch, Georges de Wailly, and Don Adams. A special thanks to the National Oceanic and Atmospheric Administration (NOAA) for posting so many cool photographs covering a wealth of subject matter at http://www.photolib.noaa.gov/, and to the National Park Service for sharing its many landscape photos at http://parkwise.schoolaccess.net/Students/PhotoGallery/photogallery.htm.

The Internet proved invaluable for researching the more esoteric points about digital cameras and photography. For those interested in pursuing this book's topic further—perhaps even into the realm of nonsense—check out the links listed at the end of each chapter as well as on my web site, www.howcomputerswork.net. Some information in this book was gathered the old-fashioned way, by interviewing people. I'm particularly indebted to Henry Wilhelm of the Wilhelm Institute, Mark Weir of Sony, Karen Thomas representing Olympus, Mary Ann Whitlock of Microtek, Beth Avant and Jenna Skidmore of Burson-Marsteller representing Sony, and Lou Desiderio of Canon.

Finally, I'm grateful for the generous expenditure of their time, photos, and equipment by display whiz Raymond Soneira, Justin Shaw, and Louis Desiderio of Canon; Amy Podurgiel and Brian Williams of Nikon; Cheryl Balbach of Casio; Chris Sluka of Olympus; Colleen Henley of Packard; and Randy Ross and Anush Yegyazarian of PC World.

Contents

You are reading this book for one of two reasons. Either you just got a shiny new digital camera or you're thinking about getting one. What you get out this book depends on what type of digital photographer you want to be.

One type is a little different from the casual user of film cameras. This species of photographer snaps photos at birthday parties and on vacations and is content to accept the results, even if they are blurry, underexposed, overexposed, or include an extensive collection of shots in which the photographer's finger is in front of the lens.

The other type of photographer is what the trade calls an "enthusiast"— sometimes the "prothusiast." For this photographer, it's not enough that a photo simply shows his son blowing out candles. It's how *well* the photograph shows his son blowing out the candles that matters. The ultimate goal of the enthusiast is to create a work of art—or, at the least, to produce a photograph that is free of the errors in focus, exposure, composition, and the dozens of other boggles that proclaim the photographer is that most dreaded of genus, a rank amateur.

Whichever type of photographer you are, digital cameras combined with simple software let you improve the most mediocre snapshot—even those taken a century ago. Whether you're looking for the cheapest digital camera you can find on eBay or you're an experienced film photographer thinking about diving into digital, then friend, you've come to the right book!

How This Book Is Organized

In Chapter 1 we'll take a look at the myriad features that you'll find on digital cameras, both low-end and high-end. If you're still contemplating which digicam to buy, this chapter is a must. The nature of digital cameras is that they can do tricks film cameras are not capable of. Even if you're experienced with film cameras, get to know what the new world of digital cameras is like.

Chapter 2 is a side trip to scanners on the assumption that, like most people, you have a shoebox full of old photos that are fading, discoloring, and deteriorating almost before your eyes. With an inexpensive scanner you can save what are invaluable family heirlooms for future generations. With the right software, you can restore them to their original glory. This chapter shows you how.

In Chapter 3, you'll learn how to put all those buttons, dials, menus, and other doohickeys that come with your digital camera to use. But it's not just about technical stuff. It's also about technique. We'll look at how to use any camera to shoot better photos.

Chapter 4 takes us to Photoshop Elements, available as free trial software on the Internet, and how you can use it to retouch those old photos you rescued with a scanner back in Chapter 2. You'll learn the concept and methods of the digital darkroom to improve the photos you shoot with your digital equipment.

Chapter 5 takes the digital darkroom into an alternate universe where you can transform your photos into images of worlds that exist only in your mind. Believe me, this stuff is fun.

Chapter 6 covers the printing of your photographs so that you can foster them off on all your relatives who don't have computers. The chapter pays particular attention to producing the highest-quality prints using inks and paper that will ensure they don't fade before the memories do.

And because this is a digital world, Chapter 7 looks at how you can share photos without photo prints. You'll see how to save your pictures to CD, as DVD shows, and on the Internet.

Finally, the appendix is a buyer's guide to digital cameras that lists the top-ten cameras appropriate for three categories of photographers: the birthday party photographer; the enthusiast; and the professional. Determine which category you fall under, and then choose the camera that's best for you.

Choose

Once you've decided to go digital, you have many choices. The good thing is there are few wrong ones. If you want to reel off a few digital shots for holidays and weddings, there is no shame in going the inexpensive, simple route that will give you digital photos to match those from blister-packed film cameras that line drugstore shelves. If you want to become the consummate digital photographer, you can do so, while still affording to send the kids to college and producing photos that match or better anything off a top-of-the-line 35mm film camera. It's up to you to decide.

In Chapter 1 we'll take a look at the differences between film cameras and digital cameras and what features you can expect to find in digital cameras if you're willing to shell out more money. Regardless of the number of controls, automations, and other thingamabobs that come with your digital camera, we'll discuss how to take better photos using your camera's features—and your innate creativity. If you're ready to commit yourself totally to the digital world, we'll find out how you can convert that pile of old photos stuffed in a shoebox into digital images before the photos fade or stick together in one unconquerable pile.

A Digital Darkroom

For all the (deserved) excitement about digital cameras, they really have more in common with film cameras than they have differences. Not counting the obvious similarities of a lens, shutter button, flash attachments, and the like, both film and digital cameras are similar at their most intimate levels, where they freeze light into the makings of a photograph.

The Chemical Past

Film does it chemically. Microscopic crystals of silver-halide spread throughout a layer of gelatin on the surface of the film. When you snap the shutter, the lens focuses light from whatever you're shooting onto the film's surface. The crystals absorb energy from the light, allowing them to combine with other chemicals in the gelatin. The stronger the light, the more crystals combine. Later, when the film is processed, the combined crystals change into pure silver, and a rinse washes away the remaining chemicals, including the silver-halide chemicals that weren't struck by light. The clumps of silver are opaque and the rest of the film is transparent. The result is a negative, which is then used with silver-halide-coated paper to produce positive prints. The process for creating color photographs is similar, using a separate layer for red, blue, and green light.

The Digital Present

Digital photography does much the same thing as chemical photography except that digital cameras convert the energy of light into electrical energy, which is then stored in a pattern that later re-creates an image of the subject of your photo. The digital analogy to film's silver-halide crystals are *photodiodes*, transistors that convert light energy into electrical energy. You're already acquainted with photodiodes in devices such as the switches that automatically turn on a porch light when the sun goes down. But that simple switch requires only a single photodiode; a digital camera often has millions of them. In the jargon of digital cameras, however, you'll rarely hear them called photodiodes. Instead, they're called *pixels*.

A pixel is the smallest area of light that a digital camera can detect, measure, and convert to digital information. The more pixels you have, the higher your *resolution*. Resolution refers to the amount of detail a photograph—chemical or digital—can capture. A low-resolution photograph might show a bridge crossing a river. A medium-resolution photo lets you see that the bridge is made of wood. A high-resolution photograph would show the wood is rotten.

The pixels in a digital camera line up in rows that form a rectangle behind the camera lens where a frame of film would be in a conventional camera. There are two types of pixel arrays: CCD (coupled charged diode) or CMOS (complementary metal-oxide semiconductor). The only reason I mention this is that you may hear some esoteric sales chatter about which type is better. Don't waste your brain cells on this distinction. Both technologies are used in high-end and low-end digital cameras. Other factors, which we'll look at in this chapter, have more important effects on the abilities of a camera and the quality of the photos it produces.

When you snap a picture with a digital camera, a shutter opens to let light from the subject travel through the lens, which focuses the light on the rectangle of pixels, called the *imager* or *image sensor*. Because nearly all digital cameras take color photographs, the camera must have some way to measure the intensities of red, green, and blue light striking the image sensor. There are various ways of doing that, but the simplest, and the one your camera is most likely to use, is to have color filters over each of the photodiodes, as shown in Figure 1-1. Each of the pixels measures the intensity of light striking it. The intensity, measured in the amount of electricity the light generates, is converted to *digital values*—simple numbers, much the way a digital thermometer converts the temperature of the air into numbers.

Figure 1-1
Colored filters create a pattern of pixels —photodiodes— that measure only red, blue, or green light. Because of the way we see green, there are as many green pixels as there are red and blue pixels combined, which come across to the human eye as true color.

Blue

Green

Red

These digital values are quickly shuffled off to some temporary memory, and then they travel through a *compression algorithm*. In most digital cameras, the algorithm

is one called JPEG (joint photographic experts group). Some digital cameras also save files in uncompressed formats. JPEG compression decreases the amount of memory needed to store the image. One way JPEG does this is by throwing away information that probably won't be missed. In a landscape, for example, there are many slight variations in the colors cast by a sunset that JPEG can reduce two colors whose hues are similar to a single color. That saves the memory needed to store the two different color values. And anyone looking at the photograph will never be the wiser. In Figure 1-2, the photo on the right was saved with 80 percent JPEG compression, eliminating the subtle differences in shadows of the clouds, water, and sand. In the enlargements taken from the center of the photo, you can see some of the distortion caused by compression. JPEG is adjustable, meaning you can trade saving storage space for picture quality, or the other way around. This is an important consideration we'll get into in more detail later in the book.

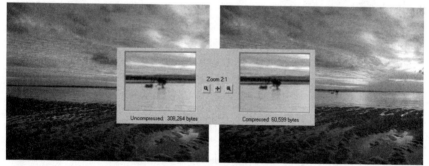

Photo courtesy of Wayne Reed Photographics, Brisbane, Australia

Figure 1-2 *The photo on the left was saved without any compression. The shot on the right was compressed 80 percent.*

AS A MATTER OF FACT *If you don't believe that you can't trust your eyes when it comes to shades and colors, get a collection of color chips from a paint store. You will first of all discover that a color as simple as white can be complex. You'll look at one "white" paint chip and swear that it's white, true white, nothing but white. Then you'll pull out a color chip that is even whiter, and what you thought was white now seems a bit gray or has a hint of blue.*

Practical Matters

Consider this: On a single roll of film that you shoot, how many pictures are really keepers? I mean the kind of photographs that you are likely to frame or show off to family and friends. The most important factor in getting a good photograph is chance. Your subject didn't blink, doesn't have a goofy expression on his face,

is facing the right way, and the light is just right—and dozens of other factors you don't notice in the heat of shutter fire, but which stand out like Ozzy Osbourne at a Southern Baptist convention when they're frozen on the surface of photo paper.

I consider myself lucky to come away with two shots out of 24 that I can really be proud of. That means that each one of those cost me $8.79, plus tax, in film and processing. Digital photography is not without its own cost of supplies. If you want prints, you have to pay for printer ink and paper. If you want really good prints that will rival chemical photography, you'll need to use special glossy paper that costs more than the paper you usually use, but at least you still pay only for the pictures good enough to warrant being turned into prints. You may wind up buying one of the special printers we'll look at later in the book, developed especially for churning out prints indistinguishable from the best Walgreens can do.

Quality Control

Whether or not you already have a darkroom in your house, the software that comes with most digital cameras gives you easier and more detailed control than anything you can do in the darkroom. And your hands don't come away smelling like you've been playing with pickled frogs.

With a digital darkroom in the form of software such as Adobe Photoshop Elements, which we'll look at in Chapter 4, you can easily change a color photo into a black-and-white picture; get rid of the infamous red-eye effect; stitch together landscape photos shot in different directions so you have a 360-degree panorama; straighten the edges of buildings that the lens has distorted into curves; create a montage worthy of a museum hanging from different photographs; and make a photo look as if it were taken under water or during a hurricane. (Just take a gander at Figure 1-3.) The digital darkroom will even do something that seems no less than a miracle to long-time photographers. It lets you sharpen an out-of-focus snapshot.

Figure 1-3
No, I'm not drowning this poor child and his father. It just looks that way thanks to some magic manipulation in Adobe Elements.

Photo by Shannon Cogen

Camera Features

If you're now convinced that digital photography is the wave of your future, you have some choices to make.

You've got to ask yourself a question: Are you that darling of new technology, the "early adopter," or someone who waits to see what's still standing when the buying storm dies down? My guess is you've already gone digital or are looking to convert soon. If you're in the latter group, that still leaves choices that would torment Solomon. If you've already bought your digital camera and equipment, the following section will help you better understand how your camera works.

Professional-quality digital cameras run anywhere from $5,000 to $30,000. At the other extreme, some digitals go for $20 to $30, suitable as party favors but definitely disappointing as a way to preserve memories in anything amounting to sharp detail. Luckily, there is a vast middle ground of cameras that provide crisp, high-quality digital photos that can memorialize the kids' college graduations without having to raid the college fund. Making a choice among them requires balancing a camera's features, its price, and what you want in a camera.

OK, I'll admit it right now. I made that sound too easy. There are plenty of features that are crucial to the quality and price of the camera you get. One—the most important—is the number of pixels used to capture the picture. You cannot have too many *megapixels* unless you don't want to pay for all of them. A megapixel is a million pixels. We'll look at their significance later. For now, you should know 2 or 3 megapixels gives you a good photograph provided you don't intend to create prints bigger than 6×4 inches, or if you plan to display your work only on the Internet. You should be able to get a camera in the 2 to 3 megapixel range at a decent price, $200 to $300 depending on what other features it has.

There are other important features, such as the construction of the lens, that aren't apparent to the naked eye. But generally, when we're talking about features on a digital camera, we mean the knobs, visors, gauges, onscreen menus, buttons, and other doohickeys that sprout from the surface of the camera. Some of these are definite advantages and worth a few extra bucks. The trouble is a few extra bucks for this knob and a few extra bucks for that gizmo soon add up to few extra hundred dollars. And for some people fewer features are better. Those who are going digital only to put their work on the Web rather than print have other considerations. All those megapixels may be wasted if they're just going to give up some of that quality in favor of small file size. Some people want a camera that will take the best picture possible while allowing them to do as little as possible. These are point-and-shooters. They are akin to people who want an automatic transmission in their car, but would actually prefer a chauffeur

if they could afford one. The other type of photographers not only always want to be the driver, but also would rather have manual transmission and as many gauges on the dashboard as possible. You should know what kind of photographer you are. There's no sense in paying for features that you don't appreciate—or find annoying. In the rest of this chapter, we'll look at the options you have among features and why they may—or may not—be worth sending your kids to a less expensive college.

Pixel Count

No matter what other features your digital camera has or doesn't have, the most important one is the number of pixels used to capture an image. The simplest rule is the more pixels, the better. More pixels give you higher resolution. They let you capture more detail and print larger photographs without running into *pixilation*, or the *jaggies*, those squared-off boxes that occur when a photo doesn't have enough resolution to draw diagonal lines properly. The photograph in Figure 1-4 shows jaggies on the insect's legs that occur because the photo lacks the resolution to depict them accurately.

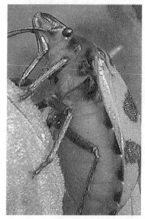

Figure 1-4
Using too few pixels to show too much information results in the pixilation shown in the beetle's legs.

Courtesy of Mike Berceanu, http://www.berceanu.com.au

You can never have too many pixels if you're willing to pay for them. But you can figure out the minimum number of pixels you'll need if you know how you plan to use your photographs. The most common choices are hard copy prints, displaying them on a web page, or blackmail. For the latter, the number of pixels is not crucial provided you can identify the people in the photograph. For prints and the Web, there are simple formulas that require, at best, an ordinary calculator to compute.

The resolution of digital cameras is measured in *megapixels*, which are millions of pixels. Today, relatively inexpensive cameras—those in the $100 to $300 range—have 1 to

3 megapixels, a medium range. For the enthusiast willing to spend $1,000 or more, you'll find digital cameras in the high-resolution range of 4 to 7 megapixels.

Figure 1-5
With more than 11 million pixels, the Canon EOS-1D is the digital camera that photographers would die for.

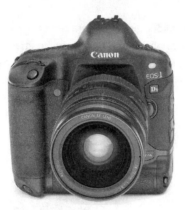

The most important factor in picking a camera is how its number of pixels translates into a printed photograph or, the second-most likely choice, an image on a web site. The requirements for the two are significantly different. For the Web, high resolution is actually a bad idea. The extra detail doesn't show up on a monitor, and high-res photos take longer to download. For prints, you need enough pixels to match two factors: How big you want the print to be, and how much resolution your printer can produce. We'll look at some ways to figure out the numbers in Chapter 3.

The Lens

Next to the number of pixels, the most important factor in the technical quality of a photograph is the lens. Note that I said "technical quality." It's quite possible to produce sharp, perfectly focused, and exposed pictures that are as exciting to look at as watching a sponge dry. And a cheap box camera can create images of beauty in the hands of the right person, such as the one in Figure 1-6 that was taken with a simple pinhole camera, which has no lens at all. The hole in a pinhole camera is so small that there is little diffusion of the light, and consequently the image is in focus.

Now let's look at the choices you have among lenses.

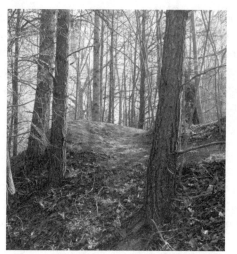

Figure 1-6
A tiny pinhole in a
lightproof box lets
in light from the
subject, such as the
trees in this photo.

Photo by Doug Burgess

Fixed-Focus Lenses

At the low end of the digital camera scale are plastic, fixed-focus lenses. They are inexpensive and designed to have everything in focus from infinity to within about five feet. At first thought that seems like a good idea—why worry about focusing on a particular face or mountainside if you can have everything in focus? Trouble is, "focus" is both subjective and relative. A photo that the eye sees as in focus may suddenly look out of focus when it's placed next to a sharper image. Anything that tries to keep everything in focus necessarily compromises so that nothing is as sharp as it could be. And it may well be impossible to get in close enough to your subject—say, a rose—so that it fills the frame without it falling outside the general range the lens focuses on.

Variable-Focus Lenses

Variable-focus lenses are a major step up from fixed focus ones. The lens, which is really made of several pieces of glass—or high-quality plastic—moves those pieces, called *elements*, in relationship to each other so that the best focus of the lens is a specific distance from the camera (hopefully the same distance as your subject). The variable focus has two advantages. It gives you a sharper image than is possible by a fixed focus that tries to keep everything in focus and winds up not focusing well on any one distance. The second advantage is that lack of focus is a valuable way to draw the eye's attention to what is in focus, which is presumably the most important element in the image you're capturing. We'll look at how to use focus and something called depth of field in Chapter 3.

Autofocus vs. Manual Focus

Unless you prefer the point-and-shoot simplicity of fixed focus, you have another choice to make. Do you want a camera that focuses automatically or one that gives

you a choice of automatic or manual focus? Although it'd seem like a good idea to have the camera handle an operation that can be as tricky as focusing, using autofocus well can be more difficult than manually focusing. Autofocus generally focuses on whatever's in the center of the shot, working on the logical assumption that the most important subject matter will be centered in the frame. That needn't be so, as we'll see in the next chapter.

Midprice range digital cameras make autofocus standard—and the only way to focus the camera. A better choice is a camera that lets you switch between manual and automatic focusing. When the camera is in manual mode, focusing is merely a matter of twisting a ring on the lens, and it quickly becomes second nature. You may well be content to let your camera do the focusing work 90 percent of the time, but there will be shots where you'll appreciate having total control over one of the key elements to photographic creativity.

Zooming Lenses

Different lenses have different *focal lengths*. This refers to the distance from the central point in a lens where rays of light converge to the *focal plane*, which is surface of the film or of the rectangle of photodiodes in a digital camera.

The distance in itself is not all that important. What's really significant is that the different focal lengths create bigger or smaller images covering the focal plane. Now, since the frame of film or photodiodes stays the same size, a bigger image means that less of the image is included in the frame, and we have a *telephoto* lens. It appears to bring objects in the center of the image closer. (Another name for a telephoto lens is a *long* lens because it has a long focal length.)

A *wide-angle*, or *short* lens, does just the opposite. It condenses the size of the image that lands on the focal plane so that more of the image is picked up by the film or image sensor. Once you get past the low-end digital cameras, any camera you choose is likely to have an *optical zoom* lens.

The Uses of a Zoom Lens The reason for a zoom lens, or for interchangeable lenses with different focal lengths, is not, as it may seem at first, to save you the trouble of walking closer to your subject matter. There are times when something—a wall, a river, a team of steroid-enhanced bodyguards—may prevent you from getting closer and then the telephoto abilities of a zoom lens may be used to skirt the fact you can't get close. And there are times when the wide-angle abilities of a zoom lens let you squeeze more of your surroundings into the picture when, say, you're in a room and literally up against the wall.

But different focal lengths are used to their best ability when they let you manipulate focus and perspective. The longer the focal length of a lens, the smaller is its depth of

field. Fixed-focus cameras save you from the agony of making artistic decisions by making nearly everything more or less in focus. But a good photographer uses a narrow depth of field to advantage by focusing only on the one object he wants to draw attention to—one face in a crowd, a drop of dew on a leaf that's surrounded by a forest. By leaving the surroundings out of focus, the photographer eliminates distractions. Figure 1-7 shows the advantages of selective focus. The use of a telephoto lens—or the telephoto position on a zoom lens—is not the only way to focus selectively. There is one other factor involved, and we'll look at the technique again in the next chapter.

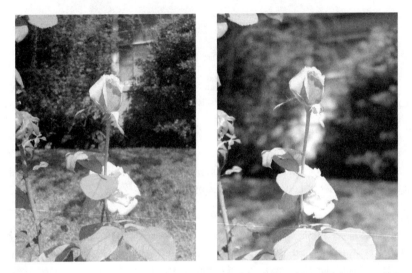

Figure 1-7 *In the photo on the left, the entire frame is in focus, giving everything equal emphasis. In the photo on the right, only the flower is in focus, drawing the eye to it.*

Digital Zoom Is Different While shopping for a digital camera, you may see some that bill themselves as "4X Optical Zoom—10X Digital Zoom." The optical zoom refers to the fact that the zoom lens can be set over a range that lets objects appear four times closer at one extreme than they do at the other. The "10X Digital Zoom" is just marketing malarkey. It means that the camera simply reuses the same pixels to simulate, usually poorly, what an image would look like if it were ten times closer. No new detail is revealed, and you can accomplish the same thing in a digital darkroom by enlarging a portion of the image. Don't pay a penny more for a camera because it boasts digital zoom.

Another "feature" worth neither the money nor the clutter it adds to a camera already covered with buttons and dials is a *power zoom*. This means that pushing one of two buttons causes the zoom lens to move back and forth between

wide-angle and telephoto. You can do the same thing faster and with more precision by twisting the zoom ring on your camera, as shown in the following illustration. And I promise you the effort won't be a strain on your hands, no matter what kind of weakling you are.

Manual zoom ring

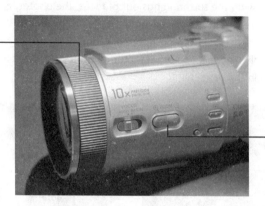

Power zoom buttons

Translating Focal Lengths

If you've been into film photography long enough to become familiar with the effects of different focal lengths, then you need to retrain you brain to what focal lengths mean when it comes to digital cameras.

In film photography, a 50mm to 55mm lens is called a *normal* lens because the angle it covers is similar to what the eye normally sees. For film cameras, 35mm is considered a good all-around wide-angle lens, and 120mm is a popular telephoto length. All that changes with a digital camera. Here's why.

For various reasons, mostly cost, the imaging sensor in nearly all digital cameras is not 35mm wide, the size of a frame of 35mm film. Most sensors are smaller, as shown in Figure 1-8. A normal 50mm lens that would fill the frame on a film camera—the largest in the figure—would overflow the imaging area of most digital cameras, turning the 50mm normal lens into a telephoto.

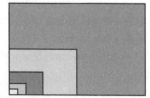

Adapted from Short Courses [www.shortcourses.com/index.htm] by Dennis P. Curtin

Figure 1-8 *The large rectangle is the actual size of a frame of 35mm film. The smaller rectangles are the sizes of image sensors frequently found on digital cameras.*

Because the image sensor is smaller, a lens that would have a normal focal length on a film camera becomes a telephoto lens on a digital camera. When you're shopping, look for the "35mm equivalent" fine print somewhere on the package or literature. For example, the Olympus E-20N has a zoom lens with a range of 9mm to 36mm, but it's equivalent to a zoom of 35mm to 140mm on a film camera.

The Viewfinder

The last crucial choice you need to make in a digital camera is the *viewfinder* or other method of seeing what you're taking a picture of, such as an LCD display. The cheapest cameras—both film and digital—have a separate *optical viewfinder* that only approximates what your lens is seeing. It often shows less. As you get closer to your subject matter, a phenomenon called *parallax* becomes more pronounced so that it's quite easy to chop off the head and the right arm of a person you're taking a picture of. Most optical viewfinders have little lines visible at the top and side of the viewfinder. You're supposed to use these to correct for parallax but, let's face it, this is not an ideal solution to the problem.

That leaves you with two other options: an LCD display or a *through-the-lens* (TTL) viewfinder. Even cameras with a viewfinder are likely to have an LCD display. It's a handy way to check the results of a picture you've just taken and decide whether it's a keeper or deserves the delete button. I find using the LCD to frame my subject matter unnatural. That may come from years of using a 35mm viewfinder, but I suspect it really comes from the fact that you have to hold the camera away from your eye. It becomes a separate object to manipulate instead of an extension of your own body. It's particularly awkward if you wear bifocals; you'll quickly develop a literal pain in the neck from tilting back your head to see the display through the "reading" part of your glasses. And be aware that LCD displays can be difficult to see in bright sunshine or at night.

If you think I'm stacking the deck toward the TTL viewfinder, you're right. There are many different ways of designing a TTL viewfinder. One is to send the view the image sensor is capturing to a small LCD display built into a viewfinder you put to your eye as nature meant cameras to be used. Other methods use mirrors or prisms to divert the focused image from the image sensor to a ground glass screen where you see the image through the viewfinder. They all have the advantage that they eliminate parallax problems completely. You're seeing what your camera sees. Some throw in a digital display of shutter or aperture settings so you don't need to remove your eye from the viewfinder. Pick a system that feels right for you, but if your budget allows, make it a through-the-lens viewfinder. If you wear glasses, try for a camera that has a *dioptric* correction built into the viewfinder. This lets you adjust the viewfinder's focus to compensate for your eyesight.

Exposure Systems

You have two basic choices for a light meter built into your digital camera. The meter can be mounted beside the lens—similar to an optical viewfinder—or it can measure the light that is coming through the lens. As with viewfinders, the type that sees through the lens is better, but, of course, more expensive.

Within TTL exposure systems, you'll find a complex variety of designs. Some sample the light in the middle of the image on the assumption that that's where the most important part of the scene is. This can be used in much the same way autofocusing lens are used. You take a light reading of what *you* think is the most important part of the scene, have the camera remember that exposure reading, and then reframe your shot before fully depressing the shutter buttons.

Other exposure systems sample the light from as many as 45 different points and calculate the exposure best suited for the scene overall. In scenes that have extremes of light or darkness, any of the systems may fail you. Some cameras have controls that tell the exposure system to cheat one way or the other—to say a scene is lighter or darker than it is overall. If the camera or you guess wrong, you'll often be able to correct the exposure in your digital darkroom.

Automatic exposure is a good example of why you ideally want a camera that lets you override automatic operations. Sometimes you know what you want to achieve is breaking the rules the camera has set up to make photography as carefree as possible.

Flash

All digital cameras come with some sort of built-in flash, usually designed to jump in when the exposure meter says there's too little light for a decent exposure. We'll get into more ways to use the flash in the next chapter. Right now, though, while you're making choices, look for a camera that has a way to attach an external flash unit to it. The location of most built-in flash units—right above or immediately to the side of the lens—is less than ideal. They create photographs of people outlined by their own shadows like something from a film noir. Such flashes also contribute to pale, washed-out faces because they eliminate the character generated by wrinkles, curves, and textures that have taken years to make your subject the interesting person they are. An add-on flash attachment that you can hold separately and point in directions different from where your camera is pointed can be the best single way to improve photos you take indoors. But the adapter and sockets needed for an external flash are rarely found on low-end digicams.

From Camera to Computer

Of all the choices you can make, how photos are stored as you shoot them is the least interesting. Most cameras use some sort of flash memory. Sometime the memory is built in as a permanent part of a computer. Avoid this. It means that when you've filled the memory with images, you have to transfer them to a computer before you can shoot any more. Instead, get a camera that uses removable flash memory. This usually takes the form of thin rectangles of plastic about the size of a matchbook. Inside the memory card are millions of transistors that, unlike the transistors in your personal computer, don't lose the information they hold when the power is turned off. When you fill up one card, you can exchange it for a blank one and keep on shooting.

Flash memory from different manufacturers may look similar (see Figure 1-9), but that doesn't mean they are interchangeable. SmartMedia is thin, the thickness of two or three sheets of paper. A notch on one corner lets you know which way to insert the card. CompactFlash cards are thicker—just a bit less than a quarter of an inch. CompactFlash and SmartMedia cost about the same, $40 to $50 for 128MB. CompactFlash is available in cards that hold as much as 512MB. SmartMedia tops off at 128MB. (Sony, which often has to be different from the competition, uses a "memory stick" that looks more like a stick of chewing gum.) Find out what kind of memory is used by the camera you're thinking of buying, and check the prices for its memory. Although you can always upload your pictures from the memory card to a computer and reuse the flash memory, you want to avoid that by carrying a few spare memory cards.

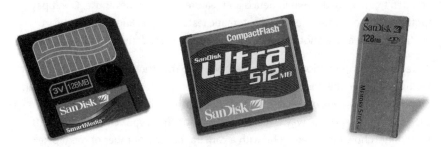

Figure 1-9 *The most commonly used forms of storage on digital still cameras are, from left, SmartMedia, CompactFlash, and Sony's Memory Stick.*

Sony's Mavica cameras take a different approach by recording digital photographs direction to floppy disks or writable compact discs. The growing number of megapixels used to capture a photo is making the storage of even one photo on a floppy unlikely without using a high factor of compression. (More about that later in the book.) But the writable CD is appealing. Blank CDs are cheap and make the task of transferring

photos to your computer as simple as reading any other file off a CD. The drive does add to the bulk and weight of the cameras, but they're worth checking out.

If you get a camera with flash memory, you'll have to have some way to transfer the images from the memory cards to your computer. Some cameras offer a *card reader* that connects to your computer. You slip in a memory card, and the computer sucks out the photos. Others systems connect to the flash memory while the card is in the camera. Either way, you have to have some sort of cable to connect to your PC. Although you're unlikely to encounter them except at some closeout sale, avoid systems that use serial or parallel cables. (The newest fad is cameras that hook directly to a printer to eliminate the computer middleman. To me, this negates a main reason for getting into digital photography—so you can improve your shots with touch-up software.) For Windows PCs, a USB connection is the simplest and fastest way to transfer photos. If you have a Macintosh, you may have a choice of USB or *firewire* connections. Both are fast, and not worth the time some fanatics spend debating their virtues.

Put Your Money Where Your Heart Is

There are other features to look for in a digital camera. Some automatically correct for the off-white coloring caused by some types of lighting. One may have a remote control for those occasions when you feel like doing some spy photography. Others may be particularly suited for *burst mode*—taking several fast, consecutive shots to capture action. Concentrate on the crucial choices we've covered in this chapter, and don't get bogged down in details and features you may never use. Don't pay for the ability to manually override automatic features if you know in your heart you're basically a lazy photographer who wants the work done for him.

All technical considerations aside, remember, too, that there is an emotional factor, not unlike the passion that takes over when you're shopping for a new car. Some digital cameras may call out to you because of something intangible... the color, the shape, the way it feels in your hands. Trust your emotions. What's important is how happy you'll be with a camera, not the number of megapixels it boasts. Be prepared to go beyond whatever you've budgeted, but only if you love the camera.

Links

And to help you follow the way of the camera, here are some Internet links to let you dig deeper into the innards of your digital camera. If you want to avoid having

to type out these URLs, this same list is posted on the author's web site, www.howcomputerswork.net.

- **www.kodak.com/US/en/nav/digital.shtml** Kodak's guide to digital cameras and photography. One of the most thorough sites on the Web, if you can stand the obligatory hype for Kodak products. Be sure to check out the Digital Learning Center.

- **www.shortcourses.com/index.htm** Excellent all-around site with a collection of no nonsense tutorials on all aspects of digital photography and cameras.

- **www.betterphoto.com/buyers.asp** Buyers' guide to digital cameras.

- **www.shortcourses.com/guides/guides.htm** Pocket guides to popular digital cameras in PDF format.

- **www.nyip.com/index.html** New York Institute of Photography, with new tips, essays, and tutorials each month on topics ranging from the history of art for photographers to photographing people of color.

- **www.dynamism.com** Good source of ultra-miniature digital cameras, some of which are not otherwise available in the U.S.

- **www.dcviews.com** Excellent source of the latest news in digital photography and cameras.

- **http://photos.msn.com/home.aspx** Microsoft pushes its own products, of course, but it's still a good site with lots of information.

- **www.microsoft.com/windowsxp/digitalphotography/default.asp** Microsoft's tutorials on digital photography and Windows XP.

- **www.megapixel.net** Monthly online magazine with hardware reviews and tutorials aimed at the beginner.

- **www.lvsonline.com/index.shtml** LVS Online Classes offers well-received six-week courses in digital photography and various image-editing programs. Tuition is $20.

- **www.diynet.com/DIY/show/0,1329,DPG,FF.html** The Do It Yourself TV network provides written material taken from its programs that's well-suited for the beginner photographer.

- **www.steves-digicams.com** Plenty of reviews of digital cameras and printers.

- **www.canon.com/camera-museum/index.html** Canon Camera Museum.

- **www.apogeephoto.com** Online monthly magazine on digital photography that includes everything from how-to articles to exhibits of great photos.

- **www.imaging-resource.com** Hot news, how-to discussion topics, and hot deals.

- **www.pdn-pix.com** PDN (Photo District News) Online's articles are aimed at professional photographers.

- **www.pcphotoreview.com** As the name suggests, this online publication is heavy on reviews of equipment and software.

Rescue

Whether a professional, enthusiast, or holiday photographer, one of the things you plan to do with your digital camera is capture history in the making. It may be personal history—your kid's first birthday, a trip to the Grand Canyon, or an image of yourself you can look at 30 years from now and wonder why you ever wore those clothes. But before you start capturing the present for the future, you have a more pressing obligation: saving the *past* for the future.

Somewhere in a closet, attic, garage—or worst of all—a damp, unventilated basement, there is a shoebox filled with photographs you shot years ago in the ancient, predigital eons. Some may be photos shot by your parents, or their parents. Every day that passes carries these photos closer to their total destruction. These are chemical photos—or, more exactly, the products of various chemical reactions. That shoebox is still a cauldron of chemicals embedded in the surfaces of the negatives and prints. Those chemicals reacting with one another, with the corrosive oxygen and moisture in the air, and heaven knows what other chemicals, from fertilizer to insecticides, that may be sharing that cramped storage space.

You have one chance to rescue those photos for the benefit of generations yet to come, and that chance is right now. Not tomorrow. Now. Already, the photos have begun to fade, lose their color, darken, or, worst of all, bond surface to surface, beyond any hope of separation and salvage.

Even if you've been dutiful in preserving your stash of family photographs, this chapter still applies to you. Unless you are storing the photographs the way the original copy of the U.S. Constitution is kept—in hermetically sealed cases filled with inert nitrogen, kept at a constant temperature and away from bleaching light—this chapter is for you, too. Now, if you are a person without a past, or at least a past in photographs, you can skip to Chapter 3, and there's no harm done. Otherwise, listen up: Get a scanner!

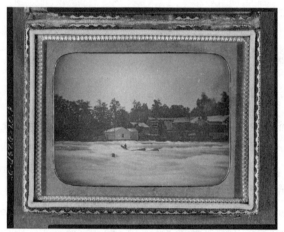

Figure 2-1
The Library of Congress is preserving the visual past by converting into digital archives old photos, such as this daguerreotype taken by Platt Babbitt in 1879. This photo is an early example of a news photograph.

Photo courtesy of Library of Congress, Prints & Photographs Division

Scanners

Scanners are actually oversized digital cameras that are really good at only "photographing" flat objects, such as printed pictures and pages of text. The most important difference between the two is that, instead of a rectangle packed with an array of photodiodes that you find in a camera, most scanners have simply one to a half-dozen rows of diodes, or pixels. Those few rows of pixels capture the image, whether text or graphic, by reading the light and color values of the image as a light moves beneath the bed of glass and a system of mirrors reflects the image to the stationary bank of diodes called the *scanning head*. The result of using a scanner is the same as using a digital camera: images are converted into bits of 0s and 1s. Shapes and colors receive numerical values. The bits are saved to a film on your hard drive. Then, using a program such as Adobe Elements, you restore the images to their original, unblemished glory.

If you do not already have a scanner, the most important thing to know about them is this: They're cheap. You can spend thousands of dollars on scanners that are designed for professional graphics companies. Or you can buy a decent scanner for under $100. Here's what to look for.

Get a Flatbed

No, not a truck. Flatbed describes the most common type of scanner. It has a flat bed of glass on which you lay facedown the object to be scanned. There are other scanners that have document feeders that allow you to scan dozens of pages automatically. These are helpful if you are planning to use *optical character recognition* (OCR) to convert printed pages of text into words you can edit on your computer. A flatbed lets you scan any size document up to its maximum size, and they most often come with OCR software so you can do text conversion as well, without the automatic feeding. But our focus is on photos, and a flatbed, such as the one shown in Figure 2-2, is the most versatile, as well as the least expensive way to get printed photos into your computer.

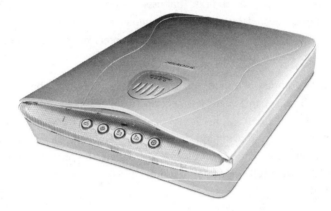

Figure 2-2 *The ScanMaker 4800, shown here with an adapter for digitizing slides and negatives, is a flatbed scanner.*

Scanning Slides and Negatives

If your old photo collection includes slides, or if you have your photos' original negatives, then look for a scanner with a 35mm filmstrip adapter. Normally, a scanner works with pictures by bouncing light off the printed photos. That doesn't work with negatives and slides. The light passes through the film or transparency and then bounces back through it. The result is a muddled double-exposure. The adapter shines light through the film from the backside so the scanning head receives a clean, crisp image.

If you have slides, this is the only way to scan them. OK, there are specialized slide scanners costing hundreds, or thousands, of dollars, but these are for professional settings, such as magazine publishers who must squeeze out every drop of quality in an image. They're overkill for you and me.

If you have negatives, then the first rule of reproduction applies: Each generation— that is, each copy of a copy—loses information. This is not true when you make digital copies of something that's already in digital form. That's why your goal should be to convert your old photos to digital files. You can copy those files endlessly, to distribute to family and friends or to preserve for centuries, with no loss in quality. But until you get to that point, you want to work with the earliest generation of an image you can find. That usually means a negative. Scanning and photo touch-up software let you convert the negative scan—either color or black and white—into a positive image. Some 35mm adapters let you scan a negative strip of up to six frames in a single pass.

Amazingly, the addition of a slide/negative adapter adds little to the cost of a scanner—usually less than $50 on scanners aimed at consumers. As I write this, the ScanMaker 4800, a flatbed scanner from Microtek shown in Figure 2-2, complete with a 35mm adapter and matching the other requirements we'll get to next, is $90 at MicroWarehouse and similar direct-order outlets. (Because the ScanMaker 4800 costs less than $100, we'll refer to it often as a reference point for what you can get for your money.)

Resolution

Not that I would ever accuse hardware manufacturers of deliberately making the specs on their products confusing, but scanners are particularly hard to pin down when it comes to resolution. Resolution is usually expressed as something like "600×1,200-dpi optical resolution." The first number refers to *optical resolution*, the number of photodiodes, or pixels, devoted to each inch across a thin strip of the photo. The second number is the resolution of the step motor that moves the scanning head across the document. You can safely ignore the second number, but you want the first number to be as large as possible. For now, 2,400 dpi should be the least you settle for. That's the optical resolution of the ScanMaker 4800 mentioned above. For under $200, you can buy a scanner with 4,800-dpi optical resolution. (You may be wondering why the ScanMaker 4800 isn't called the ScanMaker 2400. Because someone in marketing said so, that's why.) If you will be working with negatives or slides, you should consider spending the extra bucks for the higher resolution. With slides and negatives, the original you're using is much smaller than most photo prints, which automatically means you'll be enlarging the

original. The more detail you capture in the original scan, the more detail you'll preserve when you enlarge it.

Interpolated Resolution

Just to add to the confusion, the descriptions of some scanners also list *interpolated resolution*. This is actually added resolution that's been faked by software. In the case of scanners, it's software that's built into the scanner's circuitry to add the fake resolution as you scan instead of doing it later using Photoshop Elements or other retouch software.

Faked resolution is not really as bad as it sounds, depending on what type of interpolation is used and the nature of the original images. If you're scanning negatives with a 1,200-dpi scanner, you may have to resort to interpolated resolution to make any decently sized enlargements. We'll get into this more in Chapter 4, when we play with the digital darkroom. For now, when you're scanner shopping, you should know not to confuse interpolated with optical and be aware that the best type of interpolated resolution is called *bicubic*.

When Resolution Counts

Generally, it's better to have too much resolution available to you than not enough. But that doesn't mean you have to use all the resolution you can for every scan. Higher resolution also means bigger files. And if, for example, all your scans are going to wind up only on the Internet, you don't need to pay a penny more for higher resolution. Any of today's scanners will do fine for images destined for a web page.

If, though, you plan on scanning a lot from negatives or slides, 4,800-dpi optical resolution is worth the extra $100 or so it will cost. Enlarging a 35mm negative so you have a 4×3-inch print means blowing it up 280 percent. An enlargement like that will really show detail—or the lack of detail.

*AS A MATTER OF FACT There is a software side to scanners. Scanners comes with software that lets you choose the resolution level, crop an image, and convert text to words you can edit on your PC. Some scanner software also lets you do basic image manipulation, such as changing the brightness and contrast and rotating or flipping the image. But you don't have to use the scanner's own software to scan an image. Most graphics programs—and some software, such as Microsoft Word, whose main job isn't working with images—can work with a scanner. Under a menu command usually named **Acquire** or **Import**, you'll find a selection that starts the scanning process and then opens the scanned image inside the program. If you're using Adobe Photoshop Elements to retouch photos, it's faster and easier to initiate the scan from within Photoshop Elements than to do the scan separately and then open the file in Elements.*

Scanners allow you to determine how much resolution to use by selecting settings in software. For scans of old photo prints, how much resolution to have available and how much to use can be determined case by case. If you're planning to print a scanned photo at the same size it was originally, choosing anything above 300 dpi is too much if your printer's top resolution is 300 dpi. Using scanning resolutions that won't show up in printer resolutions merely creates bigger files. A 4,800 dpi scan will be 16 times larger than a 300-dpi scan. But if the original is small, you'll be happy to have the extra resolution available, as you can tell from the scans shown in Figure 2-3.

There's a formula to determine how scanning resolution translates into printing quality. Here it is:

```
(Printer resolution × width of print in inches)÷ (width of scanned
image in inches)

= (resolution setting for scanning)
```

If formulas make your eyes glaze over, here's a table that will help you out in most situations.

Size of Scanned Image	Printer Resolution	Print Width	Best Scanning Resolution
35mm slide or negative	300 dpi	4 inches	834 dpi
35mm slide or negative	1,200 dpi	5 inches	4,173 dpi
35mm slide or negative	300 dpi	8 inches	1,669 dpi
4×5 inches	300 dpi	4 inches	300 dpi
4×5 inches	300 dpi	5 inches	1,800 dpi
4×5 inches	1,200 dpi	6 inches	480 dpi
5×7 inches	300 dpi	8 inches	1,920 dpi
5×7 inches	1,200 dpi	8 inches	540 dpi

This table is oversimplified. Scanners, for example, don't come with settings for 1,669 dpi. You have to choose one of the presets, usually for 150, 300, 600, 1,200, 2,400, 3,600, and 4,800 dpi, if the maximum resolution goes that high. Plus, there are other factors, including the type of printer technology, paper, and assorted printer settings that we'll look at in Chapter 6. For now, here it is in a nutshell: Don't expect terrific prints with lots of fine detail if your scans don't have enough resolution to capture that detail. But don't get carried away or you'll have files that quickly eat up disk space and take longer to display and edit.

Resolution: 75 ppi (pixels per inch)
File size: 18,882KB

Resolution: 150 ppi
File size: 60,772KB

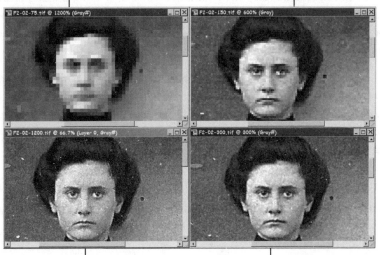

Resolution: 1,200 ppi
File size: 3,441,624KB

Resolution: 300 ppi
File size: 215,922 KB

Figure 2-3 The extent to which this photo of one of the author's ancestors can be enlarged depends on its resolution.

Color Depth

Some scanners distinguish subtle shades of color better than others. The measurement of a scanner's sensitivity to different hues is called *color depth*, or *image depth*, and is measured in bits.

For optical character recognition, a scanner really needs just 2 bits of data for each pixel created by a scan—one bit to stand for black and another bit to signify white. For black-and-white photographs, 2 bits won't do. The results would look like a photograph that's been sent over a fax machine—blocks of solid black and white. Digital black-and-white photos are created in *grayscale*, which assigns different numerical values to the range of grays that run between bright white and the deepest black. That makes color depth nearly as important for black-and-white photos as it is for color photographs. A color depth of 16 bits provides a rich black-and-white scan with 65,536 shades of gray.

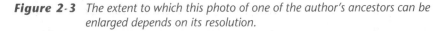

AS A MATTER OF FACT *If you are planning to convert a color photograph to black-and-white, scan it and edit it in color. A scan straight to black and white will lose some of the visual information contained in the color. Only when you're finished editing it should you convert it to grayscale.*

Several scanners, including our under-$100 benchmark ScanMaker 4800, provide up to 48-bit color depth. Forty-eight bits is more than enough for printing-press work and more than a PC monitor/video card combination can handle. PCs top out at what's called *true color*, 32-bit color—4,294,967,295 colors, which are more than the eye can distinguish.

Don't take claims of 48-bit color all that seriously. That describes what the scanner can recognize, but it doesn't mention that the software controlling the scanner can't really deal with that much information and tosses away some of it. Your printer, too, is likely to throw out some of the color information. The result is that any scanner offering 24-bit color is all you need.

Dynamic Range

Let's not waste a lot of time on this. In fact, the only reason I'm including it is in case some scanner sales guy tries to throw some jargon at you just to make you feel like you're at his mercy.

Once in a while, you'll see a reference to *dynamic range* among the specs for a scanner (or digital camera, for that matter). Here's what it is. Dynamic range, or *Dmax*, is the ability of a scanner to accurately capture the lightest and darkest colors or gray shades in an image. If a photo has both bright sunlight and dark shadows, such as the scene in Figure 2-4, its dynamic range is high, and a scanner or camera with a high Dmax is needed to match the scene accurately.

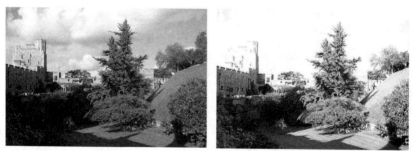

Photo courtesy of Digital Photography Review, www.dpreview.com

Figure 2-4 *At left, a scene that has a wide dynamic range. At right, what happens with too little dynamic range to capture the full range of colors.*

Dynamic range is measured logarithmically, like earthquakes, with values between 0 and 4 that represent the ratio between the brightest and darkest parts of an image. A Dmax range in a scanner or camera of anything over 3.2 is good. A value of 3.3 is

ten times better, and 3.4 is ten times better than 3.3. Most scanners and cameras compromise in some way because perfect dynamic range is impossible. At the low end and midrange, scanner makers don't mention dynamic range. But generally, you can figure that the greater the color depth, the more likely the dynamic range is better, too.

Connection

The last of your considerations is how a scanner connects to your computer. This is simple. If you have a Mac, a scanner that supports Firewire is the obvious choice. If you have a Windows PC, USB 2.0 is just as natural. If your PC is more than a couple of years old, it may not support USB 2.0. You can still connect to your USB port at USB 1.0 speeds. But to get the speediest transfer from scanner to computer, you should buy a USB 2.0 expansion card. Or, get a new computer. Your call.

Remember that your need for speed increases with the size of the originals you scan, the number of pixels absorbing light along each inch, and the number of bits devoted to recording color information for each of those pixels.

Whatever scanner you pick, as soon as you get home, start feeding it those priceless family photos. Rescue the photos as digital images before they fade away forever.

Then you can go outside and play with your new camera.

Links

Here are some web sites that can help make you into a top-notch scanner. The links are also on the author's web site, www.howcomputerswork.net.

- **www.shortcourses.com/using/index.htm** A Short Course in Using Your Digital Camera, one of the best tutorials you'll find on the Internet.

- **www.kodak.com/global/en/consumer/pictureTaking/top10/ 10TipsMain.shtml** Kodak's "Top 10 Techniques" to improve your picture taking.

- **www.kodak.com/global/en/consumer/education/programs/ composition/photoProgramCompMain.shtml** Kodak's Beginnings of Photographic Composition, a must-browse site.

- **www.photoexpert.epson.co.uk/UK/homepage.htm** Tips and tricks from professional photographers to get the most out of shooting pictures with a digital camera.

- **http://photos.msn.com/editorial/EditorialStart.aspx?article= macro_msn§ion=NOTEBOOKS** Tips on macro photography.

- **www.sunspotphoto.com/ssp/lenses/fxfilter.html** Sunspot Photography gives a good, quick overview of the use of filters that are screwed onto the end of a lens.

- **http://ccollege.hccs.cc.tx.us/instru/photog/stdpprs/vad1457.html** Scholarly look at depth of field.

Shoot

As tempting as it is to rush out and start snapping photos with your new digital camera, wait up a bit. Even if you're an experienced film photographer, chances are your digital camera has controls and features that are entirely new to you. Sit down with the manual and camera to at least learn the purpose of any button, knob, switch, lens ring, or other doohickey you can't identify.

We'll encounter some of those controls in this chapter, and you'll learn how to use them to create the photograph that is hovering in your brain. To a camera, what's in the viewfinder is just a lot of dots of light. It doesn't know what the subject matter is, and it doesn't know what you want to accomplish with a photograph. Only you know that. The purpose of this chapter is to combine the control on your camera and the vision in your head to create a photograph worthy of framing or displaying on the Web.

Know Resolution

Usually, you use most of the controls on a digital camera on the fly as you shoot pictures. But you need to set up some features of your camera before you begin shooting. Those settings should match the type and quality of photos you hope to turn out. Pictures shot for the Internet, e-mail, a family album, or a full-blown, framed display have different requirements for *resolution*, which is essentially how sharp and detailed your photos are, and for *compression*, which is how much of those details are sacrificed so your photos take up less storage room in your camera and your computer.

The number of pixels your camera uses to capture an image determines the picture's resolution. The more pixels, the higher the resolution. A software program built into your camera performs the compression by discarding information that probably won't be missed and saving the remaining information in a file format called a J-peg (or JPEG). (Its file extension is .jpg.)

Quality

You say bigger is better. You'd like to create gorgeous prints worthy of framing, put them under halogen spotlights, and, who knows, maybe an exhibit in a gallery. Then you want to take photos that have as high a resolution as you can squeeze out of your camera—and your printer. The printer really determines how much resolution to use. There's no sense in wasting your camera's memory and your computer's hard drive storage on visual details your printer can't reproduce.

Most ink-jet and laser printers use at least 300 dpi. That means each square inch of a printed image is made up of 90,000 dots of ink. That's good enough to give you a satisfactory photograph—depending on how big your print is. (The print quality also depends on the type of paper used, how the printer creates its dots, and how many shades of ink are used. We'll cover this in more detail in Chapter 6.)

So the real question becomes this: With *x* number of pixels in the camera, what's the biggest print we can make before the picture begins to pixelate? (Pixelization occurs when a graphics file doesn't have enough detailed information to fill out each individual pixel and begins to group pixels together as if the picture were a crude mosaic of different colored tiles.) Figure 3-1 shows the biggest decent prints you can make with cameras using 1 to 5 megapixels.

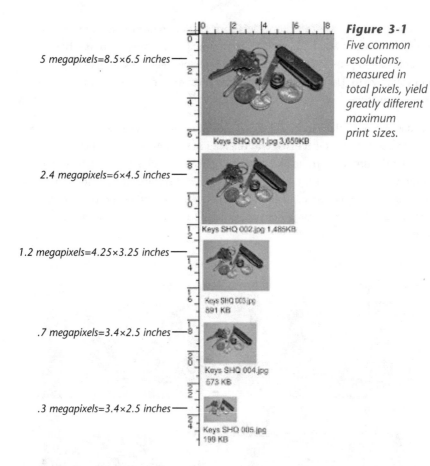

5 megapixels=8.5×6.5 inches —

2.4 megapixels=6×4.5 inches —

1.2 megapixels=4.25×3.25 inches —

.7 megapixels=3.4×2.5 inches —

.3 megapixels=3.4×2.5 inches —

Keys SHQ 001.jpg 3,659KB

Keys SHQ 002.jpg 1,485KB

Keys SHQ 003.jpg 891 KB

Keys SHQ 004.jpg 573 KB

Keys SHQ 005.jpg 199 KB

Figure 3-1
*Five common
resolutions,
measured in
total pixels, yield
greatly different
maximum
print sizes.*

Quantity

High-resolution photos take up more room on a camera's storage/memory than low-res pictures. Two or three photos at an uncompressed 5-megapixel resolution will easily fill a 32MB memory card. But often, taking a lot of pictures is more important than taking one high-quality picture. Weddings, vacations, or birthday parties—these are occasions where it's essential to shoot as many pictures as you can to make sure everyone's role in a moment of family history is memorialized. Then it's time to compress the photos.

You can take even more photos using the same storage space if you squeeze down the file size with the JPEG compression built into every digital camera.

JPEG's compression rate is variable. It lets you choose how much compression you want to trade for picture quality. You can reduce the size of a file at the expense

of image quality, or you can choose less compression in favor of a more detailed picture. Your own trade-off between size and quality will vary, of course, but no matter how you plan to use photos, you're probably keeping your files bigger than you have to. Use some amount of compression for all but the most ambitious pictures.

The four photos tiled in Figure 3-2 are all shot with a full 5 megapixels of resolution. The upper left is not compressed and the file size is 14,405KB. Going clockwise, the other pictures have more and more compression until the lower-left version, compressed at 88 percent, takes up only 1,169KB of storage. It lacks some detail, particularly in the dark areas, and is fuzzier compared to the uncompressed version, but it took an enlargement of a small portion of the original to make the flaws show.

Uncompressed TIFF, 14.4MB 63 percent compressed JPEG, 3.6MB

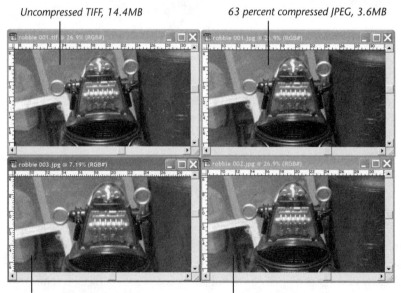

88 percent compressed JPEG, 1.2MB 75 percent compressed JPEG, 2.5MB

Figure 3-2 *Four photos made with the same high-resolution setting barely show any difference in quality caused by JPEG compression.*

Choose a Resolution

Because these resolution and JPEG settings rarely change from one photograph to another, you'll most often find them in menus, similar to those that computer programs use. The menus are located in the same small monochrome LCD that tells you how many shots you have left or on a larger, color LCD screen that also serves as a viewfinder, such as the menu shown in Figure 3-3. On most cameras,

select the menu items using a four-direction toggle that you maneuver with your thumb—sort of like one of the controls on a GameBoy. You'll encounter a lot of obscure icons in the menus. Keep the manual handy.

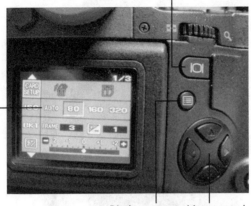

Switch between LCD and viewfinder

LCD screen —

Display menu Menu control

Figure 3-3
Use the four-way toggle control to navigate the menu on the Olympus E-20N's LCD screen to the left of the control.

You'll need to make choices, as summarized in the table below. It's best to experiment with your resolution and compression to find a combination that works best with the type of photos and prints you want. Most of your choices among resolution and compression settings are trade-offs. You don't get the advantages of one setting without sacrificing something on another setting.

Resolution	Trade-offs	Compression
High quality ◄————————————►		Lots of photos
Big prints (8×10 inches) ◄————————►		Web photos
High resolution ◄————————————►		Low resolution
No compression ◄————————————►		Maximum compression

As you'll see, though, the trade-offs are less painful than you might think.

AS A MATTER OF FACT If you're shooting photos for use on a web page or to send to someone attached to an e-mail message, don't waste camera storage on high resolution. Use a resolution of 640×480 dpi, about a third of a megapixel, and crank up the JPEG compression. Any image with better resolution is not only wasted on displays that usually have 72 dots per inch, but they add to the time it takes to download pictures. There are people and settings for which it's a good idea to include the surroundings because they tell you something about a person, as they do in Figure 3-4. If your picture is more than a close-up of the subject's face, make the subject have a relationship, at least visually, with the surroundings.

Figure 3-4
*Include the
surroundings
only if they say
something about
your subject.*

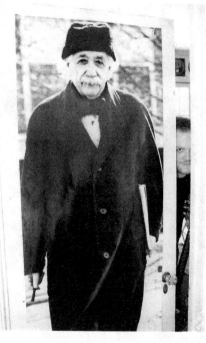

How you position the objects in your photo creates the relationship between the subject and its surroundings. Objects in the picture should create patterns that the mind recognizes and feels comfortable with—or patterns that pay a wake-up call on the brain because they are unexpected and even disturbing. (Remember, there are no rules that can't be broken for a good reason.) You can help by using focus to narrow attention to your main subject. Setting the exposure specifically for what you want to emphasize draws the eye to your central subject. Using all these techniques, we'll look at how to put the emphasis where you want it to go.

Divide the Picture

When you're including the surroundings in a portrait—or when you're shooting a landscape or any scene that has one feature you want to emphasize, avoid putting it square in the center of the photograph. Instead, obey the Rule of Thirds.

The Rule of Thirds is this: Divide any photographic rectangle into equal thirds vertically and horizontally. Those invisible dividing lines are the best places to put the main subject of your photo. Putting it in the center is too balanced, too bland. See how the rule works in Figure 3-5. The girl and the horse's head are both positioned on Rule of Thirds lines.

Figure 3-5
*Position your most
important objects
in a picture along
imaginary lines
that divide the
frame into thirds
vertically and
horizontally.*

Of course, the ideal composition doubles up on the Rule of Thirds, placing the most important object in the picture where two of the dividing lines intersect.

Use Geometry

Sometimes the Rule of Thirds just isn't going to work out, so there are some other geometric tricks to fall back on. If you position objects so that they form, roughly, simple geometric figures—preferably as simple as possible, a triangle—that brings a sense of order to the photo. The same photo of a girl and a horse we saw in Figure 3-5 also hides triangles and lines that connect the two main objects in the picture with their geometric design and tell the eye where to look. See how in Figure 3-6.

If you lack a handy geometric shape, some simple lines may do the job. Straight lines are a powerful composition force, especially when there are many of them, and they all lead the eye to the same point. Oh, and of course, it helps if that point is on one of the thirds and if the most important object in your picture is also located there.

An S-curve, such as that made by the sidewalk in Figure 3-7, does not as effectively command the eye to move to a specific point in the picture as do straight lines.

But whoever's job it is to study such things has declared that the S-curve is one of the most pleasing shapes we encounter and adds interest to any photo.

Figure 3-6
The little girl's legs line up with her body and the horse's head to tie together the two major elements of the photo.

Figure 3-7
The curving sidewalk adds visual interest to an otherwise mundane photograph, as does the bird's-eye view.

Frame Your Subject

We somehow feel more comfortable with a photograph if something else in it—a window, the curve of a staircase, fishing boat nets, dangling foliage—visually frames the subject matter. Take a look at Figure 3-8. The tree branches hold the photo together, eliminate a distracting sense of free fall, and provide scale for the building. The frame needn't completely surround your main subject; in fact, it shouldn't. And the frame certainly shouldn't be so obvious as to detract from the main subject. In landscapes, look for something to include in the foreground that can frame the scene in the distance—a tree branch, a river, or a spouse.

Figure 3-8
Trees make great framing elements in outdoor photos.

Lead Inward

A related rule that good photographers don't break, except when breaking it makes a statement, is to never have someone facing out or moving out of the frame. One reason is that we naturally tend to look in the same direction someone else is looking. Even if a person in your photo is squarely on one of the Rule of Thirds dividers, if that person is facing the outside of the frame—or worse, moving toward the frame—our inclination is to look away from the photo instead of being drawn

into it. Check out what happens when this rule is intentionally ignored in Figure 3-9, to emphasize how the one person in the picture has literally turned her back on the rest of the scene.

Figure 3-9
Breaking a rule works here. The woman facing the edge of the frame increases her sense of isolation.

Shoot a Portrait

We're an egotistical species, and like a dog that can't resist the appeal of another dog, we like photographs best when they're about people. Good thing, because I'd guess most photographs are about people. Even those scenic shots that aren't about people are frequently more interesting with people in them. Of course, most of the pictures we take of people aren't portraits. A portrait tells you something about a person that you can't put into words—or makes you wonder what secrets are hidden within.

Here are ways to turn what would have been another snapshot of a friend into a statement about who the person is.

Isolate Your Subject

Most amateur photographers don't compose their photos. The photographer puts one person in the center of the viewfinder and snaps a picture. Usually, there is scads of space surrounding the person that adds nothing to the picture, just as in the photo on the right in Figure 3-10.

The tips here don't apply only to portraits. Pictures of an individual make for an easy way to describe these techniques, but they are equally effective when applied

to pets, cityscapes, still lifes, action shots, even landscapes where "posing" your subject is easily done. So when you read "subject" here, substitute whatever is the most important object in your photograph.

Figure 3-10 *A candid photo always works better than the old throw-'em-up-against-the-wall technique.*

AS A MATTER OF FACT *Don't rush a photo session. Take some time to talk to your subject. Get him or her laughing if you can, even if you want a "serious" pose. Many people don't like how they appear in photographs. The main reason is that they're tense about being photographed, and this shows in their faces, if not in the outright scowl that appears at the first sight of a camera. If you can get your subject to relax and assure them that no one's going to see a photograph that makes them look bad, you'll both have an easier time of it, and your photo will be a lot better. If possible, take candid photos. There's no rule about whether a portrait should be candid or posed. Both work. But a truly candid pose will capture the person with their guard down. Compare the same person in the two photos in Figure 3-10.*

Get Close

Of course, that extra space around your subject can be cropped out in your digital darkroom, but that means that you're using only about a third of those umpteen megapixels you paid for. Your portrait will lack detail where it's most important— in the person's face. Do everything you can to improve a picture before you get to the darkroom. Instead of using your computer to do cropping, use your feet: Move in as close as you can to your subject. Try to get close enough to eliminate any surroundings that don't contribute to whatever you want to communicate with your photo.

Here's the simplest way to leave no doubt what a picture's about: Move in as close as possible to the subject's face. The face is the most important part of a portrait. Show as much detail of the face as possible. Close in more than you think you should. Don't worry if you don't show all of the top of the head or the chin. Shoot for the face.

AS A MATTER OF FACT *Many people use the LCD screen to compose their shots. It draws down a lot of power from the batteries. But there are times when it can be handy. For instance, if you want a worm's-eye view, looking through the viewfinder is difficult without embedding a bunch of dirt and grass in your hair and face. The LCD lets you frame your shot from a more hospitable position. Some cameras have camera bodies that swivel independently of the lens, letting you take pictures more comfortably and, if you've a mind to, surreptitiously. If you hope to become a paparazzi, swiveling camera bodies and LCD screens will let you hold the camera at arm's length, above the heads of the crowd, and still let you aim it at a passing movie star.*

Use Depth of Field

Use *depth of field* to "focus" attention on your main subject. Depth of field is the space in front of the camera that's most in focus. How deep the depth of field depends on the size of the lens's *aperture*, which is like the eye's iris, a circular opening that can be open as wide as the lens itself or closed down to a pinpoint opening. At the smallest opening—an f-stop of 11 or 22—typically everything from a few feet in front of the lens to the distant horizon is in focus. With the aperture wide open, depth of field is limited to a few feet or inches for nearby subjects.

Set your camera's exposure mode to aperture, usually indicated with an A on a dial. This allows you to set the aperture to its widest setting—f/2 or f/1.4—and prevents the camera's light meter from changing the aperture. Instead, the light meter will control only the camera's *shutter* speed. The shutter is a curtain—sort of like an eyelid—between the lens and the rectangle of pixels at the back of the camera. The light meter will hold the shutter open only long enough so that, combined with the aperture's setting that you pick, the right amount of light strikes the pixels to create a correct exposure.

In the photo on the left in Figure 3-11 the depth of field is deep enough that the house 20 yards behind the flower is still in focus. In the photo on the right, the depth of field barely extends beyond the flower itself.

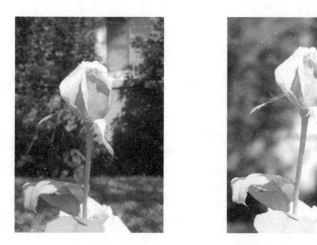

Figure 3-11 *Controlling the depth of field in the photo on the right draws attention to the flower instead of the background, as in the shot on the left.*

Focus on the Eyes

When you're shooting a portrait, always focus on your subject's eye nearest the camera because depth of field—the distance in front and in back of whatever you've focused on—extends farther in back than it does in front. This gives you a chance to have the far eye in focus too, but if the depth of field is shallow, it ensures the eye nearer the camera will be sharp. The saying about eyes being the windows to the soul has some truth to it. At least in portraits, if both eyes are out of focus, the picture is a failure.

AS A MATTER OF FACT If you're serious about taking drop-dead photos, you'll use a tripod every chance you get to eliminate camera movement despite the fact it's a cumbersome burden most of the time. Get a tripod that has a quick-release device for attaching your camera. That lets you remove the camera quickly and without a hassle for shots that are more spontaneous. If you find a tripod too ungainly, get a monopod, which provides stability with less to carry around and less to set up.

Turn Your Camera

Here's an easy way, overlooked by too many amateur photographers, to eliminate surrounding clutter and concentrate on your subject matter: Turn your camera 90 degrees. Remember, you can just as easily use your camera to take vertical shots as horizontal. We are vertical creatures, and a vertical image automatically excludes wasted space to either side of the subject, as appeared in Figure 3-10.

AS A MATTER OF FACT *If you're taking a close-up portrait of someone, set your zoom lens midway between its normal setting and its extreme telephoto (long) setting. Shooting a person's face with your lens as long as it can go tends to flatten the face, making it look more like a two-dimensional cutout than a person. The wide-angle (short) setting is even worse, creating a distorted face with a protruding nose and bulging lips. On a 35mm film camera, which uses a 50mm to 55mm normal lens, the ideal portrait focal length is 100mm. How that translates to your digital camera's zoom, depends on which camera you have. Because the size of the pixel array varies from camera to camera, their range of focal lengths also vary. Your camera may have come with some specs that let you translate film camera focal lengths to its digital focal lengths. If not, then aim for some place in the telephoto range without going to its longest setting.*

Avoid Flash

Avoid using a flash when you shoot portraits. The flash units built into most digital cameras throw light at your subject straight on, which often flattens and washes out faces. It also casts shadows just to the side of the subject that look like something out of a film noir. Try to capture your portrait using natural light or in a lit studio. If need be, take shades off lamps or have a friend hold a sheet of white poster board to reflect more light on your subject.

Shoot Indoors

Probably the greatest number of photographs are taken of the family at those occasions that bring them all together—weddings, birthdays, Thanksgiving. At least three people have cameras and everyone clicks away at people they wouldn't remember without the pictures to remind them. Here's how to create the best memories.

Forget the Flash

A party is a great opportunity to get photos of family and friends. But most parties, adult parties anyway, are indoors and at night. Sure, you could break out the flash, but your subjects will look more candid if you capture them with only the air of the room lighting, dim though it may be.

For flashless party shots, boost your camera's ISO setting to its highest rating. *ISO* is a digital form of the light sensitivity rating of film. Amplifying the light that hits the pixels produces a coarser image, but one you can live with. In poor lighting, you can use a larger aperture, which limits depth of field and risks objects being

blurred, or you can use a slow shutter speed, with its own risk of blur inducted by camera movement. If you have a choice, go with the larger aperture rather than too slow a shutter. My personal experience is that I've ruined more photos because of a shaky camera than too shallow a depth of field.

AS A MATTER OF FACT *Most likely your camera's flash provides red-eye reduction. It works by firing the flash one or more times immediately before the picture is snapped. The eye reacts to the initial flash, and the iris closes down enough to hide the retina before the flash fires a final time to take the picture.*

Correct Color

Shooting digital photos indoors with the same settings you'd use for outdoor shots causes color changes. Pictures look too orange (warm) or blue (cool) because indoor lights are different from sunlight, even if our eyes and brain gang up to convince us they're the same. *White balance* is a remedy for photos that otherwise would have a yellow or bluish cast because they were shot in incandescent or fluorescent light, such as the photo on the left in Figure 3-12. To make your photos look more like the picture on the right, use your camera's *white balance control*, identified with a label such as "WB" or "WHT BAL." On some cameras, the selection is made via the onscreen menu.

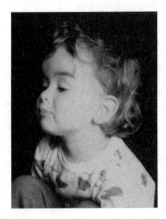

Photos by Shannon Cogen

Figure 3-12 *The photo on the left shows uncorrected colors, while the one on the right shows corrected colors.*

Digital cameras provide up to four ways to change white balance. One is totally automatic and works surprisingly well. Just push a button or make a selection from a menu, and you have instant correction. Another method shows you the scene

through the viewfinder or LCD screen and allows you to push a button to cycle through different degrees of correction until you find a mix you like. The third way is to use the camera's built-in flash. The flash produces the right color of light to match daylight although strong incandescent lighting can overpower it. Finally, select the *Kelvin temperature*, or color temperature, from a menu, but the less esoteric methods work as well or better. The last method is useful if you're shooting under predictable lighting, such as studio lights.

But remember, the great thing about digital photography is that you can make photos lie. If you forget to set the white balance when shooting, you can correct it in the digital darkroom with a few mouse clicks.

Banish Shadows

Although built-in flash units work well for run-of-the-mill shots, they have disadvantages. Depending on the background, the flash can make the subject leave a dark, unnatural shadow. Because built-in flashes line up with the lens, their light has a flat, unrealistic, and unflattering effect. Missing is the normal shading we see on three-dimensional objects.

The solution for these problems lies in an external flash. Does your digital camera have the ability to connect an external flash unit? If so, you should see at least one of two features. One is a *hot-shoe* attachment on top of your camera in line with the lens. The hot shoe provides a bracket to which a flash unit attaches as well as the electrical connection to carry the signal to set off the flash. The other feature is a separate jack into which you insert a cable to an external flash unit.

A separate jack is the more versatile arrangement. A hot shoe still has your flash unit lined up with the lens, creating the same flat lighting and harsh shadows the built-in flash provides. But an external flash—one that does not have to be anchored to the camera—lets you hold the light source above and to one side of the camera. Shadows from your subject are cast down and in back, where they are more likely to be hidden by the subject itself. Or, tilt the external flash back so light bounces off the ceiling. This diffuses the light, creating more natural shading.

Capture Action

Few photos are as dramatic as action shots. When you click the shutter at just the right time, with the right camera settings, the photo creates a rush of exhilaration that comes from being where the action is.

You have more than one way to capture action. Use all of these methods to find the ones you prefer.

Control the Shutter

Set your camera's automatic exposure to *shutter priority mode*, indicated by an "S" on the exposure dial. This mode is the opposite of aperture priority. You choose the shutter speed, and the light meter then automatically selects the f-stop the camera needs for a correct exposure.

For action shots, set the shutter to select a fast speed (at least 1/500th of a second). These speeds freeze action during sporting events or children playing. A fixed high-shutter speed also helps minimize the effects of camera movement if you're using a telephoto lens setting.

A tricky variation on this takes some practice to master. Set a relatively slow shutter speed, and move your camera as the action moves with you so the background is blurred while your main subject in the foreground remains sharp.

Blur the Action

Sometimes, though, you get a better sense of action if you use a slow shutter speed to deliberately create blurred movement. Keep the shutter priority mode and pick a shutter speed slow enough to guarantee a blur—anything below 1/30th of a second. The light meter will respond by choosing a smaller aperture setting. This is helpful because then your subject is a fast moving sports car, you don't have time to focus.

Focus Manually

In fact, for action shots, forget about the autofocus feature on your camera. Autofocus works by shooting out a beam of light that bounces back so the camera can measure the distance to whatever's in the center of the frame. Light, of course, is not exactly a slacker, but the microprocessor in the camera can get confused and not focus the lens in time to capture the key moment. Turn it off, and rely on the force, Luke. Set the focus on a point where you expect the action to be, and take your best shot.

AS A MATTER OF FACT *For best results with action photography, use a tripod. Unless you're going for a deliberately blurred background as described above, you don't want unintentional camera movement to blur the background. The main object in the photo—race car, horse, train, plane—can be blurred or the background can be blurred. Either produces a sense of speed. But blur both, and you have abstract art.*

Shoot a Burst

In action photography, capturing just the right moment is as much a matter of luck as anything else. If your camera supports it, use *burst mode*. Set the camera to shoot anywhere from two to five photos with one click of the shutter button. The rapid succession of shots increases your odds of getting the precise moment by 200 to 500 percent.

Photograph Nature

Next to people, nature is the most appealing subject for photography. Nature photography doesn't always have to be a beautiful landscape. It can be mysterious, peaceful, scary, even ugly, and still make for a good photograph. Most of the advice given for photographing people using the right lighting, composition, and cropping applies equally to photos of mountains and mule deer.

Shoot a Landscape

Most of the time spent photographing landscapes involves just looking for the right spot at the right time of the day. Then apply the host of tools your camera provides to create your unique vision of the land.

Choose the Emphasis

The zoom lens on your camera isn't meant to save you the trouble of walking or driving a few miles to get you close to a mountain or river. You have to be in just the right spot. Then use your zoom lens to change perspective. You can because your photography will be only two-dimensional, which lets you trick the eyes to control the relative sizes of objects in the distance and those near the camera. The particular illusion you create with perspective determines whether you emphasize the expanse of the landscape or the particular formations, rivers, trees, and animals that make up the landscape.

AS A MATTER OF FACT A UV filter screwed onto the front of your lens cuts out some of the haze from scenery in the distance. But the real reason to use one is to provide your lens with cheap protection. The filter is a first line of defense from accidents that can leave the lens scratched or worse. And because you never want to clean your lens directly without using special cloths and cleaning fluids that won't harm the lens, the filter gives you a surrogate surface you can clean without any risk to the lens itself.

Zoom In

Set your zoom lens to telephoto, not to get close to the mountains, but to bring together all the peaks, to unite them so that the photograph emphasizes their mass, as the telephoto shot on the left does in Figure 3-13. Telephoto settings take away the visual distances between objects, making everything appear the same size. They minimize the distance between objects that are strung out from the lens. The lens compacts trees, mountains, sand dunes, ocean waves, mesas—all that goes into a single photo—into one solid mass.

Figure 3-13 *Telephoto compresses distance in the photo on the left. A wide-angle shot, on the right, expands space without moving the people in the photo or the camera.*

Use a telephoto setting, for example, to shoot a field of flowers. By compressing the perspective, the long lens makes it seem as if flowers pack the field to overflowing. If you want the sun in your sunset shots to appear monstrously large, zoom to telephoto and include something in the frame whose size is immediately recognizable, like a house or the branches of a tree.

Zoom Out

A wide-angle lens setting has exactly the opposite effect. In the shot on the right in Figure 3-13, a wide-angle setting moves objects apart visually. A shot of a field of flowers taken with the lens zoomed out would emphasize the gaps of bare dirt that spread among the flowers. If you're shooting a landscape, but the face of a person framing the scenic view is really what you want someone to pay attention to, zoom your lens to the wide-angle setting and the person's face appears bigger than a mountain. If you're going for the big-sky look, the wide angle emphasizes the expansiveness of the landscape. See how the use of telephoto and wide-angle settings create different effects in the photos in Figure 3-13.

Add People

There are photographers—you know who you are—who go on family vacations, pull out the camera to shoot a picture of the Grand Canyon but first warn spouse and children to be sure to not walk in front of the camera.

Big mistake. All but the most talented photographers can find photos to match theirs in the canyon's gift shop. Even if the setting is the most beautiful heaven on earth, make sure the little devils in your family are in the picture. You will be creating something unique, something you can't buy in a gift shop. Twenty years from now, I guarantee you, others will be looking at the people in the photo, not your wonderfully composed and exposed photos of the Grand Canyon.

The same thing is still true even if the people in the photo are strangers. There is no landscape, cityscape, seascape, or picture shot in the deepest caverns or the bottom of the ocean that doesn't get more interesting when there are human beings in it.

Light Up a Face

For an outdoor shot, lighting may be just fine as far as your light meter's concerned. It sees no reason to activate the flash. But you should, or else an important part of your subject—most typically a face—may be lost in the shadows. Then you should activate your flash manually for a fill flash. The flash lights up the shadows caused on a face by the nose and the forehead overhanging the eyes. The flash has no effect on the surroundings that are already exposed correctly. See the difference in the two photos in Figure 3-14.

Figure 3-14 *Left, shadows obscure the face. Right, fill flash removes the shadows.*

Photojournalists often don't have the luxury of setting up lighting, and often they don't even have the luxury of a second shot. They routinely use a flash for all situations, outdoors and indoors. Unless the shadows cast on a subject are important to highlighting design or creating mood, fill flash usually improves straightforward outdoor shots.

AS A MATTER OF FACT Many digital camera lenses have a macro feature. When activated, usually by pressing a button, the macro feature allows the lens to focus on extremely close objects—objects that may be as close to the lens as an inch or two. Photos of flowers make good still lifes, but a photo of a single flower is transformed into something resembling a Georgia O'Keefe painting when the camera's lens moves to within an inch or two of the heart of the flow. Check out Figure 3-15.

Figure 3-15
The macro lens setting lets you get intimately close to your subject.

Shoot Animals

There is an important exception to the statement earlier that the purpose of telephoto settings is not to get you closer, visually, to your subject. That exception is animals. Unless you have the stalking ability of Natty Bumppo, you need the longest telephoto lens you can afford to photograph skittish wildlife. Most digital cameras have fixed lenses. They cannot be swapped for a longer lens, leaving you with the maximum telephoto setting on your zoom lens. It is possible, however, to buy extension lenses, such as the one in Figure 3-16, that screw onto the front of your camera's fixed lens to give it added wide-angle or telephoto capabilities. The results usually are not as good as a comparable one-piece lens, but unless you're terribly picky and have a lot of money to buy one of the few, expensive digital cameras with a swappable lens, you'll find the extension does quite nicely.

Figure 3-16
*Extension
lens gives the
Olympus 3-20
hyper-telephoto
ability.*

Focus Smart

No matter what you're trying to do with your digital camera, you're going to encounter those situations where you can't just point and shoot. Here are the solutions when you encounter problems that don't go by the book.

Auto vs. Manual

Autofocus is handy, but it's not always the best choice for every shot. Autofocus cameras usually focus on whatever's directly in front of the lens. But often—at least if you plan to obey the Rule of Thirds—your most important object isn't going to be directly in front of the lens. Then you can go to manual focus, zeroing in on your important object and then composing your shot.

If you're working with autofocus, use a trick called *focus lock* that's on many digital cameras. Aiming at your central object, press down on the shutter release button about halfway. Your camera will focus on the object you've got in the center of the viewfinder. Then, without removing your finger from the shutter, recompose the shot so your subject is over to the side of the frame. Because you're still pressing the button, the lens won't refocus on the new distance in the center. Press the shutter button the rest of the way, and you're home.

Sneaky Focus

If you're intent on grabbing a photo of someone who's equally intent on not being photographed, your biggest problem is the time it takes you to focus the camera once you've got your victim in the viewfinder. So do this: Focus manually or automatically on some object that is about the same distance from you as your real target. And then without changing the focus or using the focus lock if you're using autofocus, swivel to aim at your real subject and take your shot.

Focus with Telephoto

Programmed exposure sometimes chooses a large aperture opening, in the process eliminating most of your depth of field. What looked in focus suddenly lies outside

the field. So when you focus on your subject, either manually or with autofocus, first zero in on your subject with your zoom lens set to its most extreme telephoto position. Now focus. Depth of field gets narrower the longer the lens setting is. If you focus at a telephoto length and then move the zoom lens so you're at a wide-angle, normal, or even moderate telephoto focal lengths, depth of field grows until your subject is safely focused even if you move around a bit.

Expose Wisely

Light is tricky. You can't always trust your eyes. And you can't always trust your light meter either. With the best of cameras, light meters, and flash units, you will still have shots that mysteriously turn out too dark or too light. The tips here won't solve all problems, but they'll help.

Spot Metering

Through-the-lens (TTL) exposure metering, found on more expensive digital cameras, is highly accurate because it reads the same light coming through the lens that's going to be recorded by the camera's pixels. But even TTL metering doesn't always give you the exposure you want.

Many TTL light meters give you a choice of exactly what light you measure, as shown in Figure 3-17. The usual choice—the most useful for most shots—is *matrix metering*. It measures the light from several different points—from 30 to 200—and manipulates the light values to give you an average overall reading of all the light in a scene. *Center-weighed average metering* measures the entire picture but gives

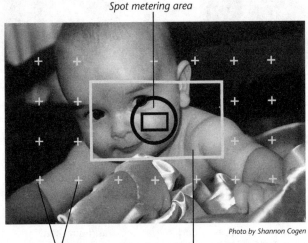

Spot metering area

Figure 3-17
Three light metering choices lets you read the light that's most important.

Photo by Shannon Cogen

Matrix metering measurement points Center-weighted metering area

greater weight to an area in the center of the viewfinder that makes up about 10 percent of the entire frame. *Spot metering* concentrates on an even smaller area—about 1 to 2 percent—dead in the middle of the viewfinder for precision metering when it's important that the exposure match exactly a specific part of your subject matter. For example, you may decide that it's crucial to get the highlight from a model's hair exactly right, and all other light in the frame is subservient to the hair lighting.

Use Backlighting

All three methods have their value in different situations. Most cameras come with matrix metering enabled, and you'll find that it works well for most situations. But you'll want one of the other two methods for measuring light when you're more concerned with the correct exposure for just a small area than for the full frame. For example, a person—or the dog in Figure 3-18—may be backlit, standing in front of a strong light source, such as a window. The backlighting would overpower the matrix meter reading, and the subject's face would be underexposed. If it's exposed for the light measured from the subject, the window is overexposed and details are lost in a general whiteness. But here the overexposure is a good thing. Like the out-of-focus background we saw earlier, the overexposure removes a lot of distracting detail from the background so the eye concentrates on the dog's face.

Figure 3-18 *Left, backlighting causes underexposure. Right, the pooch is exposed correctly.*

Compensate Exposure

There are other ways to handle exposures so that you're not stuck with a light meter reading you know isn't right. For example, if you are shooting a snow-covered landscape or a day at the beach, all of the types of light metering are going to give you a reading that is overly influenced by all that white. The snow and sand itself will be underexposed, resulting in gray snow and dirty-looking sand.

Because you'll face the same problem throughout your photo session in the snow or sand, adjust your camera's exposure system with exposure compensation.

On many cameras, you set exposure compensation on the menus that appear on the LCD screen or through the viewfinder. The adjustments are measured in fractions of an f-stop. Setting the compensation at +1 is the same as opening the aperture one f-stop. Setting it as -2 would be the same as closing up the aperture two stops. Usually, a change of one or two f-stops is all you need.

AS A MATTER OF FACT *Don't use the flash if you're shooting through glass. The glass will reflect the light, and instead of the nightlights of Paris, you'll have one enormous circle of light. Don't use the flash if you're trying to capture TV, movie, fireworks, or computer screens. Those three media supply their own light, and your flash won't help a bit.*

Bracket Your Shots

If you're in a fast-moving situation where you don't have time to fuss with exposure locks or compensation—or if you just want some insurance that every shot you take will be exposed correctly—then *bracket* your shots. Bracketing means that in addition to taking a picture using the exposure setting the light meter says is correct, you take two more shots, one with the lens aperture open one more stop and one shot with the aperture closed one stop (see Figure 3-19).

Figure 3-19 *The frames on either side are an f-stop above and below the middle shot.*

Bracketing sounds as if it's as much trouble as exposure compensation. And it would be except that many digital cameras have automatic bracketing. The camera takes care of making the adjustments for the bracketed shots. All you do is press

the shutter button once to get three pictures. It's an excellent way to go if you're shooting fast, candid photos under changing light conditions.

Polarize the Light

The *circular polarizing filter* is the one filter that can do the most to improve the quality of your color or black-and-white photos. A polarizing filter eliminates light that is aligned along a specific angle to your camera—exactly the type of light that is reflected in the form of glare from windows and shiny car hoods. Attached to the front of a lens, it produces more contrast between sky and clouds and lets the colors of objects be seen for a more saturated impact, as you can see in Figure 3-20. The filter will require a different exposure because it blocks out some of the light. For that reason, it's best used with a camera that has TTL light metering.

Figure 3-20
On the left is a normal shot. The shot on the right was taken with a polarizing filter.

Photo by Klaus Schraeder

Lock Your Exposure

Some cameras use the same mechanism we found in focus lock. *Exposure lock* lets you press the shutter release button and lock in the light meter reading when you reposition the camera so the object you took a light reading from is no longer in the center of the frame. The trouble with this method is that after you take one shot, you've lost that exposure reading. Some cameras have a separate button labeled AE or AEL, for *automatic exposure lock*. If you press this button while your camera's light meter is taking a reading, the exposure will remain locked at that setting while you continue to snap pictures. You can move all around a subject, shooting it from different angles, and your camera remains tied to the same exposure setting.

Links

You can never learn too much about the artistic side of photography. Here are some web links to get you started. They're also available on the author's web site, www.howcomputerswork.net.

- **www.shortcourses.com/using/index.htm** A Short Course in Using Your Digital Camera, one the best tutorials you'll find on the Internet.

- **www.kodak.com/global/en/consumer/pictureTaking/top10/ 10TipsMain.shtml** Kodak's Top 10 techniques to improve your picture taking.

- **www.kodak.com/global/en/consumer/education/programs/ composition/photoProgramCompMain.shtml** Kodak's Beginnings of Photographic Composition, a must-browse site.

- **www.photoexpert.epson.co.uk/UK/homepage.htm** Tips and tricks from professional photographers to get the most out of shooting pictures with a digital camera.

- **http://photos.msn.com/editorial/EditorialStart.aspx?article= macro_msn§ion=NOTEBOOKS** Tips on macro photography.

- **www.sunspotphoto.com/ssp/lenses/fxfilter.html** Sunspot Photography gives a good, quick overview of the use of filters that are screwed onto the end of a lens.

- **http://ccollege.hccs.cc.tx.us/instru/photog/stdpprs/vad1457.html** Scholarly look at depth of field

- **http://oly-e.com/pdf/polfilter.pdf** Detailed explanation and examples of the use of polarizing filters.

- **www.nyip.com/index.html** Take a course or dip into the myriad tips and archived instructions on the New York Institute of Photography web site.

4

Improve

You know the old saw: There's always room for improvement—in the case of photography, a darkroom. And for us, a digital darkroom. This chapter shows how to improve the photos you take—or the old family photos you scan—using Adobe Photoshop Elements and your PC or Mac. We're using Elements because it simplifies the powerful features of Adobe Photoshop and because it's bundled free with a great many digital cameras. If you are using a version of Elements that came with your camera, some of the screenshots and examples here may look a bit different, but the concepts behind the retouching tools remain the same.

If your camera didn't include Elements, you can download a tryout version for Windows and Macs at www.adobe.com/support/downloads/. This is the version used in this book. A tryout allows you to use a fully functioning Elements 2.0 for 30 days. You don't get phone tech support, but you can use Adobe's online help. At the end of the month, you decide if you want to shell out about $70 to keep using Elements.

In this book, we're going to cover some of the most common ways in which you can use Elements to improve your photographs (and in Chapter 5 how you can convert them into gee-whiz works of fantasy). If you want more detailed information on using Elements, get *Create! The No Nonsense Guide to Photoshop Elements 2* by Katy Bodenmiller and Greg Simsic (McGraw-Hill/Osborne, 2003).

Rescue

You're very lucky if those old family photos you scanned in Chapter 2 were in decent shape. The chemical coatings that make up traditional photographs change over the years from contact with the air, other photos, and scrapbooks made of materials not suitable for archiving. Unprotected, lying in some old shoebox, most photos will fade, discolor, crack, or turn into ash.

Don't despair. Elements has the tools to restore your family treasures to their original glory. Here's how to use it for the most common scourges—dust and scratches, discoloration, and massive physical damage.

Cleanup

Adobe Elements includes a tool to rid photos of the tiny spots caused by dust on the negative or photo paper when the print was made. The same tool is also supposed to erase scratches, but if a scratch is thick, the Dust & Scratches tool can easily blur the entire photograph. We have other tools to gang up on scratches.

> **AS A MATTER OF FACT** *Before you do any retouching, always make a copy of your photograph. Elements has ways of undoing changes, but don't push your luck. Make a fast copy by choosing* **Image | Duplicate Image**... *and give it a different filename.*

Dust

The 50-year-old photo of Baby Sue scanned in Figure 4-1 is strewn with dust specks and one major scratch. You can use different methods to rid the photo of the blemishes—either quick and dirty or careful and precise.

Figure 4-1
Dust spots and a scratch on this photo are the targets for eradication.

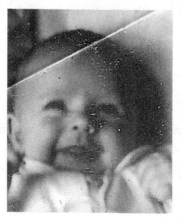

Quick and Dirty Dusting In Elements, select **Filter | Noise | Dust & Scratches....** Elements then displays the Dust & Scratches dialog box, as in Figure 4-2. The inset box shows an enlarged portion of the photo. Position the cursor over the enlargement, and the cursor turns into a hand you can use to move the section of the original shown in the dialog box so that you're looking at the target of your retouching. After you've made changes, click in the enlarged inset to remind yourself what it looked like originally.

Figure 4-2 *Open the Dust & Scratches dialog box.*

The Dust & Scratches tool looks for pixels that don't seem to belong in their surroundings because they're either too light or too dark. This tool changes the color of the oddball pixels to blend in with their surroundings. You control exactly how much blending you want with the two sliders labeled Radius and Threshold.

The *Radius slider* determines how many pixels to include in a blend. Keep the slider to the far left, at 1 or 2 pixels. Moving it to the right causes the entire image to blur. The *Threshold slider* determines how much difference there must be between a pixel and its surrounding pixels before they are eligible for blending. You have more room for play with the Threshold slider, but if you move it more than halfway to the right, the dust spots are not affected.

With both sliders set to low levels toward the left, the result is the cleaned-up baby picture in Figure 4-3. The dust is gone, but so is some of the detail in Baby Sue's face. That was caused by the blending of pixels that didn't represent dust but were different enough from each other to trigger the blending operation. That's why this is a quick and dirty method. It's fast and easy, but it's not the best we can do.

Figure 4-3
A dustless baby—but a bit blurry besides.

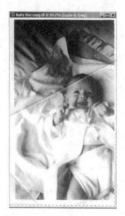

Careful and Precise Dusting For better results removing dust marks without blurring the rest of the picture, use the Lasso tool to select the irregular areas where dust is most prevalent. The Lasso lets you select a free-form portion of a picture, which you can then copy, cut, or edit through any of the menu or Toolbox selections.

Before you start lassoing, click the Zoom tool icon in the Toolbox, as shown in Figure 4-4, and then click a few times on the photograph over the area you want

to work with. That enlarges the photo, making it easier for you to draw with the Lasso. (To zoom out, press the **ALT** key while you click.)

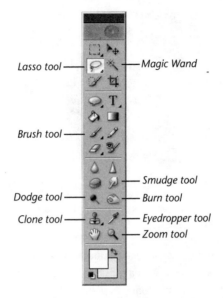

Lasso tool — Magic Wand

Brush tool

Smudge tool
Dodge tool — Burn tool
Clone tool — Eyedropper tool
Zoom tool

Figure 4-4 *The Toolbox is your source for drawing and editing cursors.*

Now switch to the Lasso tool by clicking on its Toolbox icon. Use the Lasso to select the area of your photo that is most in need of dusting by drawing a rough boundary around the area. No great precision is required. In fact, you need to make sure that you include enough of the area around dust spots so they will have shades to blend into. When you get back to your starting point, completing the loop, the Lasso line becomes animated, similar to a very long, crooked barber pole. If you press the **SHIFT** key, you can add other lassoed areas without deleting the areas you're already selected, as shown in Figure 4-5.

Figure 4-5
Hold the SHIFT key to select several separated areas with the Lasso.

Now when you select **Filter | Noise | Dust & Scratches...**, the filter is applied to only the selected areas, with the result shown in Figure 4-6.

Figure 4-6
*The Dust &
Scratches filter
cleans out dust
marks from all
selected areas.*

The dust spots are gone, but the picture doesn't look quite right. The selected areas are smoothly blended while the area outside the selections has a grainy quality that you would expect to see in a photograph, particularly an old one. Keep the selections, and choose **Filter | Noise** again, but this time, make your final selection **Add Noise...**. A dialog box similar to the Dust dialog appears. Experiment with the Amount slider and the Uniform and Gaussian (noise distributed unevenly in clusters) buttons until you find a combination that creates grain within the selected areas that matches their surroundings. Elements makes this easier to do if you check the Preview box, which applies any changes to the photo as you experiment. (Sometimes the preview takes a couple of seconds to appear. Be patient.) In the case of Baby Sue, shown in Figure 4-7, the result of adding noise is a close match to the original.

Figure 4-7
*Visible noise
gives a photo a
natural graininess.*

Scratches

Of course, we still have the scratch. It's too wide to use the noise filter without blurring Baby Sue so much her own mother wouldn't recognize her. Instead, we'll use several other tools that work in different ways. In Figure 4-8, you can see the results. The scratch deliberately has not been eradicated completely so that you can compare the results with the remaining parts of the scratch.

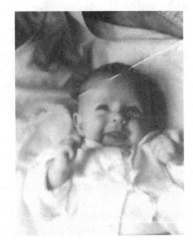

Figure 4-8
Portions of the scratch left intact let you compare it with the results of retouching.

Dodging and Burning Tools Where the scratch goes off the photograph on the right, two of the oldest of darkroom tricks are used to restore the blanket—dodging and burning. The tools, launched from the Toolbox icons shown in Figure 4-4, imitate the darkroom photographer's use of his hands to form shapes that prevent light from reaching some portions of the print (dodging) or that allow more light to hit selected print areas (burning.) Dodged areas are lighter than they'd be otherwise, and burned areas are darker.

You may have to swap back and forth between the two tools until you get an area to be exactly the right combination of light and shadow. It's best to zoom in on the area you're working on. From the Options bar shown in Figure 4-2, set the dodge/burn areas to a smaller size—5 to 10 pixels for this photo—and set exposure for no more than 25 to 30 percent. The longer you hold a dodging or burning tool over an area, the more pronounced the effect becomes. Better to build up shadows and highlights slowly than to overpower the image before you realize what's happening. If you do overdo it, though, you can click back to previous stages of the job with **ALT-Z** or by clicking the Undo icon—a left-curling arrow—in the Shortcuts bar (hidden by the Filter menu in Figure 4-2.)

Smudge Tool The retouched part of the baby's forehead was done partially with burning and dodging to make the top, dark part of the scratch lighter and the light, bottom part of the scratch darker. But the best you can do is reduce the width of the dark and light parts of the scratch to very thin lines. To get rid of them completely, you need the Smudge tool, also identified on the Toolbox in Figure 4-4.

The name of the Smudge tool is fairly self-explanatory: It works pretty much the way your finger would if you used it to mix together two stripes of black and white paint next to each other. Some of the white paint gets into the black, and some of the black gets into the white. Soon you have a mixture of gray that blends off nicely to both the white and black sides so there's no sudden demarcation to identify the scratch.

Eyedropper and Paint Tools Many of the corrections in the blanket area are made by simply painting over the scratch using a shade that matches the blanket on either side of the scratch. To match that shade, use the Eyedropper tool. When you pick it from the Toolbox, the cursor turns into an eyedropper. Place the tip of it on a color you want to use and click once.

Then select the Paintbrush tool from the Toolbox, and it comes ready to paint using the color picked by the Eyedropper. Choose a brush size small enough that you won't be painting adjoining parts of the blanket accidentally.

Obviously, there are no hard-and-fast rules for this kind of touching up. Remember to save often, and to generate a copy of your photo before embarking on a new stage of restoration. And less is usually better than more. Heavy-handed retouching is more distracting than the damage you're trying to correct. Don't be timid about experimenting. As long as you have an untouched scan of a picture, it doesn't matter what you do. You can always start over.

Correct Color

Over time, color photographs discolor. Elements lets you restore old color snapshots close to their original colors. Of course, what the original colors were could simply be a guess on your part. The keys to color correction are getting a clean white, even if it's only in the border of the photograph, and correcting what Elements refers to as the tonal range to eliminate muddy or washed-out colors.

We'll start with the photograph in Figure 4-9. You can't tell in the book's black and white reproduction, but time has turned it a Halloween orange with just a hint of the green of the trees and the red of the woman's dress.

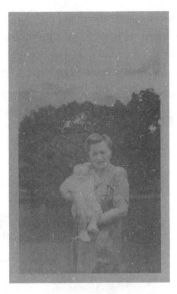

Figure 4-9
*The muddy look
of this photograph
comes from a
reddish-orange cast.*

Auto Color Correction

The obvious first thing to try is Elements' Auto Color Correction. Select it from the Enhance menu, and as its name suggests, it does its work automatically. The result is an improvement but most of the murky cast remains. You get much the same result from using Auto Levels or the **Adjust Color | Color Cast** commands also found under the Enhance menu.

Manual Color Correction

This is one time when automation isn't going to work. Instead, you'll need to tweak manually the amount of red, blue, and green in the photograph. Select **Enhance | Adjust Brightness/Contrast | Levels....** This produces a Levels dialog box similar to the one shown in Figure 4-10. The hilly graph is a representation of the how the color values are distributed throughout the picture. If it doesn't mean anything to you, don't worry about it—or about any of the numbers displayed for input and output levels. You don't need them to use the tool.

Start by clicking the Auto button. You'll see a change in the intensity of the colors in the photo, but in a badly discolored picture such as this one, don't expect the auto feature to do a perfect job. You need to round out the work with the three eyedroppers in the lower right of the Levels box. When a photograph is as discolored as badly as this one is, the automatic features of Elements can't really figure out what the original colors were supposed to be. It needs your help.

How to Help Use the three eyedroppers, left to right, to pinpoint areas of the photo that should be black, gray, and white. One by one, click on each of the eyedroppers and when your cursor changes to look like an eyedropper itself, click

on an area that comes closest to the shade that eyedropper is keyed to. In this photo, in lieu of anything really black, we chose the dark shadows in the trees to the right of the woman's head. For gray, any number of spots can be used. For white, the best area to pinpoint is the border of the picture.

Figure 4-10 *The Levels dialog box and tools for correcting color levels.*

The result is almost correct. There is still a little bit of greenish cast apparent only in the clouds and the woman's face. To fix it, click the drop-down Channels list and choose Green. Grab the triangle on the right end of the Output Levels slider at the bottom of the box. Drag it to the left until the green cast in the clouds and face disappears. For this photo, a green level of 225 made the clouds white and the faces a healthy pink. You may have to play with red or blue, or more than one color to fine-tune your own photos, but when you're through, the result is something like that in Figure 4-11.

Figure 4-11
Almost totally restored, the photo is close to real-world colors.

I know you can't see the color, but believe me, it's just about perfect. Except for a purplish stain in the upper-right corner. There's a way to fix that too, which we'll see in the next example.

Correct Damage

You don't always have an intact photograph to restore. Water, chemical reactions, insects, or simply poor handling may have physically destroyed portions of the print. You won't always be able to restore the damaged portion. You may have to be content with cropping it out. But that would be a shame with the photo in Figure 4-12. A chemical change has eaten a circular swath through the photo's emulsion, and a scrap of paper from another photo is stuck to the knee of the man on the left. Cropping would unbalance the image and eliminate a leafless tree that fits right in with the family reminiscent of *The Grapes of Wrath*.

Figure 4-12
There's hope even when part of a picture is totally destroyed.

Clone Tool

Elements and other image retouch programs have a clever tool that meets the challenge and is fun to use. In this picture, we're lucky that the damaged area is over grass and the out-of-focus tree instead of something well-defined, such as a siding-covered wall or recognizable fences. The random nature of the background makes it perfect for touching up using the Clone tool. This tool, selected from the Toolbox shown in Figure 4-4, lets you copy one part of a picture to another area by painting it on with a brush.

Zoom in on the general area you'll be cloning. Selecting the spot you want to start copying from by pressing **ALT** and clicking on the spot with the Clone brush. In Figure 4-12, you can see two initial spots indicated with the white crosshairs. (You won't actually see two cloning crosshairs. The second crosshairs and arrows were added here to help explain how cloning works.)

Click elsewhere in the picture and the area you first hit with the crosshairs is copied to the brush position, indicated by the arrows. As the brush moves, the area being copied moves with it, always keeping the same distance and direction between them.

Expect to need to stop and redefine both your copying source and the direction and distance you're copying to. And experiment with different brushes and brush options to see how varying cloning can be. After a few minutes of cloning, you have a resurrected photo, and only someone looking for it would notice your touch-up job. Look at Figure 4-13 to see how the rural photo looks after cloning and dabs of some other image tools, including burning, dodging, and sharpening. Cloning would also be the tool to remove the stain in the clouds on the photo we color corrected.

Figure 4-13
Restored, with cloned grass and new lighting

Perfect

Your family heirloom photos aren't the only ones that need help. Today's new pictures, even those taken with the best of digital cameras, rarely come out perfect. There are so many factors involved, from composition to exposure to focus, often applied to a moving target, that imperfections are bound to turn up. With Elements you can fix all but the most egregious goofs. The dust removal, color correction, dodging, burning, and cloning used for old photos are just as handy for new pictures. And here's a half-dozen more of the most useful repairs.

Red Eye

Exorcise that red demon that lives in each of us, daring only to peek out through our eyes when bursts of flash cameras serve as distraction. Elements comes with a Red Eye Tool that banishes any trace of the devil.

The only trick to using the Red Eye Tool is zooming into the bedeviled eyes as close as you can without getting claustrophobic, such as the red-eye operation in Figure 4-14. Then choose the Red Eye Tool from the Toolbox. In the Option toolbar right above the image working area, make sure the Sampling selection box is set to First Click. This lets you tell Elements what color makes up the offending red eye by clicking on the red spot before you do anything else.

Figure 4-14
Zoom in as close as you can to remove red eye without misses.

After the first click, click on the eyes wherever you see a hint of red. The pixels you click on will turn black, but any other colors you accidentally hit won't be affected—only those that are the red you clicked on originally or shades close to it. Because the Red Eye Tool leaves the pupil gray, you may also need to use the Burn Tool to darken it.

Focus

For years, the bane of photographers has been the badly focused shot. No sort of optics could reverse the blurs done by an ill-focused lens. Then came digital.

Elements has four ways of making a photograph sharper—or at least appear to be sharper. Each of the methods is reachable by choosing **Filter | Sharpen**. Three have no sliders or other controls. You simply select one of those three and Elements applies it to the entire image or to whatever you have selected.

Figure 4-15 shows the same picture untouched in the upper left and, continuing clockwise respectively, retouched by the Sharpen, Sharpen More, and Sharpen Edges filters. The fourth filter, incongruously named Unsharp Mask, is at work on only the selected areas in the center photo. All of the filters work by increasing the contrast between adjacent pixels. Sharpen and Sharpen More apply the effect to the entire area. Sharpen Edges and Unsharp Mask specialize in finding the edges of objects by looking for significant changes in color.

Figure 4-15
Five degrees of sharpness in Elements help correct bad focus.

The Unsharp Mask

Use the sharpening filters with finesse, particularly the Unsharp Mask. All the filters add visual noise to the images, and because the Unsharp Mash lets you adjust the degree of sharpness, it can create the most. The noise is more pronounced onscreen than on paper, but as a rule, don't use any more severe sharpening than you need to. Be prepared to do a little touching up to get rid of white spots in dark areas, but don't try to correct the multicolored noise that appears on faces; corrections there get out of hand too easily.

Use Sharpen and Sharpen Edges for moderate degrees of sharpening, for those photos who need just a bit of crispness. The Sharpen Edges filter has a more pronounced effect, but it also creates more noise. The Unsharp Mask was created for commercial print jobs, but that doesn't mean you can't use it at home. Just don't get carried away. By selecting areas, as was done with the center photo in Figure 4-16, you can limit the noise effects and avoid sharpening areas best left soft, such as undesired facial wrinkles.

Make a Mask

One of the great pains in graphics used to be creating *masks*, areas cut off from the rest of a photograph so that you can make changes to only the area covered by the masks. Elements makes it child's play to create masks, which in turn make it easier to add special effects and touch up trick areas.

Lassoing Selections

To make a mask, use a combination of the Lasso tool and the Magic Wand tool, both located on the Toolbox panel shown in Figure 4-4. For an example here, we'll revive the photo of a mother and her baby that we color corrected earlier in this chapter. Although it didn't show up in black and white, a residual color cast still gave a slight purple tint to the clouds. We'll use Lasso and Magic Wand to make the clouds pristine white.

Begin with the Lasso, drawing a rough outline of the clouds area. Because the borders of the photograph should be white also, include them in your outline, as shown in Figure 4-16. Don't let up on your mouse button until you've gone completely around the edges of the clouds and the borders. When you're finished, from the menus choose **Select | Inverse**. That swaps the selected and unselected areas.

Figure 4-16
Making a mask begins by roughly selecting the area you want to mask.

Magic Wand

Now switch to the Magic Wand. When you click the Wand, it selects the pixel directly under it and flows the selection outward to any adjoining pixels of the same or similar color, depending on how strict you've made the Tolerance setting in the Options bar. (Also among the Options, make sure that the Contiguous box is checked. Otherwise, the Magic Wand will select pixels with matching colors no matter where they are in the image, and we don't want to include any pixels that aren't in the clouds or borders.)

Because you're going to work next in some tight spaces, zoom in on the area between the sky and trees. Make sure either the Add to Selection button is depressed in the Options bar or hold down the **SHIFT** key. Then click in the narrow spaces between the animated, dashed selection line and the tree tops. Do the same between the selection line and the inside of the borders, adjacent to the edges of the photograph proper. Each time you click a space, the selection line will move to include the new area, as is happening in Figure 4-17. You'll have to click several different spots before the selection spreads to all the area along the edge of the trees and the sides and bottom of the picture. Oh, and don't forget to click the small spaces in the trees where sky is poking through. They'll become a part of the selection even thought they're not connected to the main selected area.

AS A MATTER OF FACT *As fun as it is to create complex selection/masks, it's not as much fun the second time you do the same one. If you think you may be coming back to the same picture and you'll want the same selection, choose* ***Select | Save Selection*** *to preserve it for the future.*

Figure 4-17
The Magic Wand adds small, convoluted areas to the selection easily.

With this picture, I then choose **Enhance | Adjust Color | Remove Color**, which converted the clouds and border to grayscale. A bit of brightening from **Enhance | Adjust Brightness/Contrast | Brightness/Contrast** followed to make the clouds less ominous. The highlights of the clouds are now pure white, but the clouds' shadows remain a neutral gray. You can save the picture just as it is, or you can add color or a gradient tint that changes from dark at the top to light near the trees for an old-fashioned postcard effect. But that's getting ahead of ourselves. We'll really get into fun and games in the next chapter.

Easy Fixes

Some of the most amazing improvements you can make to your photos are reduced to less than a half-dozen mindless mouse clicks in Elements. Here are the most amazing.

Look Like a Pro

Of all the changes you can make to your photos with Elements, here's the one trick in Elements' bag that will do the most to give your photographs impact and the rich look of a photo by a pro. It's Auto Levels. It corrects something called the *tonal range*. Tonal range defines the lightest and darkest pixels in an image and adjusts all other pixels so they are in the proper proportion of brightness. The result is more detail, brighter highlights, and cleaner shadows. Run Auto Levels on every photograph you shoot or scan. It will improve nearly every one of your pictures.

In Figure 4-18, the photo on the left is without tonal range correction. The photo on the right is corrected, using the Quick Fix dialog box overlapping the bottoms of the two images. Choose Quick Fix from the Enhance menu. It gives you a two-step adjustment for tonal range with the **Brightness | Auto Levels** button plus settings for brightness, color casts, background lighting, and fill flash.

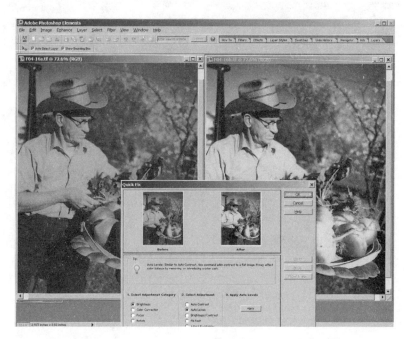

Figure 4-18 *The photo on the left is raw out of the camera. On the right is the photo after using Elements' Auto Levels.*

The Quick Fix dialog isn't the only way to apply automatic adjustments. You can select Auto Levels, Auto Contrast, and Auto Color Correction. If auto correction doesn't work, as it didn't correcting the color earlier in this chapter, the Enhance menu also leads you to the nuts and bolts of the adjustments so you can tweak to your heart's content.

Fill Flash

In the last chapter, we saw how using a flash outdoors can take care of the shadows from hats, hair, and brows that hide faces. If you forget to use the flash on location, you can use the Fill Flash feature in Elements.

Choose **Enhance | Adjust Lighting | Fill Flash...**. The dialog box that appears, as in Figure 4-19, has only two controls, both sliders: Lighter and Saturation. Moving the Lighter slider to the right manages to lighten mainly those parts of a photo that a real fill flash would affect. In Figure 4-19, with the original photo on the left and the flash-filled retouch on the right, the trees and the sky are barely affected.

Photo by Shannon Cogen

Figure 4-19 *Fill Flash fills in light on only the faces and knows to ignore the background.*

You can ignore the Saturation slider unless you want to make it look as if someone has a sunburn.

Backlighting

Backlighting is a great effect—when you can find it. There are only so many sunsets and sunrises every day. Elements doesn't let you put backlighting into all photos. But for a subject in which it works, the effect is as amazing as the program's Fill Flash effect.

And simpler. Select **Enhance | Adjust Lighting | Adjust Backlighting...**. As you see in Figure 4-20, there is only one slider. Moving it right darkens the sides of the pears facing the camera. But notice that the highlights along the top rims of the pears don't go dark. They mimic the way the pears would pick up real backlighting.

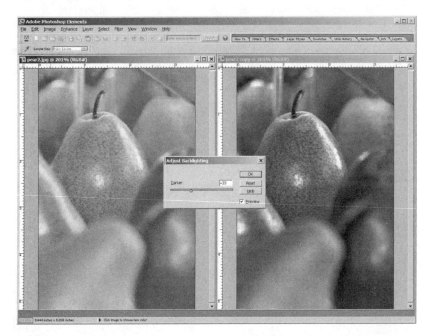

Figure 4-20 *On the left is a normally lit shot. The same shot on the right has artificial backlighting.*

Links

The digital darkroom is addictive. To learn more of its possibilities, check out these links, which are available for the clicking on the author's web site, www.howcomputerswork.com.

- **www.jasc.com/tutorials/revised/photorestor.asp?#** Restoration tutorial by Paint Shop Pro but the principles are useful with any photo editing program.

- **www.adobe.com/products/tips/photoshop.html** Adobe Photoshop tutorials, some of which also apply to Photoshop Elements.

- **www.aim-dtp.net/index.htm** Aimed at desktop publishing but just as helpful for digital photography; includes instructions for color calibration and good examples of the application of unsharp, blur, and other digital filters.

- **www.mediachance.com/pbrush/help/index.html** Excellent explanation of obscure but important functions, such as histogram, white balance, gamma correction, with lots of helpful illustrations. An offshoot of a good shareware program, PhotoBrush.

- **www.retouchpro.com/gallery/index.php** Visit Retouch Pro and post your best retouching work or join in the weekly challenges to restore old photos or create art.

- **www.mediachance.com/** Source of specialty digital darkroom tools, from programs that erase hot pixels in dark shots to one that cleans up wrinkles, puffy skin, and acne.

Astonish

The digital darkroom gives you more power than ever before to salvage, improve, and correct your photographs. But the darkroom is also an artist's studio, filled with the brushes and colors to convert a photograph of the everyday world into a universe that exists only in your creation.

In this chapter we're going to look at some of the ways you can use Adobe Elements to unleash that creativity lurking behind your eyes. If you don't have Elements, you can download a fully functional, 30-day trial for Windows and Macs at www.adobe.com/support/downloads/. You'll also find similar photo-editing tools in other programs, such as Paintshop Pro and Microsoft Picture It. They may do things a bit differently and have different names for their tools, but the concepts are the same.

And with any of these programs, no matter how earnest your intentions, it's important to experiment and play. They have dozens of tools to manipulate images and most of those tools have scores of settings that change the way they work. Add the fact that you can apply multiple tools in different orders, and it's safe to say that even the most experienced user doesn't know everything that Elements and its kin can do. So play and experiment. Pretend you and your photo editor have the same pictures to use that I do. And below are some playtime activities to show you what wonders await you in a digital darkroom.

Unite

Every time you see Darth Vader's TIE fighter swoop past the Death Star, you're seeing one of the oldest photographic special effects, *compositing*. It's the combining of two images into one. Once something limited to movie studios and photographers with more obsession than sense, combining photos is something you can easily master in an hour or so. But enough with preamble. The play bell is ringing.

Create a Universe

The photograph in Figure 5-1, "Highway to the Stars" by Arthur Rosch, is one of the most breathtaking photos I've seen. (You can find more such cosmic pictures at Rosch's Web site, www.artsdigitalphoto.com.) But the photo's a fake. Well, not exactly. It does show a real location on our world, and it shows the stars as they appear at that location at a certain time of the year. But the human eye would not be able to see them both at the same time, as they appear in the photograph. Here's how Rosch did it.

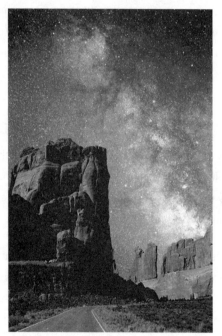

Figure 5-1
"Highway to the Stars" combines two photos.

Photo by Arthur Rosch, www.artsdigitalphoto.com

Shooting the Seminal Photos

The star portion of the photograph was taken with a traditional film camera mounted to a polar-aligned, motorized telescope in Utah's Canyonlands National Park. The exposure was 10 minutes as the telescope's motor kept the camera

pointed at the same stretch of sky while the earth revolved beneath it. Later he scanned the negative into Adobe Photoshop, the program that gave many of its features to Elements.

During the day, Rosch braved scorpions and dehydration to return to the scene, where he photographed the rock formations using an Olympus C2100 digital camera. The results of both photo sessions are in Figure 5-2.

Figure 5-2 *The photo on the left shows the Milky Way. The same vantage point by day is on the right.*

Extract the Foreground

Back in the digital darkroom, Rosch wanted to select the rocks and highway in the foreground so he could move it to the photo of the Milky Way. He used Photoshop's Magic Wand, a kissing cousin of Elements' Magic Wand. When he clicked the wand in the day sky shown in the photo on the right in Figure 5-2, the wand selected the entire sky because all the pixels in the sky were close to the same color.

You tell the wand how close other colors must be to the pixel you click by setting its tolerance anywhere from 0—an exact match—to 255, which accepts pixels even if they're only vaguely the same color. You also tell it whether the selected pixels must be contiguous (adjoining) or can be anywhere in the image.

The reason Rosch selected the sky instead of the foreground that he wanted was because the foreground included such a wide range of colors than he couldn't easily select it using the wand. But now, with the sky selected, he merely chose **Select | Inverse** to make what had been selected—the sky—unselected and make what had been unselected—the foreground—selected.

Move Selection to Second Photo

Before moving the foreground, Rosch used the software's brushes to touch up the dark and light areas of the foreground and to add a slight red coloration to contrast

with the blue sky. Then, using the Move Tool—the same tool in Elements—he dragged the foreground onto the Milky Way photo, as shown in Figure 5-3. (I've re-created his Photoshop work in Elements. For illustrative purposes, the sky in the background of the park photo has been made transparent using Elements' Magic Eraser Tool so the foreground stands out. But that's not necessarily how Rosch did it.)

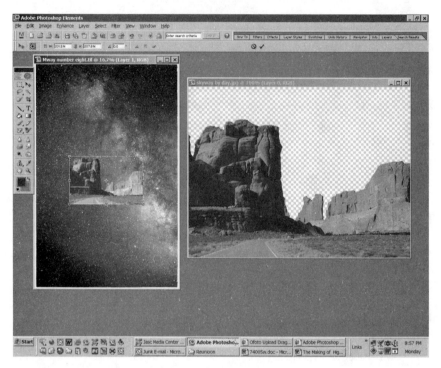

Figure 5-3 *Drag from one picture to the other to create a photo that's more than the sum of its parts.*

Using the Transform function, Rosch completed the job by tugging at the handles of the moved selection until it fills the bottom of the frame. Once saved, the image looks for all the world—or all the universe—like a single photograph.

Stir Up Drama

Other photos require a different approach to compositing. The old French MD 312 FLAMANT in Figure 5-4 fades off into the blackness of its hanger. The Magic Wand in Elements can't find a line of demarcation in conditions like that. So instead, we'll use the Magic Lasso Tool to outline the airplane and give it one last flight, digitally.

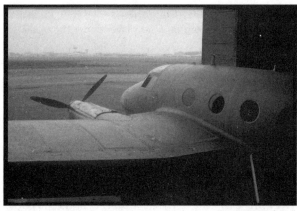

Figure 5-4
An old French plane gets to fly again—virtually.

Photo by Georges de Wailly

Vanish Background

The Magic Lasso deserves its name. It works similarly to the Polygonal Lasso Tool to draw a selection in the form of an irregularly shaped polygon. The difference is that if you lead the Magic version near a portion of a photograph that's a meeting place for two distinct colors or decidedly different light and dark areas, the line drawn by the Magic Lasso automatically clings to the border dividing the two areas like static charged Saran Wrap. Each time you click the mouse, a small box appears on the line, anchoring it to the current location.

> **AS A MATTER OF FACT** *It's best to use the Magic Lasso Tool for all your freehand selecting even if you don't need to trace a line along some boundary. With other lasso tools, if you wiggle your hand unintentionally, the lasso's line scurries across the page. With Magic Lasso, pressing* **DEL** *backs the line up to the last box you clicked. Continue hitting* **DEL** *and you keep backing up, a neat way to regain control of a selection gone wild.*

Lasso and Erase

To outline the airplane, first use the Magic Lasso to draw a rough outline of the plane. Don't bother to include the propellers for this particular picture. Then use the Zoom Tool to move in close to the line, revealing plenty of small wiggles that take bites from the plane or include pieces of the background. Elements' lassos allow you to make a choice in the Options bar to whether subsequent areas enclosed by the lassos are added to or subtracted from your original selection. A combination of the two techniques quickly produces a smooth outline of the plane.

At this point, we could drag the plane onto another photo, as Art Rosch did with his starry highway photos. But we've been there, done that. So let's use another

technique to combine two photos. We'll drop out the plane's background by making it transparent, and then slip a second photo on a new layer under the plane.

To drop out the background, as shown in Figure 5-5, from the menu choose **Select | Inverse** to switch the selection from the plane to the background. Choose the Eraser from the Toolbar and on the Options bar, select a large brush size for the eraser and set Opacity to 100 percent. Sweep the selected background with the tool. Don't worry about the foreground; the eraser will affect only the selected area. Within the selection, each sweep of the eraser replaces the image with a checkerboard pattern that indicates that that area is transparent.

> **AS A MATTER OF FACT** *For a ghostlike effect, set the eraser Opacity at 50 percent or so. The eraser will evenly convert only half the pixels to transparency so that the selected area and whatever you put behind it both show at the same time.*

Figure 5-5 *Selection and eraser tools change the background to a transparency.*

Use Layers

Layers are one of the trickier features in Elements, and I'll admit to a slow learning curve while getting used to their quirks. The concept is to create different layers, or

versions, of your image that you can work on without disturbing the other versions. It's similar to protecting one part of a photo by selecting only another part that you will edit. It's even more like the way animated cartoons were made of partial illustrations on sheets of clean celluloid; the camera could see through the clear portions of the top layers of celluloid to include artwork on the layers beneath, combining them all into a single image.

Add a Layer

Start by choosing **Layer | New | Layer** or press **SHIFT-CTRL-N**. Nothing looks different, but if you click the Layers tab on the Palette bar, you see thumbnail views of what are now two layers. (See the upper-right corner of Figure 5-5.) One shows the plane with its transparent background; the other is nothing but a transparency. You can use the thumbnails to rearrange the order of the layers and to select some layers for editing or to meld with others.

AS A MATTER OF FACT If you'd like the Layers palette—or any palette—to stay open as you work, open the palette by clicking it while it's in the Palette bar and drag the Layers roll-up off the bar to the Work Area. Or choose View and the name of the palette you want to keep open.

Edit a Layer

Select the new, transparent layer to work with by clicking the area to the right of its thumbnail. That area turns to indicate that the layer is now active for editing. Here's where we'll paste our new background, an NOAA weather photo, shown in Figure 5-6. Open that photo, copy the part you want for the background, and switch back to paste it into the blank layer.

Figure 5-6
The gathering storm—part two of the composite.

Weather Bureau photo

> **AS A MATTER OF FACT** *When you paste a selection or layer into an image with a different resolution, the pasted image keeps its original size, which may appear too big or too small for the image you paste into. Fix the imbalance by using the* **Image | Resize | Image Size**.... *command to make the source and destination images the same resolution before copying and pasting. If you forget to resize before pasting an image, hook its handles and drag the image to its new size.*

If all has gone well, you should now have an airplane flying into a thunderstorm, as in Figure 5-7. A touch of Elements' **Enhance | Auto Levels** command is responsible for the shinier airplane. But we lucked out because the position of the lightning makes it look as if that's what is lighting up the front of the airplane. If it hadn't been positioned so fortuitously, in a digital darkroom we could have flipped, enlarged, shrank, rotated, and distorted the storm image until the lightning bolts were wherever we wanted them.

Figure 5-7 *Use the Elliptical Marquee to select an area to be blurred for you to fake a propeller.*

But there is still the problem of the missing propellers, the ones I told you to forget about as you outlined the plane. We cut them because they should be turning,

unless we want to say the plane's flying into a storm with an engine out. And a turning propeller is a blur, not distinct vanes sticking out and steady.

Blur a Propeller

One of Elements filers is exactly what we need.

First, though, Choose the Elliptical Marquee Tool from the Toolbar. On the Options bar, set Feather to about 40px. Feathering softens the edges of a selection so there's no hard-and-fast break between selected and unselected.

Check to make sure you're working on the correct layer. Click the Layers palette, and notice which layer has an area to the right that's a dark blue. That's the layer that's active. If it's not the storm cloud layer, click on that layer to make it the active one. Draw a vertical ellipse—one that looks as it if would match the area covered by the propellers when they're turning. If you don't get the right size or position, back up with **CTRL-Z** and try again, or use the Move Tool to grab the ellipse and position it properly in front of the engine. Don't worry that part of the ellipse extends down over the wing.

Choose **Filter | Blur | Radial Blur**. Make sure the blur's controls are set to Zoom, Best, and that the Amount slider is set to about 50. This uses the light from the lightning to create a circular blur within the selected area—except for where the eclipse falls in front of the wing. You created the blur only on the layer that had only the weather picture. The plane is on a different layer, so the blurring didn't touch it.

The difference between the dark clouds and the bright lightning makes for some lovely streaking that looks like a fast-turning propeller. The result is shown in Figure 5-8.

Figure 5-8
Together, all the elements needed for a very unpleasant flight.

Alternative Blurs If this special effect is too subtle for you, choose **Filter |**
Brush Strokes | Accented Edges, which will, in effect, boldface the streaks of
light created by the Blur filter. Adjust the three sliders to taste. For a more subtle
effect, after using Radial Blur with Blur Method set for the Spin cycle, add on another
Radial Blur effect, this time in Zoom mode.

Stitch a Panorama

Elements' feature to join several photos into one very long or very tall photo works
like the spy movies have always said computers work—with a minimum of human
intervention and a maximum of self-directed artificial intelligence. Choose **File |**
Photomerge and select the photo files you want to stitch together. Then sit back
and watch your computer as it fits the pieces together with uncanny accuracy.
Here's all you have to do.

Take Individual Shots

When you're shooting the photos you plan to make into a panorama, try to
eliminate as many differences as you can among them. Use a tripod so that your
camera is always at the same level and isn't tiling left or right. If your shots include
patches of sun and shadow, bracket your exposures so you'll have choices to avoid
shadow on one photo abutting light on another.

Elements recommends that you shoot all your photos from one spot, simply
panning your camera left and right to take all your photos. This time, Elements
is wrong. If you do that, any horizontal lines will be running uphill or downhill
in some of the pictures. You're better off walking parallel to your subject matter,
stopping and setting up your tripod, and then shooting a new photo.

Your photos should overlap by 30 to 50 percent. Less or more may cause problems
when the software tries to find overlapping points. If your camera permits, lock your
camera's aperture so that changes in lighting won't cause changes in depth of field.
Let the shutter do the adjusting for exposure. The five shots of the San Antonio
Riverwalk in Figure 5-9, as we'll see, are not sterling examples of this advice.

> *AS A MATTER OF FACT* *Shutter speeds aren't that crucial in most panoramas*
> *because the subject matter is often something as unmoving as a mountain range or a*
> *cityscape. If you want a panorama of a scene with action, such as a bike race, enlist the*
> *aid of friends with digital cameras and space yourselves along a city block. Eliminate as*
> *many differences among you as you can, such as focal length, each person's distance*
> *from the street, and camera level. Use walkie-talkies, stopwatches, or signals from*
> *someone all of you can see to ensure you click the shutters at the same time.*

Figure 5-9 *Pictures for a panorama should share exposures and height levels. These don't.*

Automatic Stitching

Once you've selected the picture files you want in your panorama, leave the first pass to Elements. In our collection of photos in Figure 5-9, some are exposed lighter or darker than average. And the riverbank in one shot abruptly climbs uphill to the right. Elements manages to put together three of the photos anyway, as shown in Figure 5-10.

Elements wasn't able to cope with the fact that the shot on the far right slopes up. Selecting the Perspective setting in Photomerge transformed the photo by widening one end so the riverbanks stay level. Photomerge can't handle the differences in exposure between the first and second frames, and it can't figure out how the last two shots fit together. It's time for some human intervention.

Manual Stitching

Fitting the last two shots into the panorama isn't hard. Drag down one of the remaining shots. It and the already assembled photos both remain visible as you slide the single shot over the fledgling panorama. Plenty of objects, such as the table umbrellas, match in adjacent pictures. Line up two of them, and Elements finally makes the connection and eases them into place, making little adjustments of its own.

Figure 5-10 *Elements joins three frames despite problems with exposure.*

The differences in exposure are noticeable mostly on the water. By using the Magic Lasso tool to draw a line around a selection that needs fixing, we limit the work area. Passing the Dodge Tool over the selected areas a few times lightens them to match the rest of the water. The boundary between the original and lightened areas takes some work by the Smudge and Blur tools to hide the telltale evidence of a seam.

The results are in Figure 5-11. A print of the panorama, at 300 pixels per inch, would be 52×12 inches.

Figure 5-11 *Ready for a long walk down the river.*

Speed

They shouldn't call them "still pictures." By slowing down your shutter so that anything speeding in front of the camera would be captured as a blur, you can pack a lot of motion into a still picture. But what if your subject isn't moving at all? The digital darkroom comes to the rescue.

Fix POV

How you add speed to a subject depends on your subject and your *point of view* (POV). In Figure 5-12, we have a train that appears to be sitting still. If it were a running person, we'd have to be cautious about how we make it appear to be moving because heavy-handed special effects can look phony. Because trains really do move fast, we can knock ourselves out making this one go supersonic.

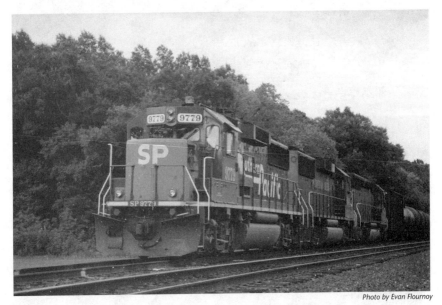

Photo by Evan Flournoy

Figure 5-12 *Waiting at the station instead of tearing down the rails.*

First, think about the angle to the train from your point of view. You're looking at the train from a three-quarters viewpoint. Now consider this. Things that are speeding by at a right angle to you appear to be going faster than those speeding straight in your direction. For that reason, we make two separate selections. As seen in Figure 5-13, one selection is along the side of the train, and the other is the front of the locomotive. Because we're going for a blurred look, there's no point in doing detailed selections that follow the outline of the train precisely.

Figure 5-13 *Separate blur styles for the front and side.*

Apply Blur

We apply a different, customized Motion Blur to each of the two areas. Choose **Filter | Blur | Motion** Blur to display the basic blur controls. For the front of the train, the controls are set so the direction of blur, the Angle control, points along the path of the train. The Distance setting of 15 pixels means each pixel in the selection will blur that far in the direction set in Angle.

For the side selection, the blur's direction stays the same but the Distance is 37 pixels. The effect is that the side of the train in Figure 5-14 is more than twice as blurred as the front, and the side appears to move faster, just as our perception of perspective expects it to.

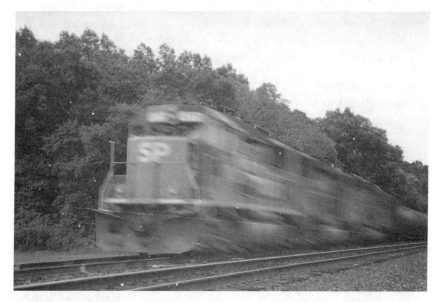

Figure 5-14 *The train in motion.*

Animate

Your inner Chuck Jones just called, and the message is, "Move it!" Since any motion picture is really just a very fast slide show of still photos, and you can supply the still shots, here's how to put them into one file to add animation to web pages and HTML documents.

Shoot for Animation

As strange as it sounds, the best subject matter for animation is something that doesn't move around a lot. You want it to stay right in front of your camera, not move out of camera range and not move so fast that your animation would necessarily appear jerky. You, in turn, should also not move around. Mount your camera on a tripod or use what you can find to brace your camera.

If your camera has one, use the burst mode to make as many pictures as you can as fast as you can. Set your camera's resolution as low as it will go. Most of your animations are going to wind up on the Web, where high resolution and big image size clog the download, and that takes the spontaneity out of springing an animation on someone. Plus, the more pictures you can take the better. Lowering the quality of the photos means more of them can be stuffed into your camera's memory, and that will raise the quality of your animation.

Elements will object if the photos are too large. This only makes sense because large files take too much time to download form the Internet, which is where your animation is likely to wind up. Now's a good time to use the **Image | Resize** command to reduce the size to less than 100 pixels vertically and horizontally. While you're at it, make sure all the photos are the same dimensions so the edges of the image don't move when you run the animation.

Again, the example we'll look at makes no pretense about obeying these rules. It's a worst-case scenario: only nine photos, shot freehand, as shown in Figure 5-15.

Figure 5-15 *The makings of an animation—a very short animation.*

Plan Images

Open the photos—the future frames of your animation—and plan the order they should appear in the animation by dragging them around in Elements. Essentially,

you're creating a storyboard, the visual outline that film and animation makers create to plan the order of their shots. Remember that you're not limited to presenting only the frames you shot in the order you shot them. Look for patterns of movement that intersect or flow into other movements.

Tricks with Timing

Elements' animation feature doesn't allow you to vary the display time for each frame. (Other programs do. Check Internet download havens for shareware programs that specialize in animation.) But you can make it seem as if some movements were slower than others by repeating the same frame several times in a row.

To quickly duplicate a photo, right-click in the picture's Title bar and choose Duplicate Image. Accept the suggested name; it's a temporary file and not important. With some experimentation, you can probably reuse enough frames or segments to boost your animation's length and smoothness.

Animate Layers

To set the photos in motion, you're going to copy each one to a different layer in a single file. The stacking order of the layers determines the sequence of the animation frames. The first—bottom—layer becomes the first frame. In Figure 5-16, the open Layers palette shows thumbnails of the images that have been copied to each layer.

Figure 5-16 *Photos on the left become layers on the right.*

Go to the photo that's the second to last in your storyboard. Choose **Select | A**, or press **CTRL-A**, to select the entire photograph. Use your favorite method of copying stuff, and then go to the photo that will be your last frame, and make it the active picture.

Paste into New Layers

There, use the last-frame graphic as the single file into which you will fold all the other pictures. Paste the image from the second-to-last picture into the last-frame picture. The paste automatically creates a new layer to hold the second image.

Now go to the third-to-last picture, copy it. Go back to the last frame and paste the third-to-last picture. Repeat this until all the frames are copied to the master, layered file. Click the Layers palette tab to display all your animation's layers, starting from the bottom, in the order in which the frames will appear. If you want to make changes in the order, click and drag layers to their location.

Put It All Together

When you've finished fiddling, choose **File | Save For Web**. You'll get a screen like the one in Figure 5-17. Under Settings, select GIF and check Animate. Further down, under Animation, decide if you want the animation to loop. A looped animation will immediately repeat itself endlessly until you stop it manually.

Figure 5-17 *In the Save For Web dialog box, choose the details of how your animation works.*

Also choose the length of time you want to display each frame. If you had enough, you'd choose 30 frames per second. That's the frame rate for motion pictures. Since you're not likely to have that many photos in a sequence, you'll have to experiment to find out how long the frames should show. Too little time, and the animation is over before the brain can register what it's showing. Too much time, and it will seem more like a slide show than animation. Start at value of 0.2 or 0.5—a quarter and half of a second—and experiment from there.

By clicking the Internet Explorer icon at the bottom of the screen, you can see the animation in action. When you are satisfied with the settings, save the file. Elements will automatically choose to make it a GIF file, a format that's used for simple animations on the Web.

Create Art

The scores of effects, filters, and color tools in Elements—and in other photo-editing programs—make it possible to capture the look of such varied media as watercolors, tempera, embossing, pencil, pen, and charcoal, plus looks that don't really exist in the real world. Control is so varied as to let you transform photographs into the styles of the impressionists, representational artists, modern artists, and a kid's finger paintings.

In this section, we'll look at some before-and-after images, photos that have adopted the trappings of fine art. I'll give you the basics about which filters, effects and commands were used, but I won't take you by the hand, step-by-step as we've gone through other examples. There are no hard-and-fast rules for how to create an imitation watercolor. Consider these examples to be launching pads for your own experimentation. That's how I created most of these images—trying different effects, sometimes modifying the results of other effects, until I stumbled on the right combination. Remember, this is for fun.

Watercolor

Elements has a filter specifically labeled Watercolor; to access it, choose **Filter | Artistic | Watercolor**. Take a look at Figure 5-18, a photograph of some water lilies included as a sample with Elements.

Figure 5-18
The water lilies in their original photographed splendor.

Now compare that photograph with five illustrations that follow to see how different filters have converted that same photograph into watercolors of various styles and a couple of other media.

Elements official Watercolor filter changes the entire photo at once, as shown next.

The Smart Blur filter also does a decent watercolor.

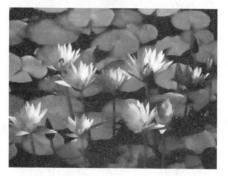

The Impressionist Brush Tool looks like that of Monet and gives you more brush control.

If you change the Impressionist Brush Style to "Tight Long," and it looks more like van Gogh on acid.

For a change, the Conte Crayon Brush Stroke filter adds a convincing paper texture.

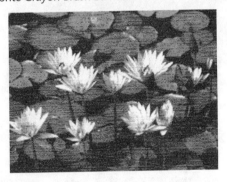

Gild the Lily

Some of the most interesting effects come from applying different filters on top of one another. The lily in Figure 5-19 began as an ordinary orange lily. (I realize this book is in black-and-white. You're going to have to trust me when I tell you what these colors are and when I say the final look dazzles.) I outlined it with the Magic Lasso and then set out to find some way to make it look dipped in gold.

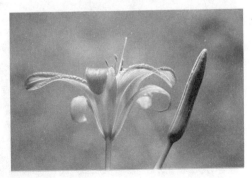

Figure 5-19
The lily before digital processing.

I began by applying the Plastic Wrap filter to the selected lily. The filter thickened the petals and introduced some wonderful highlights, not so much like close-clinging

plastic wrap, but as if the flower had been tipped in a liquid plastic that hardened smoothly around each petal.

After experimenting with various ways of changing colors, I used the **Enhance | Quick Fix** commands. I played with the Hue and Lighter sliders shown in Figure 5-20 until the lily looked encased in gold—a change of about +20 points on both of the sliders. The result is the gilded lily in Figure 5-21. And it really does look a dazzling golden. Really.

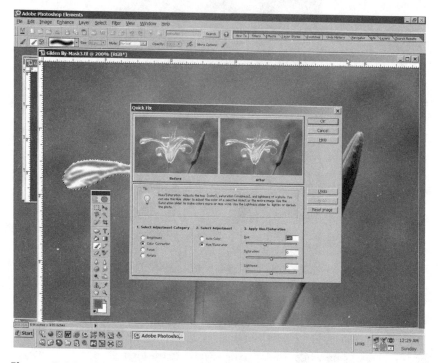

Figure 5-20 *The Quick Fix tools at work changing color and hue.*

Figure 5-21
The lily after digital gilding.

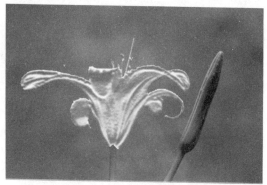

Draw

Photo-editing programs can turn any photograph into a pencil, charcoal, or pen-and-ink drawing. Some of the transformations look as if they'd been drawn by hand. Others look like bad photocopies.

The secret to converting a photo to a drawing is the selection of pictures that will survive the process gracefully. Look for images that have a lot of edges, such as the bird in Figure 5-22 with feathers and lines that are naturals for drawings. Photos that have smooth expanses with little detail are poor candidates for a media transplant.

Figure 5-22 *Look for subjects with detailed edges and lines to convert to line drawings.*

Find Edges

There are as many ways to create line drawings as there are ways to convert to watercolors. One that works is choosing **Filter | Stylize | Find Edges**. To clean out some dark, solid areas from the result of Find Edges, choose **Image | Adjustments | Threshold**. Set Threshold to about 200. This raises the standard for converting some gray area to a solid dark color. Adjust to suit your image. Finally, get the Eraser tool and get rid of stubborn dark blotches. Last step, choose **Image | Mode | Grayscale** to convert color to black-and-white. What you get looks something like Figure 5-23.

Figure 5-23 *A line drawing without pencil or pen.*

You can also convert photographs to good-looking line drawings using combinations of the Poster Edges filter, the **Posterize** menu command, and the Smart Blur filter with Mode set to Edge Only.

Dilly-Dali

When I came across the photograph of a bent tree in Yosemite buried in a Swedish web site's collection of lost photos (Figure 5-24), it cried out to be a parody of Salvador Dali's *The Persistence of Memory*. Using Google.com's image search, I was able to find an ad with a wristwatch in it. I used the Magic Lasso to select the face and bezel on the watch and to copy it to a new layer in the Yosemite photograph.

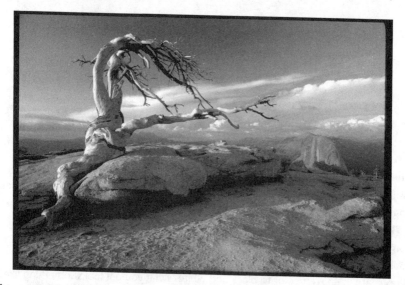

Figure 5-24 *A beautiful photograph waiting to become a joke.*

There I sized the watch face to match the tree and selected portions of the watch that I warped using the **Image | Transform | Free Transform and Distort** commands. When the watch was in the neighborhood of a decent droop, I used the Clone, Blur, and Smudge tools to blend the places where different selections met so they appear seamless.

On the ground beneath the tree, I added a jellyfish and did the same distortion tricks with it. Finally, I added some clip-art ants and a drawn eyelid to the erstwhile jellyfish. The result is in Figure 5-25.

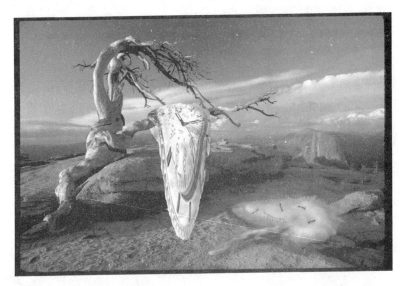

Figure 5-25 *Who needs Dali to go surreal?*

The result is not here so much to tell you how to do the same thing, but to show what you can do just by fooling around, experimenting, and patience. This required neither artist's skills nor geeklike knowledge of the software. Remember, this should be fun. Make sure you have a backup of the original image, and you can't hurt anything. It's time to go play.

Links

If your desire to astonish grows, here are some sites on the Internet that will give you more advice, tools, and inspiration. Clickable links are available on the author's web site, www.howcomputerswork.net.

- **www.ncc.sdccd.cc.ca.us/resource/qtvr/index.html** Techie explanation of creating QuickTime virtual reality 360-degree panoramas.

- **http://lcweb2.loc.gov/ammem/pnhtml/pnhome.html** Library of Congress panoramic photography collection.

- **http://thepluginsite.com/index.html** A source for unusual plug-in and filter effects, plus a good introduction to plug-ins for beginners.

- **www.photographytips.com/** An unusual site that, step-by-step, shows you how to do the unusual, such as photograph a cat after it tastes a scorching hot sauce.

- **www.rit.edu/~andpph/text-special-effects.html** Scholarly overview of special effects in photography.

- **www.peimag.com** You need a subscription to the hard-copy version of PEI (Photo Electric Imaging) magazine to make the most of the step-by-step tutorials by artists telling how they created the images used in the magazine. Well worth the $20 a year subscription price.

- **www.artsdigitalphoto.com** More beautiful astronomy photos by Art Rosch.

Print

After buying the best digital camera you can afford, after you've used it to the point that it has become a Star Trek Borg-like extension of your own body, and after surmounting the intricacies of the digital dark room, it comes down to this: Do you have a print that looks good enough to send to Grandma?

Digital photography opens a vast, new world for creating, manipulating, and sharing images. But there's plenty of space in that world for the old-fashioned photographic print—something we can frame or put in a wallet, something we can view without a computer or an Internet connection. Luckily, if you have a computer, you most likely already have a printer to deliver a photographic hard copy that's often the equal of a print made from a film negative. If your computer's ink-jet printer has a resolution of 300 dpi and if it uses black ink—as opposed to older, cheap printers that try to create black by combining cyan, yellow, and blue inks—then you have a perfectly acceptable photo printer.

Pick a Printer

You have a choice of three types of printers for everyday, nonprofessional use with photos. "Nonprofessional" doesn't mean mediocre. It applies to magazines, graphic designers, and other publishers where the only acceptable printers are those that produce the highest quality in a jiffy. That leaves you with an array of printers, some of which produce prints that are indistinguishable from film-based photos, unless you inspect them with a magnifying glass and you know what to look for.

We'll take a quick look at the common ink-jet printer, the less common "photo" ink-jet printer, and the dye-sublimation printer.

Combine Printing

It would certainly save money and desktop space if you could use the same printer for photographs that you use for letters, reports, and homework. You probably can. In addition to having the aforementioned separate black plus three colors of inks, your printer should be at least 300 dpi. That's what the experts say. What the experts don't say is that you'd have a hard time today buying a printer with less than 1,200 dpi.

The truth is that 1,200 dpi in many cases refers to the precision with which the print head moves across the paper, not how many actual dots of color it lays down every inch. Many of those dots must be dithered before they collectively make up a single dot of a certain color. Never turn down a few more hundred dpi, but don't expect a 1,200 dpi image to be four times sharper and more detailed than a 300 dpi printer. And don't expect that all 1,200 dpi printers are equally good.

AS A MATTER OF FACT Dithering is the grouping of dots of colors in different combinations so they appear to be different shades, including green—a color missing from most printers. If you want to see how dithering works, look at the Sunday paper funnies through a magnifying glass. Or check out Figure 6-1.

Figure 6-1
An enlargement of a newspaper comic reproduced to its actual size to show how colored inks are patterned to create different shades.

Copyright Bill Amend, distributed by Universal Press Syndicate

The upshot? If you're unhappy with your photo hard copy, getting a new printer isn't always the solution. Other factors, such as the paper you use, can mean more than what printer you use, and we'll come back to that in a bit. Unless you're itching for an excuse to buy a new printer—and we've all been there—the ink-jet printer you have, provided it was made in the last few years, will churn out acceptable photo prints.

If you're one of those photographers itching for an excuse to buy new hardware, then you want to check out the next category of printer.

Go for Photo

Within five years, the standard type of printer used in the home will be what we now call *photo printers*. There is no formal definition of what makes a photo printer, and any ink-jet could call itself a "photo printer." If a printer really deserves the name, though, it should have extra colors of inks, at the very least. Most often, these inks are light cyan, light magenta, gray, and sometimes green—usually specially formulated inks created to resist fading. Print quality being roughly equal, look for an ink-jet that uses individual cartridges or ink wells for each color. This makes it practical for a photo printer to double as an ordinary black-and-white office printer.

AS A MATTER OF FACT The makers of photo printers will tell you they print at resolutions higher than 300 dpi. But just as important is the newer printers' ability to vary the size of the dots of ink they spit on the paper from 1 picoliter to 25 picoliters. (A picoliter is one millionth of one millionth of a liter. This makes for not only more control over shades of color, it produces a sharper image.) See Figure 6-2.

Figure 6-2
By varying the sizes of ink drops, photo printers increase an image's sharpness.

Bang Bucks

Expect to pay anywhere from $175 to $700 for a photo-quality printer, although at the high end, you should expect every feature available, including borderless printing, so your images and colors bleed off the page, and large-format printing, for such jobs as posters.

You're better off if you stick to Canon, Epson, and Hewlett-Packard printers. It's not that there is anything wrong with printers by other makers, but those three brands have become the "Big Three" of photo ink-jets. Canon and Epson, in particular, have attracted third-party ink and paper makers with products directed at the digital photographer crowd, which gives you more options, such as cartridges containing only shades of gray.

Figure 6-3
The Epson Stylus Photo 2200 printer delivers high-quality prints using seven colors of ink.

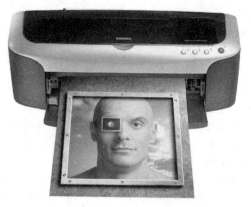

Avoid Gimmicks

There are some features on the higher end that are...OK. But they're really gimmicks you shouldn't let dazzle you. The best example is the ability to print directly from your digital camera. Some printers add on a small LCD screen and some push-button controls to do rudimentary retouching, such as brightness and contrast.

Figure 6-4
The LCD screen on the Hewlett-Packard Photosmart 230 printer allows you to edit without a computer.

This is a pointless idea. An advantage of digital photography is that you don't have to have prints of every blurry, ill-composed, boring picture that you took. The printers' LCD screens won't let you see subtle flaws. And built-in image correction tools don't begin to approach what you can do on a computer with any photo-editing software.

Nor will they let you catalog and organize your hundreds of pictures, soon to be in the thousands now that you have your digital camera, free of film and processing charges.

Don't Print—Dye

Ink-jets are not the only choice for color printing. Color laser and solid-ink printers produce excellent color quickly, but they're in the multithousand-dollar price range. No, the type of printer I'm talking about is *dye-sublimation*.

This strangely named printer is born of the sublimation process, in which a solid changes directly to a gas without the messy in-between liquid state. The solids in the case of printers are dyes coating a ribbon in paper-sized areas for each of the four colors that combined into a spectrum on the page.

AS A MATTER OF FACT *Dye-sublimation printers produce printouts that are virtually indistinguishable from film photographs because the colors blend together so smoothly, but they're still only 300-dpi printers. As such, they don't do as good a job at text—but the pictures are beautiful.*

In a dye-sub printer, such as the Olympus 400P, the ribbon passes over the printing paper four times, once for each color. Minuscule resistors put off varied amounts of heat that sublimate equally minuscule areas of dye. Depending on how hot each heating element becomes, either a little or a lot of a little dye turns into a gas that freezes back to a solid when it hits the paper. The dots overlap, providing *continuous-tone color*, a quality in which colors blend so smoothly there's no clue to where the colors change. It's a term otherwise reserved mainly for film prints.

Figure 6-5
The Olympus 400P is one of the few low-cost dye-sub printers that produce 8×10-inch prints.

Best for Less

One problem with a dye-sublimation printer is that it uses the same amount of dye-coated ribbon for every print, even if only one color is used. And the cost per print of the ribbon—71 cents—is almost equal to the 78-cent price for one sheet of dye-sub photo paper. Because the ribbon must make four passes over the paper, one for each color carried by the ribbon, it takes 90 seconds to turn out a simple print. This makes it an impractical choice for high-volume jobs, especially if the dye-sub is used to produce a lot of ordinary black-and-white letters and other documents. The cost of supplies alone would be high enough to justify a separate printer for the monochrome work.

But if you want the absolutely best quality for your photographs and price and time be damned, you should at least look at a dye-sub. A few years ago, an office dye-sub printer cost several thousand dollars. Now camera makers are turning out dye-subs at decent prices. If you don't mind a limit of 4×6-inch prints, you can find a dye-sub for $300 to $500. Limit yourself some more—say, to wallet-size prints—and it'll cost you just over $200. Olympus sells a dye-sub that produces 8×10-inch prints and costs $500.

The final criterion for quality, though, is your eyesight. You must first examine the actual hard copy produced by any printer you're considering. It should be done on the printer's own best paper. (The unattended printers displayed in stores that give you a printing sample at the push of a button aren't usually done with the best paper and the highest settings. Track down a sales rep and ask him to break out the good paper.)

Take a look at Figure 6-6. It shows extreme enlargements of a portion of a standard color test image (available for your own tests at http://digitaldog.net/files/PrinterTestfile.jpg.hqx). Starting clockwise beginning at the top left, the printers used are a Hewlett-Packard G85 ink-jet, an Epson photo-quality ink-jet, and a Sony dye-sublimation printer. The fourth print was done using conventional chemical photo processing. All of these prints look good at their normal 4×6 size, but the enlargements reveal subtle differences among them.

Paper

I'm sure you've read a familiar warning on various product labels. It always advises you that, "for best results," you should use some accessory—whether batteries, paint brushes, or cooking ingredients—that just happens to be made by the same company that made the product to which the advice is posted. And I'm sure you regularly ignore such friendly advice. But don't, when it comes to printer paper.

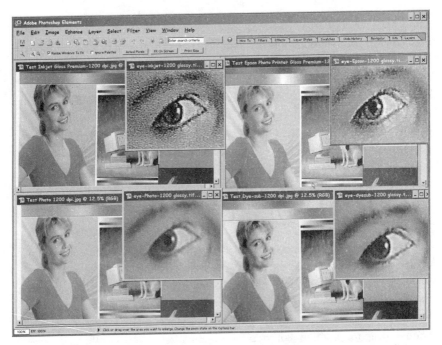

Figure 6-6 *Dye-sub printing, shown in the lower right, comes closest to ordinary chemical photo processing.*

Match Paper

I know it sounds like a lot of hustle made up by the printer manufacturers, but the truth is that Hewlett-Packard printers do better with Hewlett-Packard paper, Epson printers do better with Epson paper, and Canon printers do better with Canon paper. The ordinary printer paper you use for everything else is too absorbent. Inks sink into the paper and spread through the fibers, destroying sharpness, color, and contrast.

Printer makers' papers are designed to work with their inks so that the ink neither soaks into the paper nor sets on top in a puddle. I don't have a photo-quality printer myself. I use a Hewlett-Packard Office jet that does extra duty as a scanner, copier, and fax. But when I print on Hewlett-Packard Premium Plus paper, the results are as good as I get from the drugstore—unless I look at them through a magnifying glass.

By this, I don't mean to suggest that HP's papers are superior to those by Epson and Canon. What I do mean is that you're better off for the most part using papers created specifically for your printer.

Everyday Papers

Even limiting yourself to a single brand of paper gives you a lot of leeway. There are top-of-the-line and less-expensive photo papers, and they are available in glossy and matte finishes. Neither finish is better than the other. Glossy brings out colors better, but it shows off fingerprints better, too. The subtler look of matte paper works well for black-and-white prints, particularly historic family pictures. If you create a panoramic photo, such as the one in Chapter 5, Canon and HP both offer banner papers that are the equivalent of 20 ordinary sheets laid end-to-end without a break. HP's paper is not glossy. If you have a panorama that's a work of art, you may have to search for a place that can do oversized prints. (There are a few in the list of web links in the back of the book.) But this banner paper is fine for proofs and birthday party banners.

Use your everyday paper for tests or proofs of your photos before you print the final version on photo paper that can cost $1.50 a sheet. HP makes glossy and matte Everyday Photo Paper that costs only 20 cents a sheet; colors are not as vibrant but they're more than adequate for proofing or if you get hooked into making prints for everyone in Junior's homeroom. The paper is glossy on both sides, making it doubly cheap for proofing. But for photos that matter to you, get the best paper you can for your printer. Figure 6-7 shows the enormous difference between the same image printed on the same printer but on different papers.

Figure 6-7
The photo on the left is an enlargement of a print on everyday ink-jet paper. On the right is the same enlarged image on HP Glossy Premium Plus paper, improving color and detail.

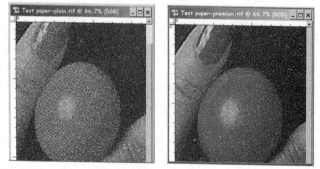

If you don't have a Canon, Epson, or Hewlett-Packard printer, you'll need to experiment to find a paper that works best with your printer. In addition to papers by the "Big Three," Kodak has an extensive selection. There are plenty of store brands that are usually less expensive, and as store brands usually work, the paper is made by a well-known supplier in the same way generic aspirin is manufactured by a company like Bayer.

Rolling Paper

If you're the adventurous type, there are other sources for paper that claim they meet or exceed the quality of paper made by a printer's manufacturers. Ilford, Luminos, and other makers, primarily of art supplies, have entered the printer paper markets with papers that have unusual surfaces, such as watercolor or canvas, "a subtle textured surface that replicates the fine fabric of Renaissance wall hangings," or metallic (my favorite; it makes neat highlights).

You won't find most of these papers at just any office store. A list of web links at the end of this chapter shows where you can order them. Some have reasonably priced sample packs that let you see how the paper works with your setup.

Save

At the price of high-quality photo papers, you should make the most of every square inch. Unless you want an 8×10-inch print, cram as many pictures as you can onto a single sheet of paper. If you're using Photoshop Elements, that's not easily done. Elements has functions that let you print more than one photo on a page. One of them is fine if you want to use a single sheet to make several prints of the same photo, the same size or different sizes, like school pictures. But if you want to print several different pictures on a single sheet of photo paper, Elements wastes a lot of space.

Paintshop Pro does it the way it should be done. You drag photos onto a layout sheet and then position them, rotate them, and resize them until you've got an ideal layout that fills the surface.

For an inexpensive solution regardless of the editing program you use, download Photo Paper Saver from www.fpdoctor.com/pps/main/main-j-0-0.html. The shareware program—$20 to register—lets you click and drag the images you want to print and choose the size for each from a menu. Then the program automatically juggles the pictures on the page until it finds the layout that makes the best use of space. Figure 6-8 shows the way Photoshop Elements and Photo Paper Saver make the most, or least, of a page of expensive photo paper.

Ink

The creation of color inks is as mysterious as a witch's brew, as much a result of experimentation and intuition as it is straightforward science. Each printer maker customizes its inks to work with its ink nozzles and how the spray droplets hit the paper. And they formulate their papers to work best with those inks so that ink doesn't soak into the paper or pool on its surface.

Figure 6-8 *Photoshop Elements makes good use of paper (top) if you want prints of the same photo. Photo Paper Saver, shown below, makes better use of paper when printing different photos.*

Ink Pigment

Generally, you're not going to improve the quality of your pictures by buying a cheap substitute ink. And unless you like trouble, don't refill your old cartridges with generic inks. Aside from the fact that you won't get the same quality of prints you're used to, you risk, at the least, a messy desk and, at the most, a clogged cartridge.

The trend is to turn from dye-based inks to pigment-based inks. The dyes are not as vivid as the ink-based, but they resist aging longer. Epson, Canon, and Hewlett-Packard have dye-based ink-jets designed to be so well matched to their own brand papers, it's hard to justify looking for a better ink.

If, however, you use a Canon or Epson printer, there are some inks worth looking at for special purposes. The photo in Figure 6-9, for example, was printed on an Epson printer using cartridges with only black and gray inks, producing subtle shades and fine detail. The makers of some of these substitute inks claim that they resist fading longer—a topic we'll get to in the next section—or that they cover more fully or that they're more vivid. Whatever. The eye does wander, and if you want to experiment with some off-brand but respected inks, there are web addresses for a few online sources at the end of this chapter.

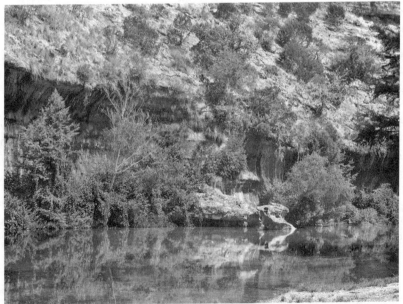

Photo by Don Adams

Figure 6-9 Cartridges with seven shades of gray and black create subtle tones in this landscape.

Archive

Here's the first dirty little secret of digital photo printing: The prints bleed and fade.

Carry a print fresh off the printer in a sweaty hand, and you'll have a blur the size of your thumb on the prints and a mess of ink on your thumb. Even a print that's dried for several days will run if it comes in contact with water.

You may be able to avoid sweaty palms and sudden showers. But you can't avoid light and time. Both are killers when it comes to any type of photographic prints—whether from film or from a computer printer. But it's only recently that people have realized that those irreplaceable pictures of their great-great-grandparents aren't going to last forever. Not only that, but the way we've chosen in the past to protect them—mounted in scrapbooks—has been putting them face-to-face with chemicals in the paper and other photographs that only hasten their deterioration.

Hard copy from computer printers had, until the last few years, been worse than film prints when it comes to fading and discoloration. Computer printer photos are susceptible to ultraviolet light and ozone.

Confronted by a realization that they were running out of time to save some of our photographic treasures, photographers have become as concerned as museum keepers when it comes to using archival-quality materials for storage and display. The printer companies have jumped on the bandwagon in a race to extend the life of printed pictures.

You can do your part. Following is some advice on how to produce prints with more built-in immunity to the environment and heat.

Preserve Digitally

In a sense, digital photos still have it over film in the race for survival. Film prints may last long naturally, but once negatives go bad—and they will—you no longer have a source for an original print. But digital files do not fade or crack. They can

become unreadable, but you can avoid that disaster with a few precautions. In addition to any prints you make, save your photos to a CD-ROM, preferably two, just in case. It's estimated that data on a CD-ROM will last 100 years if it's stored away from light in a way that protects the surface from scratches. Of course, the 100-year claim hasn't been tested, and so it wouldn't hurt if every decade or so you burn new CDs from the old. The new copies will be as good as the old ones were ten years earlier.

Preserve on Paper

With your pictures safely stored on CDs, you could simply plan on replacing your printed pictures every few years after they become faded. But you have better things to do with your life. You're better off doing what you can to produce prints that will last as long as possible from the very start.

So why do prints fade? The inks used by ink-jet printers break down when ultraviolet light strikes them. The inks' exposure to chemicals in the air, particularly ozone, eat away at the ink. The defense? Paper.

In just the last few years, printer makers have stretched the lifetime of computer printer photos past the point where film prints have faded away. Much of it has to do with the absorption factors of manufacturers' house-brand photo papers. Henry Wilhelm of Wilhelm Imaging Research (www.wilhelmresearch.com/articles_ist02_2002.html) has been running ongoing tests for years to predict the lifespan of photos reproduced with different inks, papers, and printers. The table that follows shows the results (note that all results are for framed prints under glass, in a bright room).

Desktop Ink-jet Printer and Inks	Print Paper and Type of Coating	Years Displayed Before "Noticeable Fading"
Printer: Canon S800 Photo Printer Ink: Canon BCI-6 (six dye-based inks)	Canon Photo Paper Pro PR-101 (microporous coating)	27 years
	Canon Glossy Photo Paper GP-301 (microporous coating)	6 years
Printer: Epson Stylus Photo 890, 1280, 870, and 1270 Ink: Epson (six dye-based inks)	Epson Color Life Photo Page (swellable polymer coating)	26 years
	Epson Matte Paper–Heavyweight (matte-coated paper)	25 years

Desktop Ink-jet Printer and Inks	Print Paper and Type of Coating	Years Displayed Before "Noticeable Fading"
	Epson Premium Glossy Photo Paper (microporous coating)	9 years
	Epson Photo Paper (microporous coating)	6 years
Printer: Epson Stylus Photo 2000 Ink: Epson archival (six pigment-based inks)	Epson Premium Luster Photo Paper (microprocessor coating)	100+ years
	Epson Premium Semi-Gloss Photo Paper (microprocessor coating)	100+ years
	Epson Enhanced (Archival) Matte (matte-coated paper)	100+ years
Printer: Hewlett-Packard Photosmart 7350 Ink: HP (six dye-based inks)	HP Colorfast Photo Paper (swellable polymer coating)	19 years
	HP Premium Plus Photo Paper (swellable polymer coating)	65 years
	HP Premium Photo Paper (swellable polymer coating)	3 years
Kodak: Personal Picture Maker PPM200, manufactured by Lexmark Ink: Kodak Photo (six dye-based inks)	Kodak Ultima Picture Paper, High Gloss (swellable polymer coating)	24 years
	Kodak Premium Inkjet Paper, Matte (matte-coated paper)	6 years
	Kodak Picture Paper, Soft Gloss (microporous coating)	3 years
Printer: Lexmark Z52 Color Jetprinter Ink: Lexmark Photo (six dye-based inks)	Kodak Premium Picture Paper, High Gloss (swellable polymer coating)	Less than 1 year
Traditional film-based prints	Fujicolor Crystal Archive Paper (multilayer gelatin-coated photo paper)	60 years
	Kodak Ektacolor Edge 8 Paper (multilayer gelatin coated photo paper)	22 years

This doesn't mean you should rush out and stock up on Epson paper for your HP printer. Remember, the results are only for papers used on printers for which the paper has been especially created. What this does mean is that a quick, fading death for computer printed photos will disappear completely within a few more years. Though Epson has a jump start, other printer makers will eventually catch up.

Do Your Part

Using the right paper and inks with the right printer is what's needed to create archival collections and displays of photos. There are some simple rules to follow to make sure you produce—and preserve—prints that resist the ravages of light, air, and display materials.

- **Dry** When you print a photo, allow it to dry without anything on it for 24 hours. It may seem to be dry much sooner or even feel dry to the touch, but the absorption process goes on for hours afterward. Glossy and premium papers take longer to dry than photos on ordinary printer paper. Don't allow prints to pile up in the printer's output bin.

- **Varnish** When a print is dry, spray it with a varnish such as Lyson Print Guard or any other varnish with a UV blocker. Spray horizontally across the surface lightly three times and vertically three times. Let the spray dry thoroughly before stacking or handling the prints.

- **Archive it** If you're not going to display the photo, put it in an archival-quality plastic sleeve. That means it contains a filter to block ultraviolet light and is made of a material that won't react with the paper or inks. Store your sleeved prints so that they don't weigh on each other in a dark, dry place.

- **Use archival-quality materials** In you want to put the photos in a scrapbook, use only archival-scrapbook materials that are chemically inert and won't react with the chemicals in the photos. Scrapbook paper should be marked acid-free and lignin-free. To label photos in your scrapbook, use permanent markers that are acid-free and water-free. If you have a hard time finding archival materials at photo shops, check art supply stores and the latest phenomenon, scrapbook stores.

- **Don't use adhesives** Avoid using any adhesives directly on the photo—front or back. No adhesive tape. It will yellow and the glue will bond with your pictures. Acid-free adhesives work well, as do archival-quality photo corners. If you want to put your photos in a scrapbook, get a scrapbook that has archival-quality pages, and a UV treated plastic sheet over each page. It blocks not only the most harmful light, but the air as well.

- **Use UV-filtered glass** For framed photos, of course, use archival-quality materials, including UV-filtered glass. The best mounting uses cardboard matte so that the glass is not actually in contact with the print. Hang the framed photo on a wall where it gets as little direct sunlight as possible.

Calibrate

I've saved the second dirty little secret of digital photo printing for the last because it's a drag. It's this: Your camera, monitor, and printer don't see eye-to-eye, or lens to screen, on how colors should look. If your prints' colors consistently look different from how they look on the screen, you need to calibrate your equipment. Monitors, printers, and cameras all use different methods to record and express color. The monitor, for example, uses additive colors in the form of red, blue, and green lights. The printer uses subtractive black, yellow, cyan, and blue dyes or pigments. You need to get them to agree on what it means for an object to be a full, rich red or a somber blue.

Now, if your printer output appears to match your screen output, there's no problem. But if not, then check out the sites listed at the end of this chapter. They will take you places that will explain the fairly esoteric technique of color matching. At most, it means you'll have to calibrate—in other words, you'll need to change some of the adjustments on your monitor, which you can do using Adobe Gamma, a program that comes with Photoshop Elements. At the least it means finding color management files and adding them to the properties for your monitor and printer. (Sometimes a camera will have equivalent color management selections.)

I hesitate to even bring this up because it's very geeky and the type of thing that can drive even geeks mad in their quest for an absolutely perfectly calibrated system. There ain't no such thing. Colors will always be a bit off, and your monitor in particular will change as the phosphors in the screen dim, requiring further calibration. If this sounds like fun to you—or if you really have a serious color-matching problem—check the following links and knock yourself out.

Links

Matters like archiving and color matching get esoteric. Here are some sites that explain the complex processes in simple terms, while giving you all the necessary details. These sites also provide tips on shopping for photo printers as well as sources for special inks and papers.

- **www.inkjetart.com/archival_inks.html** Excellent source of archival inks for Epson photo printers and high-quality papers for all ink-jets.

- **www.displaymate.com/printcal.html** Calibrating your printer, scanner, and camera with DisplayMate, the best software available for testing and manipulating monitors.

- **http://digitaldog.net** The Digital Dog is the ultimate source of detailed information, tricks, and tips for color matching.

- **www.microsoft.com/hwdev/tech/color/default.asp** Color management for Windows.

- **www.businesswire.com/webbox/bw.042502/221150021.htm** Press release on the current leading photo printer: the seven-color archival desktop photo printer, the Epson Stylus Photo 2200.

- **http://photos.msn.com/editorial/EditorialStart.aspx?article= ComparisonShoppingForAPhotoPrinter§ion=NOTEBOOKS** Guide to comparison shopping for a photo printer.

- **www.inkjetcolorsystems.com/images/Address-1c.jpg** Good information on matching monitor to printer for accurate color.

- **www.dp-now.com/Features/Printer_reviews/Photo-inkjets/photo-inkjets.html** Two-part series on the truth about ink-jet printers.

- **www.westphotoimaging.com** Check out this printer if you need a bigger format than your own printer can handle.

- **www.inkjetcolorsystems.com/Welcome_Inkjet_First.htm** Extensive information on color theory and color management. Also a source of special inks for photo printers, particularly the Epson.

- **www.redrivercatalog.com/index.htm** Red River is an excellent source of high-quality, archive photo papers and specialty papers such as magnetic and metallic. Get one of there sample kits to find the paper right for your photos.

- **www.lyson.com** The home site of Lyson, the major manufacturer of archival inks for Epson and Canon photo printers.

Save and Share

You don't have to print your photos on a special photo printer using seven colors of ink on paper that's so expensive you have to go through a credit check to buy more than ten sheets. In fact, you don't have to print your photos at all. This is the digital age, after all. The ability to send your pictures by e-mail or create a virtual gallery where friends, family, and the whole world can see your work are only a few clicks away.

And it's also a multimedia world. Your photos can gain new life displayed on the living room TV set or as a computerized slideshow complete with narration, music, titles, and many of the things you'd expect from a movie (except for a big budget). In short, you'll find myriad ways to present your pictures to friends and family, and you can do it simply or you can do it big time.

In this chapter, we're going to look at displaying your photos through e-mail, the Web, and custom CDs, which is really quite fun. But first, we need to do some housekeeping.

Save

Because digital photography makes shooting pictures so much fun and so inexpensive, before long you're going to find yourself without any space left on your hard drive to store them. You have two choices to forestall your photo file overrun: Make the files smaller, or find somewhere else to keep them.

Compress

In Chapter 3, we looked at graphic file compression in connection with the quality of photos. The more a picture is compressed, the smaller it is and the more quality it loses. The method that works best with graphic files, such as JPEG, is a *lossy compression*, which means that the visual information that gets thrown away in the name of compactness is lost forever. Sure, you may not need it, but it's something to keep in mind should you later want to use the files for enlargements or if you're fussy about having sharp, detailed pictures.

Photoshop Elements, set for the least compression and the best quality, reduces a totally uncompressed TIFF file to anywhere from 50 to 20 percent of its original size, and any differences in 8×10-inch prints from compressed files are indistinguishable from uncompressed prints. At its most-compressed size and worst quality, the file is reduced by as much as 94 to 99 percent. And when I compare 8×10 prints, I can't tell whether the differences I see aren't imaginary.

> **AS A MATTER OF FACT** How much JPEG compression reduces the size of a file depends on what's in the picture. If there are a lot of mixed colors and shapes, as in the photo on the left in Figure 7-1, then the file must use more bytes of data to record more parts of the picture individually. If the photo is more like the desert sky picture on the right, compression takes advantage of the fact that many parts of the photo—the sky, the lighted rocks, and the rocks in the shadow—are close or identical in color. The information for all the matching pixels of color are stored only once with a list of what pixels that color belongs to, a much more economical process than recording most pixel values separately.

Test

Of course, your software and printer may get different results. Make some prints with JPEG files compressed to different levels and see what you think of your own results. From then on, after you've done all your digital darkroom manipulation, save the results to the most compressed JPEG that your experience tells you is safe. At the same time, don't forget to move original, larger versions of the same picture to removable storage, such as a writable CD-ROM or a zip drive. This gives you a

backup if anything ever happens to the JPEG version, and frees up space on your hard drive.

Figure 7-1 *Both photos on the top are uncompressed TIFFs. Below are JPEGs of the same photos compressed to less than 10 percent with no noticeable decline in quality.*

Double Up

Compression has its limits—as do all of the methods we'll look at for storing more in less space. Eventually, you'll reach the point where there is no more space on your hard drive for even a picture the size of a postage stamp.

It's time to buy a second hard drive. Don't do as did a friend of mine, who, confronted with a full hard drive, went out and bought a new computer. If you're looking for an excuse to buy a new computer, go ahead. But don't throw away the hard drive from your old PC. Make it a second drive for your new one.

All PCs sold these days can handle two hard drives and provide an empty space and the cabling to install a second one. The obvious advantage is that you get a lot more storage space. However, the capacities of hard drives increase while their prices decrease, so you're in for a pleasant surprise if you haven't shopped for hard disks in a few years. A drive that holds 120GB of data costs less than $200.

Drive Faster

The extra storage isn't all you get. New drives are also faster, an important factor especially when you're working with graphics. Large photos often don't fit entirely

in memory, at least not all at the same time. Part of the data that represents the photo must be spooled to the hard drive. That means part of the picture is in memory, where you can actively make changes, and the rest of the picture is on the hard drive. Before you can edit the hard drive part, it has to read from the drive into RAM, which is the biggest slowdown you face with a computer. If your software simply must continue to go to the hard drive, you want the drive to feed its information to RAM as quickly as possible.

AS A MATTER OF FACT *The best hardware boost any graphics software can get is more memory. With more memory, your computer doesn't have to waste as much time going to the hard drive for different parts of a photo. Max out the memory to see a dramatic increase in speed.*

A second drive gives you another boost, depending on what software you're using. Photoshop Elements asks if you have a second drive. If you do, Elements will offer to store all its temporary, working files on the second hard drive while it uses the first drive for its own code. This arrangement lets both drives operate at the same time, drawing program code and photo data off the two drives simultaneously.

Back Up Quickly

If this weren't enough in itself to justify a second hard drive, consider this: Computer experts are fond of telling you to back up the data on your hard drive. These experts usually have someone else backing up their data. A second drive can cut in half the dreary job of backup. Here's how.

Move all of your data files to your new larger, faster hard drive, drive D:. Never install programs on it. If the programs automatically save such things as macros and settings to a hard drive, try to get the programs to use the new drive. Now, on your old C: drive, keep only your programs and never save any data files, which are photos, letters, spreadsheets, anything you created using the programs.

From now on, forget about backing up the C: drive. If it crashes, you can reinstall all the programs that were on it, which should take no more than an afternoon. But you must back up your D: drive. It's filled with files you can't buy and reinstall because you created them. If you don't need some files badly enough to back them up, zap them. But do regularly back up what's left. It's not hard this way.

I know that doesn't have a lot to do with digital photography, but it's good advice anyway.

Offload

If you're the dedicated digital photographer I think you are, eventually you're still going to run out of space on drive D:, or wherever you keep your photos. You'll need to move some of the files onto removable storage.

Forget about floppy disks. Only the most compressed photos will fit on a floppy. Zip drives are a better choice, but the best is writable or rewritable CD drives, which are standard on new PCs. (Writable DVD drives, although not yet standard, are cropping up more and more on new computers and eventually will be the backup of choice because of their multigigabyte capacity.)

When you archive photos to compact discs, store them away from light and heat. Both can distort the metallic film on the bottom of the discs that is used with a laser to write data. If properly cared for, your CDs should preserve your photos for 100 years. But to be on the safe side, copy the CDs to fresh discs every ten years or so—at least until Silicon Valley comes up with a new and better way to store computer information.

Mail

Being generous with your photos may be the best way to ensure their immortality. Once a picture, joke, or message makes it into e-mail, it takes on a life of its own. You can't call it back, and you can't control what other people do with it. Chances are, if your photos are good enough, funny enough, or breathtaking enough, your pictures could get passed along to people you'll never know.

Downsize

Your photos have a far better chance of eternal virtual lives if they are small. The larger a file is, the more that conscientious computer users hate to pass it along to others. They know that people connecting to the Internet on a 56K modem may spend hours receiving a gigantic graphic. Some e-mail systems limit the size of a single message to less than 10MB, which is hummingbird feed by TIFF file standards.

Lower Res

Start by reducing a photo's resolution, which makes it dramatically smaller because there are fewer pixels to account for. Lest you think that's the equivalent of asking you to clean your lens with coarse grit sandpaper, let me explain that any photo destined to be displayed primarily on a computer monitor doesn't need a lot of resolution. That's because even the best monitors don't have much resolution themselves.

Tops, your monitor probably is good for 1,280×1,024 pixels, or about one megapixel. Compared with printers that have at least 300 dots per inch, a monitor gets by fine with fewer than 75 pixels per inch.

Change Size with Elements In Photoshop Elements, reducing the size of a photo takes about half a dozen clicks.

Figure 7-2 shows two versions of Ansel Adams' photo of the Grand Tetons and Snake River. On the left is the original scan from the National Archives. It has a resolution of 3,000×2,402 pixels, more than 6 megapixels. In Elements, the quickest way to reduce it to e-mail size is to choose **Image | Resize | Image Size**. The Image Size dialog box displays the photo's dimensions in pixels, printed inches, and its resolution, which is 300 pixels per inch (ppi) for the original file on the left.

Figure 7-2 On the left, a photo at 300 ppi resolution at 7,049KB. On the right, the same photo at 72 ppi at 418KB looks just as good.

Don't worry about the settings at the bottom. They're correct. Skip past all the other controls and go straight for the Resolution fill-ins measured in ppi. I copied the 300-ppi file on the left and changed the resolution to 72 ppi, which is the resolution of a good monitor. Anything higher is wasted. And it reduces the image proportions to 720×577 pixels. File size goes from 7,049KB to 418KB. But both versions of the Adams photo look identical on a monitor.

Crush 'Em

Next, resave the lower-resolution version of a photo using Choosing Elements' **File | Save for the Web** (ALT-CTRL-SHIFT-S). The commands open up an expansive dialog box, shown in Figure 7-3, that displays a photo uncompressed and with compression cranked up to Smush!—90 percent.

Figure 7-3 *The Save for Web dialog box lets you see immediately the effects of different compression levels.*

Again, go with the default settings, including JPG Low, in the top right of the dialog box. The "low" supposedly refers to quality. But the before and after shots look identical—again, on a monitor.

Post and Show

If you have more than a few photos, even if they're all shrunk to the max, they can still build up to more Internet traffic than some systems can handle. Instead of sending 10 photos to 20 people you know, invite everyone you know to see 200 of your very best photos on your own web gallery.

Web galleries are catching on as the place to chronicle the kids' growth so cousins all over the country can be kept up-to-date. The galleries are big among genealogists and, of course, photographers who want to show off their work for hire. You can create a gallery with the tools in Photoshop Elements or you can have someone else create a gallery for you.

Use Painless HTML

If you haven't already, move the photos you'd like to include in a gallery into a separate folder. **Choose File | Create Web Photo Gallery** from Elements'

menus. The Web Photo Gallery dialog box opens with a host of choices that you can play with or run with pretty much as they appear. The first of them, **Styles**, lets you pick a motif for your gallery, anything from cartoonish to high-tech. In Figure 7-4 you see the other settings are for such things as picture size and compression quality, titles, and of course, the ever important copyright mark.

Figure 7-4
The Photo Gallery
dialog is all you
need to decide
how your web
pages will look.

Having made your choices, click the Browse button and track down the folder that you previously stuffed with photos for your gallery. I keep a folder chock-full of grandchildren pictures crying out to be displayed in an online gallery. I choose that folder in the Browse dialog, and all the pictures are sucked into Elements, resized, and churned out again as photos set in nicely decorative HTML pages, such as the one shown in Figure 7-5.

The only thing left to do is upload all the gallery files created by Elements to your home page on the Web and send out an e-mail announcing your opening night. Your visitors can click on the thumbnails to display a bigger photo in the spotlight.

Hitchhike

If you don't have a web page and don't want the responsibility of maintaining one, use someone else's web site—or example, Shutterfly.com, a web site that generously offers to post your photos in a slide show, gives you some rudimentary

tools for touching them up, and sends invitations to your friends to stop by and view the pictures.

Figure 7-5 *A painless web page production rolled out by Elements for you to display your photos online.*

Shutterfly.com isn't entirely altruistic, of course. The site is hoping your friends will be so delighted with the pictures that they'll order prints. Or they hope that, if you're not using a digital camera, you'll get all your film processing done by Shutterfly.com.

> **AS A MATTER OF FACT** *You don't have to order prints through services such as Shutterfly.com to get prints. Your friends can right-click on the large pictures that appear in an online slide show, choose print, and get a decent 3 1/4×2 1/2-inch hard copy from their own printers.*

I used Shutterfly.com to post photos of these old men with gray hair and pot guts who mysteriously turned out for my high school reunion (Figure 7-6). Even at low resolution and high compression, the photos collectively were too big to send to everyone through e-mail. Posting the 80 photos on Shutterfly.com took about 10 minutes, and the results, which you can see in Figure 7-6, look a lot neater than a bunch of JPEG files wrapped up in a zip file.

Figure 7-6 My own photo album at Shutterfly.com, a slide show in progress.

This is not the perfect business plan. Other similar sites have become impatient waiting for the print orders to come pouring in and have started charging $10 to $15 a year to display pictures.

MSN (http://photos.msn.com) offers a free service to display your pictures, provided you sign up for a Microsoft Passport. MSN Photos is hoping you also sign up for MSN Photos Plus, which for $22 a month provides 100MB of storage, tools from Microsoft Picture It, and high-resolution downloads.

Share on Disc

What about friends who don't have an Internet connection—if you can imagine that? How can you get a bunch of digital photos to them? If you have a CD burner, you're on your way.

The simplest way to go is with the Create Web Photo Gallery function in Elements, the one we looked at earlier. Even without an Internet connection, friends and family can still use Internet Explorer or any other browser to view the HTML pages that Elements creates. Elements makes you create the files in folders dedicated exclusively to them. Simply copy all those folders to a writable CD and slip it in the

mail with instructions to double-click on the CD's INDEX.HTM file. From there on, the gallery will display as if it's online, only faster.

> **AS A MATTER OF FACT** If you don't have Photoshop Elements, go to FotoTime.com and download the free FotoAlbum software. The purpose of FotoAlbum is to provide an easy way to post pictures on FotoTime.com, but you don't have to use it for that. FotoAlbum does most of what you can do with Elements when it comes to creating slide shows, even if it does get more complicated than is necessary. Compensating for the complexity is a built-in ability to write a slide show to a CD, complete with the software to play the show on someone else's PC whenever the CD is popped into a drive.

Make VideoCD

As long as you're copying your pictures to a CD anyway, why not do it up right and create your own photo CDs that you can distribute to friends and family to play on their PCs or DVD players as a slide show complete with music or your narration?

The no-brainer way to do this is to drive over to the nearest drugstore and pay them to send off your film, scanned images, or old photos you need scanned and have them transferred to a Kodak Picture CD or Photo CD for a few bucks. Although the Picture CD format includes a way to present the pictures in a slide show, both formats are basically ways to store pictures on a CD. Neither has soundtrack capability.

But you have a brain. And a CD burner. You can do better.

> **AS A MATTER OF FACT** You can get your photos on a Picture CD or on a Photo CD. Here are the differences between them. Pictures on a Photo CD Disc are for professional use. They can be saved in six levels of resolution, ranging from 128×192 pixels to 4,096×6,144 pixels. A Picture CD, on the other hand, holds images stored at only one resolution, 1,024×1,536 pixels; it's intended for the average picture-taker. A Photo CD holds about 100 images, and you can add images to the CD at any time. Images are written to a Picture CD at the time of the original processing from a single roll of film and you cannot add more images to it later. Photo CD Discs require the use of enabled software to view and use the images, while Picture CDs come with software included on the CD.

Do It Yourself

For the most versatility, you want to create a VideoCD, or VCD. Your friends and family have a choice of playing your slide show on their computers or their DVD

players, complete with a soundtrack of your narration or your selection of music (or both if you want to spend time mixing audio tracks). The slides can have fancy dissolve and wipe transitions, and you can even mix in live-action video.

Sound like fun? It is, if you have the right software. The best I've found is Pinnacle Systems' Expression. Download a 30-day evaluation copy of the program at www.pinnaclesys.com. There, click Products and scroll down to Expression. If you want to keep it after 30 days, you can find it for about $40.

> **AS A MATTER OF FACT** *I tried to find some VideoCD software that was entirely free and discovered VCD Easy, a freeware program that does much of what Pinnacle Expression does. But where Expression hides the nitty-gritty details underlying the construction of a VideoCD, VCD Easy lays them open for all to see, and it's not a pretty sight. VCD Easy is good for developers and those who can look at all the internal workings of a program without turning to stone. If you're that intrepid, check out http://vcdeasy.org/ and www.vcdhelp.com/ for free software and lots of advice.*

Expression has three basic steps. First, pick the photos and/or videos you want to include in your show. Then, edit the show, as shown in Figure 7-7, which includes changing the order of the pictures, picking a menu style, adding dissolves and fades, giving your show a title, and—this is a real kick—selecting music from any MP3 or wave file. Finally, burn the finished slide show to CD or DVD.

Figure 7-7 *All the controls to produce a slide show or video with soundtrack are grouped in one simple dialog box in Pinnacle Expression.*

Hack

The resulting disc plays on most entertainment center DVD players, which means your work gets the big screen, big speaker treatment. For those of your acquaintances who don't have a DVD player, the same slide show will play on a PC, but you have to cheat by renaming some files.

Tell the recipients of your CD to open Windows Media Player or their favorite digital jukebox, choose **File | Open** ..., go to the CD-ROM drive, and then go to the MPEGAV directory, one of four folders created by Expression.

At first it will seem as if no files are there. To correct that, click on the **Files of Type:** drop-down box. Instead of the default selection, Media files (all types), drop to the bottom of the list to select All files (*.*). Two or more files will appear, with filenames such as AVSEQ01, AVSEQ02, all ending with the extension .DAT.

The files are actually MPEG files, the type used to compress video and audio. Protocol for VideoCD, however, insists they be called .DAT files. Double-click on the one with the highest number before the extension. Voilà! Your slide show masterpiece begins to play.

If you use a different media player and this doesn't work, try copying all the directories to an empty folder on your hard drive, rename the files with .MPG extensions, and see if your player recognizes them.

Digitize

The slide/movie show with soundtrack is something you could never have done with a film camera. In fact, it's almost not photography. It involves directing and producing, which may not appeal to your still-photo soul. That's fine. The whole idea behind digital photography is that it expands the range of things you can do to fields you didn't dare dream of before. Or, if all you want to do is take a better snapshot, digital cameras will help you do that, too—better, faster, and cheaper.

But you'll never get any photos if you continue to stay inside, reading a book. It's time to get back to the real virtual world and start snapping.

Links

Here are some web sites for information and supplies for archiving your digital photos.

- **www.lightimpressionsdirect.com/servlet/OnlineShopping** Light Impressions, an excellent source of archival display, mounting, and scrapbook materials.
- **www.kodak.com/global/en/service/faqs/faq1001c.shtml** Info on getting pictures transferred to Kodak Photo CD.

- **http://photos.msn.com/editorial/EditorialStart.aspx?article=SafekeepingYourKeepsakes§ion=NOTEBOOKS** Good survey of various methods of storing digital photos for the long run.

You can learn a lot by browsing through these collections of online photos.

- **www.artsdigitalphoto.com** More astronomy photos by Art Rosch, featured in Chapter 1.

- **http://images.fws.gov/** U.S. Fish and Wildlife Service National Image Library.

- **www.greaterlynnphoto.org/intlphotoscolor02~ns4.html** Greater Lynn Photo Association International Color Slide Salon 2001.

- **www.zonezero.com/** Exhibitions by several artists accompanied by narration audio.

- **http://pages.zdnet.com/aimeeholcomb/hawaiiphotos/id8.html** Flowers.

- **www.photolib.noaa.gov/collections.html** National Oceanic & Atmospheric Administration (NOAA) Photo Library.

- **www.photolib.noaa.gov/** NOAA Photo Library Home Page.

- **www.josephholmes.com/** Beautiful natural light nature photography.

- **http://parkwise.schoolaccess.net/Students/PhotoGallery/photogallery.htm** Alaska National Parks landscapes.

- **www.apexnewspix.com/main/portfolios2/portfolios2.htm#** Portfolios of top photos.

- **www.betterphoto.com/gallery/dynoGall2.asp?cat=32** Gallery of technology photos.

- **www.nps.gov/yell/press/images/** Yellowstone National Park public domain photographs.

- **www.webphotoforum.com/artist_pic.asp?pID=22002** A well-organized database and search engine lets you find photos by subject matter.

- **www.google.com/imghp?hl=en&ie=UTF-8&oe=UTF-8&q=** Google Image, the best search engine on the Web for finding images, not all of which are photographs.

- **www.people.virginia.edu/~edb9d/home1.htm** Photographs by Doug Burgess of Charlottesville, VA, including his pinhole photos.

- **http://memory.loc.gov/ammem/dagquery.html** America's First Look into the Camera: Daguerreotype Portraits and Views, 1839–1864.

Buyer's Guide to Digital Cameras

As wonderfully versatile as digital cameras are, no one digital camera fits all types of photographers. You can pay less than $100 or several thousand for one. You can find simple point-and-shoot digicams or find cameras that give you god-like control over every aspect of a photograph from light to color to perspective to the quality of detail. They come small enough to fit in a shirt pocket or so big that an afternoon shooting on location qualifies as cardiovascular exercise.

Cameras are divided into tables according to three types of photographers: the birthday party photographer who just wants simple, inexpensive snapshots of the kids and family; the enthusiast who already knows a good deal about photography and aspires to take pictures that will wow others; and the pro who makes his living with his camera and will pay for the best. The tables each include the ten best/most popular cameras in their categories, based on reviews and best-seller lists from photography and computer magazines and web sites. The world of digicams is changing rapidly, and some of the models listed in the tables may have evolved by the time you read this. The street prices, which were obtained from www.pricescan.com, most certainly will fall as newer models out-class the current models.

What each class of photographer can expect varies from group to group. But here are a few factors that remain true whether you're buying the lowliest point-and-shoot or the ultimate top-of-the-line model.

- Digital zoom is worthless. It merely magnifies the image artificially without increasing resolution. You can do the same with a darkroom software.

- Docking stations are a mistake. They just take up room on the desk, and generally do nothing more than a USB cable. Better to spend 20 bucks on a card reader that takes up less room and doesn't require your camera to be hooked up to it.

- The ability to send photos directly to a printer is overrated. You'll wind up printing a lot of pictures that aren't keepers. Even if the printer has an LCD display that allows you to preview and edit photos, you can do a better job with software and your PC or Mac.

- Don't get confused by the various types of digital memory—CompactFlash, Secure Digital, xD-Picture Card, Microdrive, SmartMedia. The important difference among them is their price per megabyte and how fast they are. Prices are generally comparable. Unfortunately, the speed differences are difficult to quantify and may vary depending on what camera a memory card is used with. Bottom line: The type of memory card should be a factor. Take what you get.

- Most of the cameras have video capability, but just barely. These are not videocams. At best you'll get a small video of the kids wishing Grandma happy birthday that you can send over the Internet.

- A battery charger included in the price is a minor plus. All cameras eat up batteries like potato chips at a frat party.

- Lay your hands on a camera before you buy it. Use the controls—in particular, the zoom, focus, and exposure controls—peek through the viewfinder, look at images on the LCD screen, and actually take some photos with it. If a camera in a store doesn't have a charged battery in it, find a clerk who'll power it up—or take a walk.

Here are a few specifics for whatever type of photographer inhabits your soul.

If you're a birthday party photographer, you probably want the same point-and-shoot ease-of-use in a digital camera that you're used to in film cameras. If you're looking for any cameras in this category, here are the basics you should expect:

- A price under $300 and $200 will be more common as prices sink, which they invariably do when it comes to electronics.

- An imager (the microchip covered with pixels that capture the light from a scene) should have at least 2 megapixels.

- Autofocus zoom lens, preferably with an optical zoom of at least 3×. Digital zoom doesn't count.

- Macro mode.

- An optical view finder.

- Video capture ability, at least for 20 to 30 seconds. Sound capture is a plus.
- Autoexposure, and adjustments for different lighting conditions and white balance.
- Shutter speeds of at least ½ to 1/1000 of a second.
- Built in autoflash with red-eye reduction and fill-in.

If you're an enthusiast, you of course want the best camera you can buy. Who doesn't? But who can always afford the best? Make some sensible compromises.

- Expect to pay between $400 and $1,000. Online direct purchasing will save you some bucks. Check out www.pricescan.com and eBay.
- Go first for megapixels. In this price class, you'll find imagers with 3 to 5 megapixels.
- Look for glass lenses. They're doing wonderful things with plastics these days, but glass is still the lens of choice.
- If you wear glasses, get a camera with a diopter adjustment on the viewfinder or you'll be guessing at manual focus.
- Test a camera to see how quickly it responds from the time you press the shutter button to when the shutter trips. Autofocus and autoexposure are slower on some cameras than others. Test the burst mode that takes several pictures with a single press of the button.
- How intuitive are the controls? Do you have to think about how to use the zoom and focus or do they come naturally?
- You won't find interchangeable lenses at these prices, but if you're a real enthusiast, find out if you can get an extension lens that fits on a camera's fixed lens to give you greater telephoto and wide-angle ranges.

If you're a pro, you probably already know what you want. Here are your chances of finding it.

- You'll pay anywhere from $1,500 to $4,000. And at the high end, that price is usually only for a camera body. Lenses are extra.
- If a camera lets you swap lenses, those lenses will most likely be Nikons. You can find a digital back for a Hassleblad, by the way, but it costs about $22,000.
- All controls should have manual modes.
- Test the white balance under different conditions. Not all work as well as advertised.
- Make sure the camera can sync with external flashes.

Canon PowerShot A40

The PowerShot A40 has a 2.0 megapixel CCD sensor while the PowerShot A30 features a 1.2 megapixel CCD. Both cameras incorporate a 3× optical zoom lens and offer features and image quality normally found in more expensive models, such as movie mode (with sound on the A40); a shutter speed range of 15 seconds to 1/1500 second; manual exposure; spot metering; selectable ISO settings from 50 to 400; built-in flash with 5 modes; and magnified playback up to 10× for convenient image revision. **Street price: $214-$249**

Number of CCD Pixels:	2 megapixels
LCD Screen Size:	1.5 inches
Viewfinder:	Optical
Optical Zoom:	3×
Digital Zoom:	2.5×
Lens Mount:	Fixed
Focus Features:	TTL autofocus, full-screen, or center
Minimum Focal Length (Wide Angle):	7.1mm (35mm film equivalent of 35mm)
Maximum Focal Length (Telephoto):	21.3mm (35mm film equivalent of 105mm)
Macro Mode:	No
Minimum Focus Distance:	Information not available
Exposure Settings:	Programmed AE full-screen or spot metering or manual; +/- 2.0 EV in 1/3 step increments
Minimum Aperture:	f/4.8
Maximum Aperture:	f/2.8
Minimum Shutter Speed:	1/1500 second
Maximum Shutter Speed:	15 seconds
White Balance:	TTL Auto WB, pre-sets for daylight, cloudy, tungsten, fluorescent
ISO Equivalencies:	100, 200, 400

Removable Memory Included:	CompactFlash 8MB
Power Source:	4 AA alkaline batteries
Flash Characteristics:	Auto/on/off, auto red-eye reduction, slow-sync
Connections:	USB, video out, Canon photo printer
Image Formats:	JPG
Video Capture Format:	AVI
Video Capture Resolutions:	320×240; 160×120 ppi
Frames per Second:	2.5
Maximum Video Length:	30 seconds
Size:	4.3×2.8×1.5 inches
Weight:	8.8 ounces without battery and CF card
Other Features:	Direct printing to Canon Card Photo CP-100 or CP-10 printers
Included Software:	ArcSoft Camera Suite CD-ROM
Included Components:	Wrist strap USB cable AV cable 4 AA batteries

Sony Cyber-shot DSC-P51

The DSC-P51 combines a 2.0 effective megapixel imager and 2× optical zoom and 3× digital zoom for a total 6× zoom. It has a hot-looking Sony design, and a host of features including advanced auto-focus and low-light options; versatile movie and clip motion modes; and playback and editing on the spot. **Street price: $213-$350**

Number of CCD Pixels:	2 megapixels
LCD Screen Size:	1.6 inches
Viewfinder	"True-zoom" optical Viewfinder
Optical Zoom:	2×
Digital Zoom:	3×
Lens Mount:	Fixed
Focus Features:	3-area multi-point AF, 5-step manual, preset auto-focus illuminator light
Minimum Focal Length (Wide Angle):	8mm (35mm film equivalent of 41mm)
Maximum Focal Length (Telephoto):	24mm (35mm film equivalent of 82mm)
Macro Mode:	Yes
Minimum Focus Distance:	3.1 inches
Exposure Settings:	Selectable multi-pattern measuring or spot meter auto exposure modes Selectable twilight, twilight portrait (slow shutter with flash), and landscape scene modes
Minimum Aperture:	f/3.8
Maximum Aperture:	f/3.8
Minimum Shutter Speed:	1/1000
Maximum Shutter Speed:	2
White Balance:	Auto, daylight, cloudy, fluorescent, incandescent
ISO Equivalencies:	50, 100, 200, 400
Removable Memory Included:	Memory Stick 16MB
Power Source:	2 AA alkaline or NiMH batteries
Flash Characteristics:	3-mode intelligent flash with TTL pre-flash metering, adjustable level, and selectable red-eye reduction

Connections:	USB, Video output with connector cable
Image Formats:	JPEG
Video Capture Format:	MPEG
Video Capture Resolutions:	160×112; 320×240; 320×240 ppi.
Frames per Second:	8-16
Maximum Video Length:	Limited only by capacity of media (90 minutes with 128MB)
Size:	Information not available
Weight:	10.1 ounces with battery, memory stick, and strap
Other Features:	Picture effects: black and white, solarize, sepia, negative Scene modes: twilight, twilight portrait, landscape 10-second self timer Multi-burst mode captures 16 320×240 frames at selectable 1/7.5, 1/15, 1/30 second intervals
Included Software:	Pixela Image Mixer for Sony v1.0
Included Components:	NH-AA-DI rechargeable NiMH batteries BC-CS1 NiMH battery charger Video and USB cables Wrist strap 16MB Memory Stick Media sofware CD-ROM

Fujifilm FinePix 2650 Zoom

Fujifilm uses its proprietary algorithm to boost this camera to what it claims are 2 million effective pixels, producing images with 1600×1200 recorded pixels. It has simple, user-friendly controls and an easy USB computer connection. A sliding lens cover protects the lens during storage. The 2650 features a Fujinon 3× optical/2.5× digital zoom, video recording, and PC-cam Internet mode. Set to automatic, or select manual for greater control over each exposure. **Street price: $137-$249**

Number of CCD Pixels:	2.0 effective megapixels
LCD Screen Size:	1.5 inches
Viewfinder:	Optical
Optical Zoom:	3×
Digital Zoom:	2.5×
Lens Mount:	Fixed Fujinon lens
Focus Features:	Autofocus Normal: 2.6 feet-inf. Macro: 0.3-2.6 feet.
Minimum Focal Length (Wide Angle):	Equivalent to 38mm on a 35mm camera
Maximum Focal Length (Telephoto):	Equivalent to 114mm on a 35mm camera
Macro Mode:	Yes
Minimum Focus Distance:	4 inches
Exposure Settings:	64-zone TTL metering
Minimum Aperture:	f/8.7
Maximum Aperture:	f/3.5
Minimum Shutter Speed:	1/2000
Maximum Shutter Speed:	1/2
White Balance:	Auto, 6 positions selectable in manual mode (fine, shade, daylight fluorescent, warm white fluorescent, cool white fluorescent, incandescent light)
ISO Equivalencies:	100
Removable Memory Included:	xD Picture Card 16MB
Power Source:	2 AA type alkaline/Ni-MH batteries

Flash Characteristics:	5 modes (auto, red-eye reduction, forced flash, suppressed flash, slow syncro)
Connection:	USB
Image Format:	JPEG
Video Capture Format:	AVI
Video Capture Resolutions:	320×240; 160×120 ppi
Frames per Second:	10
Maximum Video Length:	80 seconds
Size:	4.0×2.6×2.0 inches
Weight:	6.5 ounces without batteries
Other Features:	10-second self-timer
Included Software:	FinePixViewer DP Editor Apple QuickTime 5.0 ImageMixer VCD for FinePix
Included Components:	16MB xD picture card 2 AA alkaline batteries Hand strap USB cable

Fujifilm FinePix 2800 Zoom

The FinePix 2800 has been selected as a top camera by both *PC World* and *PC* magazines—with good reason. Although it is only a 2.1 megapixel camera, it has the look, feel, and features of higher-end digicams. The plastic body feels familiar to any photographer used to a full-featured 35mm camera. The retractable Fujinon lens features a 6× zoom and a mini through-the-lens electronic viewfinder. Add in picture voice annotation, and the ability to function as an Internet camera and you've got an all-around winner. **Street price: $253-$380**

Number of CCD Pixels:	2.1 megapixels
LCD Screen Size:	1.8 inches
Viewfinder:	TTL electronic
Optical Zoom:	6×
Digital Zoom:	2.5×
Lens Mount:	Fixed, retractable; supports optional wide and tele extension lenses
Focus Features:	Autofocus
Minimum Focal Length (Wide Angle):	35mm film equivalent of 38mm
Maximum Focal Length (Telephoto):	35mm film equivalent of 228mm
Macro Mode:	Yes
Minimum Focus Distance:	3.9 inches
Exposure Settings:	64-point TTL metering
Minimum Aperture:	f/8.8
Maximum Aperture:	f/2.8
Minimum Shutter Speed:	1 second
Maximum Shutter Speed:	1/1500 second
White Balance:	TTL auto white balance, pre-set white balance (available settings: daylight, cloudy, tungsten, fluorescent, or fluorescent h)
ISO Equivalencies:	100
Removable Memory Included:	CompactFlash 16MB
Power Source:	4 AA alkaline batteries
Flash Characteristics:	Multi-programmed flash with red-eye reduction
Connections:	USB, video out
Image Formats:	JPEG
Video Capture Format:	MPEG, AVI

Video Capture Resolutions:	320×240
Frames per Second:	10-60
Maximum Video Length:	60 seconds
Size:	3.7×3.0×2.8 inches
Weight:	9.5 ounces (excluding batteries)
Other Features:	Voice annotation, video recording, and PC-CamInternet mode Set to automatic for point-and-shoot, or select manual for greater control over each exposure
Included Software:	FinePixViewer DP Editor Apple QuickTime 5.0 VideoImpression Adobe PhotoDeluxe HE 4.0 for Windows Adobe Active Share for Windows
Included Components:	16MB SmartMedia card 4 AA Alkaline batteries Shoulder strap USB cable

Hewlett-Packard Photosmart 620

The HP Photosmart 620 is a great camera if you plan to share a lot of your photos over the Internet. It works with Hewlett-Packard's Instant Share technology, an Internet-based software application for quick and easy sharing of digital photos. From the back of the camera, select up to 14 destinations for any photo. Then, by connecting the camera to a computer, the photos are instantly sent to the selected destinations—e-mail addresses, printers, or for storage at www.hpphoto.com. If a destination is an e-mail address, a low-resolution thumbnail image is sent along with access to the original high-resolution image at www.hpphoto.com, where up to 200MB of photos are stored for up to 60 days. If the destination is a printer, a high-resolution image is automatically sent to it. The 620 can use the optional Photosmart 8881 camera dock, which connects the camera to a computer, TV, or printer while recharging batteries. **Street price: $189-$200**

Number of CCD Pixels:	2.1 megapixels
LCD Screen Size:	1.5 inches
Viewfinder:	Optical
Optical Zoom:	3×
Digital Zoom:	4×
Lens Mount:	Fixed
Focus Features:	Auto-focus
Minimum Focal Length (Wide Angle):	Information not available
Maximum Focal Length (Telephoto):	Information not available
Macro Mode:	No
Minimum Focus Distance:	7.9 inches
Exposure Settings:	Automatic, TTL
Minimum Aperture:	f/8.0
Maximum Aperture:	f/2.8
Minimum Shutter Speed:	1/1000 second
Maximum Shutter Speed:	1/3 second
White Balance:	Automatic
ISO Equivalencies:	100
Removable Memory Included:	8MB nonremovable internal memory; slot for removable Secure Digital memory card
Power Source:	4 AA batteries, photo lithium, alkaline, or NiMH
Flash Characteristics:	Red-eye, fill-in, forced off

Connections:	USB, docking station
Image Formats:	JPEG
Video Capture Format:	MPEG, AVI
Video Capture Resolutions:	340×210 ppi
Frames per Second:	15
Maximum Video Length:	30
Size:	4.7×1.9×2.9 inches
Weight:	7.4 ounces
Other Features:	Compatible with HP Photosmart printers 10-second self-timer Portrait and landscape modes
Included Software:	Memories Disc Creator software requires CD writer and 700 MB additional hard disk space
Included Components:	Information not available

Canon Powershot A200

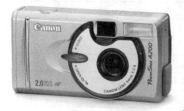 Canon's done a fine job of incorporating some high-end features into a camera that's simple enough to use that amateurs making the transition from point-and-shoot film cameras will feel at home and have room to expand their skills as they become more adventurous. The best feature is the Photo Effect mode pioneered in the more expensive Canon G2. It lets the photographer capture pictures in sepia, black and white, vivid colors, and soft focus. Its f/2.8 fixed aperture and selectable ISO 400 setting makes it a good choice for natural and dim lighting. The only serious feature it lacks is an optical zoom. It has a 4× digital zoom, but that's a poor substitute. **Street price: $148-$199**

Number of CCD Pixels:	2 megapixels
LCD Screen Size:	1.5 inches
Viewfinder:	Optical
Optical Zoom:	None
Digital Zoom:	4×
Lens Mount:	Fixed
Focus Features:	Selectable 3-point or center autofocus
Focal Length:	Single focal length of 5mm (35mm film equivalent of 39mm)
Macro Mode:	Yes
Minimum Focus Distance:	2 inches
Exposure Settings:	Auto exposure adjust the ISO equivalent rating based on the ambient light Exposure compensation of +/- 2.0 EV in 1/3 steps
Minimum Aperture:	f/2.8
Maximum Aperture:	f/2.8
Minimum Shutter Speed:	1/2000 second
Maximum Shutter Speed:	1 second
White Balance:	TTL auto or preset for daylight, cloudy, tungsten, fluorescent, and fluorescent H
ISO Equivalencies:	50, 100, 200, 400
Removable Memory Included:	CompactFlash Type I 8MB

Power Source:	2 AA alkaline or NiMH batteries
Flash Characteristics:	Auto/on/off, auto red-eye reduction auto/on, slow-sync
Connections:	USB
Image Formats:	JPEG
Video Capture Format:	AVI
Maximum Video Capture Resolution:	320×240; 160×120 ppi
Frames per Second:	20
Maximum Video Length:	26 seconds
Size:	4.3×2.3×1.4 inches
Weight:	6.2 ounces
Other Features:	10-second timer, stitch assist
Included Software:	ZoomBrowser EX for Windows ImageBrowser for Mac PhotoStitch for Windows PhotoStitch for Mac RemoteCapture for Windows RemoteCapture for Mac
Included Components:	Wrist strap 2 AA alkaline batteries USB interface cable

Fujifilm FinePix 30i

The camera need not be just a camera. The Fujifilm FinePix 30i is also a voice recorder and an MP3 player. All these features are enclosed in a case so small it invites you to carry it with you at all times. The larger than usual LCD screen is perfect for on-the-spot playback of movies. You can add audio captures to still shots. It also takes pictures. **Street price: $225-$350**

Number of CCD Pixels:	2 megapixels
LCD Screen Size:	1.8 inches
Viewfinder:	Optical
Optical Zoom:	None
Digital Zoom:	2.5×
Lens Mount:	Fixed
Focus Features:	Fixed focus 2 feet to infinity
Focal Length:	Single focal length equivalent to 38mm lens on a 35mm camera
Macro Mode:	Yes
Minimum Focus Distance:	3.1 inches in macro mode
Exposure Settings:	64 zone TTL metering
Minimum Aperture:	f/11
Maximum Aperture:	f/4.8
Minimum Shutter Speed:	1/1000
Maximum Shutter Speed:	1/2
White Balance:	Automatic or manual presents for fine, shade, fluorescent light (daylight), fluorescent light (warm white), fluorescent light (cool white), incandescent light
ISO Equivalencies:	100
Removable Memory Included:	SmartMedia 0MB
Power Source:	2AA Ni-MH rechargeable batteries
Flash Characteristics:	Auto flash, red-eye reduction, forced flash, suppressed flash, slow syncro
Connections:	USB
Image Formats:	JPEG
Video Capture Format:	AVI
Video Capture Resolutions:	320×240 ppi
Frames per Second:	10
Maximum Video Length	20 seconds

Size:	3.3×2.9×1.2 inches
Weight:	5.6 ounces, excluding batteries
Other Features:	MP3 playback at sampling rate of 4.1 kHz Bit rate: 128/112/96kbps Audio recording: Max. approx. 4.5 hours with 128MB SmartMedia card WAV format Voice captioning: Up to 30 seconds, WAV format
Included Software:	Apple QuickTime 5.0 Video Impression RealJukebox 2 Plus for Windows MacMP3 for Macintosh
Included Components:	2 AA-size Ni-MH batteries Ni-MH battery charger Shoulder strap USB cable Headphone with remote controller

Casio EX-M2

Fujifilm's not the only one with a multimedia digicam. Casio's EX-M2 looks amazingly like the Fujifilm FinePix 30i. As a camera, it also suffers from the same fixed focus and fixed aperture found on the 30i. Casio hopes to compensate by offering Best Shot Mode, letting you set the camera for Portrait, which enhances flesh tones; Night Scene, which slows the shutter speed and sets the white balance to daylight; Retro Style, which tints the image sepia for an antique look; Twilight High, which adds a magenta filter for drama; Monochrome, an option that produces enhanced black-and-white images; and Scenery to increase color saturation and hardens edges. The EX-M2 also shoots video with sound, records voice memos, and plays MP3 tracks. All that's lacking is a built-in Game Boy. If you'd like better resolution that the M2's 2 megapixels can deliver, check out Casio's 4 megapixel QV-R4. **Street price: $343-$400**

Number of CCD Pixels:	2 megapixels
LCD Screen Size:	1.8 inches
Viewfinder:	Optical
Optical Zoom:	0×
Digital Zoom:	4×
Lens Mount:	Fixed, integrated with pixel imager
Focus Features:	Fixed focus, 1 yard to infinity
Single Focal Length:	7.5mm, equivalent to 36mm lens on a 35mm film camera.
Macro Mode:	No
Minimum Focus Distance:	39 inches
Exposure Settings:	Programmed multi-node auto-exposure Exposure compensation +/- 2EV in 1/3EV steps
Minimum Aperture:	f/3.2
Maximum Aperture:	f/3.2
Minimum Shutter Speed:	1/6400
Maximum Shutter Speed:	1/4

White Balance:	Auto or four manual presets
ISO Equivalencies:	Not available
Removable Memory Included:	Permanent 12MB internal flash memory; External memory slot accommodates SD memory cards to supplement internal memory
Power Source:	Lithium ion rechargeable battery (NP-20)
Flash Characteristics:	Auto/fill in/off/red-eye reduction
Connections:	USB, cradle for recharging
Image Formats:	JPEG
Video Capture Format:	AVI
Video Capture Resolutions:	320×240 ppi
Frames per Second:	Information not available
Maximum Video Length:	30 seconds
Size:	3.46×2.16×.49 inches
Weight:	3.2 ounces, excluding battery
Other Features:	Voice memo recording in wave format, up to 50 minutes using internal memory MP3 player, with sampling frequencies from 32 to 44.1/48khz, and bit rates from 32 to 320kbps; variable bit rate –compatible 10-second self-timer Date and time recording with photo data
Included Software:	Information not available
Included Components:	Docking station AC adapter for docking station USB cable Strap Lithium ion battery Remote control Stereo headphones

Olympus D-520 Zoom

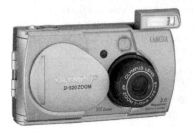

The Olympus D-520 Zoom doesn't have the sexy frills of the 30i and M2. It's a no nonsense, solid camera that puts all its design into providing many features that you'd usually find only on higher-priced cameras. The zoom lens has real, optical zoom, there is a generous range of aperture and shutter speeds to accommodate more situations.

Although the Camedia software boxed with the D-520 isn't the equal of Photoshop Elements, it's one of the few programs bundled with cameras in this price range that actually allows you to organize and retouch your photos. If you're a serious birthday photographer on a budget, check it out. **Street price: $178-$300**

Number of CCD Pixels:	2 megapixels
LCD Screen Size:	1.5 inches
Viewfinder:	Optical
Optical Zoom:	3×
Digital Zoom:	2.5×
Lens Mount:	Fixed aspherical glass
Focus Features:	Autofocus TTL
Minimum Focal Length (Wide Angle):	5mm (35mm film equivalent of 38 mm)
Maximum Focal Length (Telephoto):	15 mm (35mm film equivalent of 114mm)
Macro Mode:	Yes
Minimum Focus Distance:	7.9 inches in macro mode
Exposure Settings:	Programmed auto exposure; multi-node and spot metering
Minimum Aperture:	f/7.5
Maximum Aperture:	f/2.8
Minimum Shutter Speed:	1/1000
Maximum Shutter Speed:	1/2
White Balance:	Multi-pattern auto TTL, or pre-sets for daylight, overcast, tungsten, and fluorescent
ISO Equivalencies:	Auto-selected 60, 80
Removable Memory Included:	SmartMedia 16MB

Power Source:	1 CR-V3 lithium battery pack, or 2 AA NiMH batteries, AA lithium batteries, AA NiCd batteries
Flash Characteristics:	Auto for low light and backlight Red-eye reduction Fill-in (forced on) Night scene Forced off
Connections:	USB, NTSC video out, DC input
Image Formats:	EXIF, JPEG, DCF
Video Capture Format:	QuickTime motion JPEG
Video Capture Resolutions:	320×240, 160×120 ppi
Frames per Second:	15
Maximum Video Length:	Information not available
Size:	4.4×2.4×1.4 inches
Weight:	6.3 ounces without batteries or SmartMedia card
Other Features:	12-second self-time Date and time stamp with photo data Resize, sepia, black-and-white image effects Supports digital print order format (DPOF) for direct-to-printer printing
Included Software:	Camedia Master provides photo management, retouching, including stitching together up to 10 photos to create a panorama and printing
Included Components:	16MB memory card USB cable Video out cable Carrying strap 2 AA alkaline batteries

Nikon Coolpix 2000

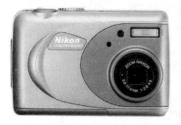

Nikon is, of course, the most prized name among 35mm pros, which makes it a real treat when a Nikon turns up in a category targeted at the everyday schmoo with a budget to keep. The Nikon Coolpix 2000 manages to present good range of lens, exposure, and zoom features found on more expensive cameras, while keeping them user-friendly for someone who wants to point and shoot. The controls are some of best designed on any camera. The compromise is the lack of any video recording, almost as if that's too plebian for Nikon to pander to. The jazzy colored case promises a friendly camera. And the Coolpix delivers. **Street price: $178-$239**

Number of CCD Pixels:	2 megapixels
LCD Screen Size:	1.5 inches
Viewfinder:	Optical
Optical Zoom:	3×
Digital Zoom:	2.5×
Lens Mount:	Fixed, retractable, all-glass Nikkor lens
Focus Features:	Autofocus
Minimum Focal Length (Wide Angle):	5.8mm (equivalent of 38mm on 35mm film camera)
Maximum Focal Length (Telephoto):	17.4mm (equivalent of 114mm on 35mm film camera)
Macro Mode:	No
Minimum Focus Distance:	Information not available
Exposure Settings:	Auto exposure; shooting modes for portrait, party/indoor, night portrait, beach/snow, back light), movie
Minimum Aperture:	Information not available
Maximum Aperture:	Information not available
Minimum Shutter Speed:	Information not available
Maximum Shutter Speed:	Information not available
White Balance:	Auto
ISO Equivalencies:	Information not available
Removable Memory Included:	CompactFlash 16MB
Power Source:	4 AA alkaline batteries

Flash Characteristics:	Auto, red-eye reduction, anytime flash, flash cancel, slow sync
Connections:	USB, video
Image Formats:	JPEG
Video Capture Format:	AVI
Video Capture Resolutions:	Information not available
Frames per Second:	15
Maximum Video Length:	20 seconds
Size:	4.3×2.7×1.5 inches
Weight:	6.7 ounces without batteries or CompactFlash card
Other Features:	Multi-shot (16 frames) Exposure compensation Image sharpening Selectable image size
Included Software:	NikonView 5 ArcSoft PhotoImpression ArcSoft VideoImpression ArcSoft Panorama Maker Arcsoft PhotoBase for PDAs Instruction CD
Included Components:	Strap 16MB Starter Memory Card Video Cable EG-CP10 USB cable 4 AA alkaline batteries

Sony DSC P85 Cyber-shot

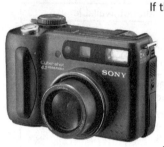

If the name of the game is pixels, the Sony DSC P85 has the right equipment: 4 megapixels to capture images that can easily be blow up to 8×10-inch prints. The 3× optical zoom Carl Zeiss Vario-Sonnar lens delivers crisp images that deserve 4 million pixels. There are tons of automatic features, and the ability to turn them all off and rely on your own experience using a full range of aperture and shutter settings.

Street price: $395-$500

Number of CCD Pixels:	4.1 megapixels
LCD Screen Size:	1.8 inches
Viewfinder:	Optical, true zoom with diopter adjustment
Optical Zoom:	3×
Digital Zoom:	6×
Lens Mount:	Fixed; 52mm lens adapter optional
Focus Features:	Autofocus; contrast detect with illuminator light
Minimum Focal Length (Wide Angle):	7mm (equivalent of 34mm on 35mm film camera)
Maximum Focal Length (Telephoto):	21mm (equivalent of 102mm on 35mm film camera)
Macro Mode:	Yes
Minimum Focus Distance:	1.6 inches in macro mode
Exposure Settings:	Center-weighted averaging or spot Aperture and shutter priority programs Exposure bracketing with +/-0.3, 0.7, or 1.0EV steps Exposure compensation: +/- 2.0EV in 1/3EV increments
Minimum Aperture:	f/8.0
Maximum Aperture:	f/2.0
Minimum Shutter Speed:	1/1000
Maximum Shutter Speed:	8 seconds

White Balance:	Auto, outdoor, indoor, one-push custom
ISO Equivalencies:	100, 200, 400
Removable Memory Included:	Memory Stick 16MB
Power Source:	InfoLithium NP-FM50 7.2v
Flash Characteristics:	Adjustable levels; selectable red-eye reduction; cold shoe and terminal for optional detachable flash
Connections:	USB, video
Image Formats:	JPEG, TIFF
Video Capture Format:	MPEG, animated GIF
Video Capture Resolutions:	80×72; 160×112; 160×120; 320×240, 160×112, and 320×240 ppi
Frames per Second:	16
Maximum Video Length:	Limited by capacity of recording medium
Size:	4-5/8×2-7/8×2-5/8 inches
Weight:	15 ounces without battery
Other Features:	Exposure bracketing with +/-0.3, 0.7, or 1.0EV steps Exposure compensation: +/-2.0EV in 1/3EV increments In-camera sharpening: +/- 2 in 1 step increments Playback zoom: 1.1 to 5× in 17 steps Playback index: 9 frames Video trimming and resizing MPEG 6× cue and review
Included Software:	MGI PhotoSuite 8.1 MGI PhotoSuite SE 1.1
Included Components:	InfoLithium M battery AC-L10 AC adaptor/in-camera charger A/V output cable USB cable Shoulder strap Lens cap with strap 16MB Memory Stick

Canon PowerShot G2

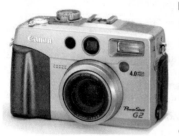

Not all the advantages of the Canon PowerShot G2 are visible. The 4 megapixel imager is supplemented by improved filters and algorithms that process the light signals to filter out the noise that clutters digital photos. It packs a lithium ion batter that can record 400 images with the LCD display turned on, or 1,000 with the display turned off, or replay 300 minutes of recorded images. It will shoot up to 2.5 frames a second. An onscreen histogram mode shows how well colors are captured by the G2 and lets you correct them. **Street price: $460-$700**

Number of CCD Pixels:	4 megapixels
LCD Screen Size:	1.8 inches
Viewfinder:	Optical
Optical Zoom:	3×
Digital Zoom:	3.6×
Lens:	Fixed; optional lens converters increase telephoto, wide-angle, and close-up capabilities
Focus Features:	TTL autofocus; center or three switchable focus points; focus lock and manual focus are available
Minimum Focal Length (Wide Angle):	7mm (equivalent of 34mm on 35mm film camera)
Maximum Focal Length (Telephoto):	21mm (equivalent of 102mm on 35mm film camera)
Macro Mode:	Yes
Minimum Focus Distance:	Normal: 2.3 feet; macro: 2.4 inches
Exposure Settings:	Program AE, shutter-priority AE, aperture-priority AE, or manual exposure control AE lock Exposure compensation: +- 2.0EV (in 1/3-stop increments) Auto exposure bracketing
Minimum Aperture:	f/2.5
Maximum Aperture:	f/2.0
Minimum Shutter Speed:	1/1000 second
Maximum Shutter Speed:	15 seconds
White Balance:	TTL auto white balance, pre-set white balance (available settings: daylight, cloudy, tungsten, fluorescent, fluorescent×, or flash), or custom white balance
ISO Equivalencies:	50, 100, 200, 400

Removable Memory Included:	CompactFlash 32MB
Power Source:	Rechargeable lithium-ion battery type BP-511 (included) or BP-512 (optional)
Flash Characteristics:	Auto; red-eye reduction; sync-terminal at accessory shoe for external flash; flash exposure compensation +/- 2.0EV in 1/3-stop increments
Connections:	USB, video/audio
Image Formats:	JPEG (superfine, fine, and normal compression); RAW
Video Capture Format:	AVI
Video Capture Resolutions:	320×240; 160×120 ppi
Frames per Second:	15
Maximum Video Length:	120 seconds
Size:	4.8×3.0×2.5 inches
Weight:	15 ounces, camera body only
Other Features:	10-second self-timer Magnified view (approx. 3× or 6×) on build-in LCD monitor) Slide show or image output to direct printer (CP-10) Remote control
Included Software:	Canon ZoomBrowser EX (for Windows) Canon ImageBrowser (for Mac OS) Canon PhotoStitch (for Windows) Canon PhotoStitch (for Mac OS) Canon RemoteCapture (for Windows) Canon RemoteCapture (for Mac OS) Raw Image Converter (for Windows) Raw Image Converter (for Mac OS) Adobe Photoshop LE (for Windows) Adobe Photoshop LE (for Mac OS)
Included Components:	Lens cap Neck strap NS-DC300 Compact power adapter CA-560 with AC cable Battery Pack BP-511 Terminal cover (for battery pack BP-511) CompactFlashTM Card FC-32MB Case for CompactFlashTM card AV Cable AVC-DC100 USB interface cable IFC-200PCU Wireless controller WL-DC100 with battery

Olympus C-4000 Zoom

It's easy to see why the Olympus C-4000 Zoom was ranked as the number one best buy for digital cameras under $500 by *PC World* magazine. Its 4 megapixel imager is combined with quality optics and automatic controls (which can be set for manual operation) so that you can take any type of shot you can conceive of with a digital camera. It's all in a package that's light and compact but still has the feel of a "real" upscale film camera. All of this is at a street price you'd expect for a birthday-shooter camera. **Street price: $325-$465**

Number of CCD Pixels:	4 megapixels
LCD Screen Size:	1.8 inches
Viewfinder:	Optical real-image with autofocus and backlight marks
Optical Zoom:	3×
Digital Zoom:	3.3×
Lens:	Aspherical glass; fixed mount; accepts lens converters for enhanced telephoto or wide-angle
Focus Features:	Autofocus, TTL contrast detection; manual focus; selectable AF point moveable by jog dial
Minimum Focal Length (Wide Angle):	6.5mm (equivalent of 32mm on 35mm film camera)
Maximum Focal Length (Telephoto):	19.5mm (equivalent of 96mm on 35mm film camera)
Macro Mode:	Yes, focus from 8 to 31 inches
Minimum Focus Distance:	8 inches
Exposure Settings:	Programmed autoexposure; multi-pattern meter, spot meter, multi-spot averaged (up to 8 separate points), histogram display available in shooting mode
Minimum Aperture:	f/10
Maximum Aperture:	f/2.8
Minimum Shutter Speed:	1/1000 second
Maximum Shutter Speed:	16 seconds
White Balance:	Multi-pattern auto TTL; pre-set manual settings (daylight, overcast, tungsten, fluorescent, and custom)
ISO Equivalencies:	100, 200, 400

Removable Memory Included:	SmartMedia 16MB
Power Source:	2 CR-V3, or 5 AA Ni-M× rechargeable, alkaline, lithium, or NiCd rechargeable batteries
Flash Characteristics:	Auto flash for low and backlight; red-eye reduction; fill-in flash; slow shutter synchronized; flash off
Connections:	USB, video out
Image Formats:	EXIF JPEG, DCF, TIFF
Video Capture Format:	QuickTime Motion JPEG
Video Capture Resolutions:	320×240, 160×120 ppi
Frames per Second:	15
Maximum Video Length:	Information not available
Size:	4.3×3.0×2.8 inches
Weight:	10.5 ounces
Other Features:	Noise reduction 12-second self-timer Image playback: index display; up to 4× enlargement; slide-show; scene rotation; histogram display Date/time stamping Panorama: up to 10 frames stitchable with supplied software Image effects: sepia, black and white, white board, black board Resize: portable file size for e-mail or the Web; crop Digital print order format Adjustable resolutions from 2288×1712 to 640×480 ppi
Included Software:	Camedia Master 4.0× for Windows and Mac
Included Components:	16MB SmartMedia card USB cable Video cable 2 CR-V3 lithium battery packs Carrying strap Lens cap with retainer cord

Nikon Coolpix 4500

Even if you haven't been paying all that much attention to digital cameras, you must have noticed Nikon's swiveling Coolpix digicams. Take one in hand and give it a twist, and half of it swivels to turn it into a half-vertical, half-horizontal camera. There may be a few instances in which the swivel ability would be handy, but mostly it's a gimmick meant to prove that respectable old Nikon can get down with spunky upstarts. That said, it must be added that the Nikon Coolpix 4500 is a good no nonsense camera even with the swiveling nonsense. It has 4 megapixels, and the focus, metering, and exposure controls are designed to respond swiftly and precisely. It has other touches such as the ability to use up to five flash units that you'd expect to find only in the professional class. And it's a good conversation starter everytime you swivel it around. **Street price: $440-$650**

Number of CCD pixels:	4 megapixels
LCD Screen Size:	1.8 inches
Viewfinder:	Optical zoom with diopter adjustment
Optical Zoom:	4×
Digital Zoom:	4×
Lens Mount:	Fixed 10-element glass Zoom-Nikkor, accepts all optional Coolpix lenses and accessories including the 8mm fisheye, wide angle, 2× and 3× telephoto converters, and macro converter
Focus Features:	Contrast-detect TTL 7,900-step autofocus with: 5 focus areas or spot focusing selectable 50 position manual focus
Minimum Focal Length (Wide Angle):	7.85mm (equivalent of 38mm on 35mm film camera)
Maximum Focal Length (Telephoto):	32mm (equivalent of 155mm on 35mm film camera)
Macro Mode:	Yes
Minimum Focus Distance:	11.8 inches normal lens; 3/4 inchs macro mode
Exposure Settings:	4 mode TTL metering: 256-segment matrix; center-weighted; spot; AF spot Programmed autoexposure for shutter-priority, aperture-priority, and manual.
Minimum Aperture:	f/5.1
Maximum Aperture:	f/2.6
Minimum Shutter Speed:	1/2300 second
Maximum Shutter Speed:	8 seconds

White Balance:	Matrix auto white balance with TTL control, 5-mode manual for daylight, incandescent, flourescent, cloudy, flash, white balance bracketing
ISO Equivalencies:	100, 200, 400, 800
Removable Memory Included:	CompactFlash amount not determined; compatible with CompactFlash Type I and Type II and IBM Microdrive hard drive
Power Source:	One rechargeable Li-ion EN-EL1
Flash Characteristics:	Auto pop-up; slow sync, red-eye reduction with pre-flash, flash cancel; multi-flash sync terminal connects to external Nikon flash units
Connections:	USB
Image Formats:	RGB EXIF 2.2 file (uncompressed TIFF or compressed JPEG) Design rule for camera file system (DCF)
Video Capture Format:	QuickTime Motion JPEG (movie with audio)
Video Capture Resolutions:	640×420, 320×210 ppi
Frames per Second:	15; 35
Maximum Video Length:	35 at 15 fps
Size:	5.1×2.9×2.0 inches
Weight:	12.7 ounces
Other Features:	16 presets for photos including portraits, fireworks, close-ups, multiple exposure, panorama assist, and dawn/dusk 3-second and 10-second self-timers
Included Software:	ArcSoft Software Suite Photo Impression Video Impression Panorama Maker PhotoBase for PDAs
Included Components:	Lens cap Neck strap Audio video cable Nikon Coolpix starter memory card USB cable Rechargeable Li-ion Battery EN-EL1 Battery charger NikonView 5 (COOLPIX) CD-ROM

Canon PowerShot S45

The Canon PowerShot S45 looks like a simple point-and-shoot camera. It's a disguise. The pocket-sized camera hides a host of features you'd expect on bigger cameras. Things like 4 megapixels of imaging, a 3× optical zoom, multipoint focusing and exposure, and the ability to print directly to Canon photo and bubblejet printers. Sweet. **Street price: $427-$523**

Number of CCD pixels:	4 megapixels
LCD Screen Size:	1.8 inches
Viewfinder:	Zooming optical
Optical Zoom:	3×
Digital Zoom:	3.6×
Lens:	Fixed, retractable
Focus Features:	User can choose any of 9 points for autofocus Offers AF lock and manual focus
Minimum Focal Length (Wide Angle):	7.1mm (equivalent of 35mm on 35mm film camera)
Maximum Focal Length (Telephoto):	21.3mm (equivalent of 105mm on 35mm film camera)
Macro Mode:	Yes
Minimum Focus Distance:	1.6 feet normal mode; 4 inches macro mode
Exposure Settings:	Evaluative metering, center-weighted average metering or spot metering Programmed exposure for shutter priority, aperture priority, manual; AE lock is available Exposure compensation: +/- 2.0EV in 1/3-step increments Auto-exposure bracketing
Minimum Aperture:	f/4.9
Maximum Aperture:	f/2.8
Minimum Shutter Speed:	1/1500 second
Maximum Shutter Speed:	15 seconds
White Balance:	TTL auto white balance, pre-set white balance for daylight, cloudy, tungsten, fluorescent (fluorescent h or flash), and two custom white balance settings
ISO Equivalencies:	50, 100, 200, 400
Removable Memory Included:	CompactFlash, 32MB

Power Source:	Rechargeable lithium-ion battery (type: NB-2L)
Flash Characteristics:	Auto on/off, red-eye reduction
Connections:	USB, video
Image Formats:	JPEG, RAW
Video Capture Format:	MPEG, AVI
Video Capture Resolutions:	320×240; 160×120 ppi
Frames per Second:	Information not available
Maximum Video Length:	30 seconds
Size:	4.4×2.3×1.7 inches
Weight:	9.2 ounces
Other Features:	10-second self-timer Shooting modes: portrait, landscape, night scene, fast shutter, slow shutter, stitch assist, and movie Effects: vivid color, neutral color, low sharpening, sepia, black and white, and custom Wireless remote control
Included Software:	Digital Camera Solution CD-ROM ArcSoft Camera Suite CD-ROM
Included Components:	Wrist strap WS-300 AV cable AVC-DC100 Interface cable IFC-300PCU Lithium battery pack NB-2L Battery charger CB-2LT CompactFlash Card FC-32M

Sony DSC P9

The Sony DSC P9 is deceptive. It looks at first glance like a far less interesting point-and-shoot camera. Look closer, and you'll see the compact camera features a whopping 4.0 megapixel resolution, 3× optical zoom, and advanced autofocus and multi-pattern light metering found on bigger Sony digicams. It may weight in at only 7.5 ounces, but its capabilities are gargantuan. **Street price: $405-$597**

Number of CCD pixels:	4 megapixels
LCD Screen Size:	1.5 inches
Viewfinder:	Optical zoom
Optical Zoom:	3×
Digital Zoom:	2×
Lens:	Fixed, retractable
Focus Features:	3-area multi-point autofocus, 5-step manual presets; AF illuminator light
Minimum Focal Length (Wide Angle):	8mm (equivalent of 39mm on 35mm film camera)
Maximum Focal Length (Telephoto):	24mm (equivalent of 117mm on 35mm film camera)
Macro Mode:	Yes
Minimum Focus Distance:	Information not available
Exposure Settings:	Multi-pattern measuring evaluates 49 areas of the image Auto bright monitoring
Minimum Aperture:	f/5.6
Maximum Aperture:	f/2.8
Minimum Shutter Speed:	1/2000 second
Maximum Shutter Speed:	2 seconds
White Balance:	Auto, daylight, cloudy, fluorescent, incandescent
ISO Equivalencies:	Auto, 100, 200, 400
Removable Memory Included:	Memory Stick 16MB
Power Source:	NP-FC10 InfoLithium rechargeable battery

Flash Characteristics:	3-mode pop-up flash w/TTL pre-flash metering, red-eye reduction
Connections:	USB, audio/video
Image Formats:	JPEG, TIFF
Video Capture Format:	MPEG
Video Capture Resolutions:	160×112, 320×240, 320×240
Frames per Second:	16 fps
Maximum Video Length:	Information not available
Size:	4.4×2.1×1.7 inches
Weight:	7.5 ounces
Other Features:	10-second self-timer Scene modes: twilight, twilight portrait, landscape
Included Software:	Pixela ImageMixer for Sony v1.0
Included Components:	NP-FC10 InfoLithium rechargeable battery AC-LS1 AC adapter with in-camera charger A/V and USB cables Lens cap with strap 16MB Memory Stick

Hewlett-Packard Photosmart 720

You can get extraordinary snapshots and enlargements up to 11×14 inches with this unpretentious little camera from Hewlett-Packard. Add audio to every photo and video clip. Use HP Instant Share to select where photos will go—with up to 14 destinations including e-mail addresses, printers, and more. **Street price: $270-$329**

Number of CCD pixels:	3.3 megapixels
LCD Screen Size:	1.6 inches
Viewfinder:	Optical
Optical Zoom:	3×
Digital Zoom:	4×
Lens Mount:	Fixed
Focus Features:	Autofocus
Minimum Focal Length (Wide Angle):	Information not available
Maximum Focal Length (Telephoto):	Information not available
Macro Mode:	No
Minimum Focus Distance:	8 inches
Exposure Settings:	Autoexposure
Minimum Aperture:	f/8.0
Maximum Aperture:	f/2.6
Minimum Shutter Speed:	1/1000 second
Maximum Shutter Speed:	2 seconds
White Balance:	Automatic, manual control with setting for daylight, cloudy, tungsten, fluorescent 1, and fluorescent 2
ISO Equivalencies:	100, 200, 400
Removable Memory Included:	16MB nonremovable internal memory and removable secure digital (SD) memory
Power Source:	4 AA batteries, any type
Flash Characteristics:	Automatic, red-eye, fill-in, forced off
Connections:	USB, audio/video, docking station
Image Formats:	JPEG
Video Capture Format:	AVI with audio
Video Capture Resolutions:	160×120 ppi
Frames per Second:	Information not available

Maximum Video Length:	60 seconds
Size:	4.7×2.9×2.1 inches
Weight:	9.4 ounces
Other Features:	10-second self-timer Burst shooting mode Direct printing capability compatible with HP Photosmart printers, HP PSC 950 all-in-one, and USB enabled deskJet printers
Included Software:	HP Photo and Imaging Software for Microsoft Windows and Macintosh HP Share-to-Web software HP Memories Disc Creator
Included Components:	4 AA batteries USB cable USB host cable to printer

Casio QV-R4

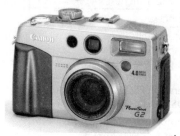

The Casio QV-R4 combines a compact and sleek stainless steel design with impressive power to take some great pictures. It has lightning-fast 1/100 of a second response so the picture never escapes while you're waiting for a response. There are digital cameras with more features that pros would insist on, but this is small enough and light enough to take anywhere, and fast and automatic enough to always capture the picture you want. **Street price: $480-$600**

Number of CCD pixels:	4.13 megapixels
LCD Screen Size:	1.6 inches
Viewfinder:	Optical
Optical Zoom:	3×
Digital Zoom:	3.2×
Lens Mount:	Fixed, retractable, aspherical, seven-element lens
Focus Features:	Autofocus using contrast method; manual focus; infinity mode
Minimum Focal Length (Wide Angle):	7.6mm (equivalent of 37mm on 35mm film camera)
Maximum Focal Length (Telephoto):	22.8mm (equivalent of 111mm on 35mm film camera)
Macro Mode:	Yes
Minimum Focus Distance:	15.7 inches normal mode; 5.5 inches macro mode
Exposure Settings:	Autoexposure with multi-point, center weighed, or spot metering Exposure compensation: -2.0EV to + 2.0EV in 1/3EV steps
Minimum Aperture:	f/5.0
Maximum Aperture:	f/2.6
Minimum Shutter Speed:	1/2000 second
Maximum Shutter Speed:	2 seconds
White Balance:	Auto balance, 4 fixed modes
ISO Equivalencies:	Information not available
Removable Memory Included:	11MB of internal, non-removable memory; also accepts SD memory cards

Power Source:	Rechargeable lithium ion battery
Flash Characteristics:	Autoflash, fill in, off, red-eye reduction
Connections:	USB
Image Formats:	JPEG
Video Capture Format:	MPEG, AVI
Video Capture Resolutions:	320×240 ppi
Frames per Second:	Information not available
Maximum Video Length:	30 seconds
Size:	3.5×2.3×1.2 inches
Weight:	7 ounces
Other Features:	Self timer takes three photos Still modes: movie, "best shot," continuous, interval, night scene Coupling shot: divides frame in half, and allows each half to be shot separately; frames are then combined into a single picture Pre-shot: sllows user to shoot a background and then photograph an object or person to be superimposed over the background Camera generates HTML files for view on LCD screen, uploading to Internet, or printing album pages
Included Software:	Information not available
Included Components:	Camera strap Rechargeable lithium ion battery Recharger USB cable

Olympus C-720 Ultra Zoom

Few cameras, including models a lot more expensive than the Olympus C-720 Ultra Zoom, can boast about an 8× optical zoom such as the C-720 has. It combines with 3 megapixels of imaging, four easily selectable exposure modes, and advanced color management to give you exactly the shot you want using a small, handy camera. **Street price: $315-$500**

Number of CCD pixels:	3 megapixels
LCD Screen Size:	1.5 inches
Viewfinder:	Eye-level electronic (similar to LCD screen)
Optical Zoom:	8×
Digital Zoom:	3×
Lens:	Aspherical glass; fixed; retractable
Focus Features:	Autofocus TTL contrast detection
Minimum Focal Length (Wide Angle):	6.4mm (equivalent of 40mm on 35mm film camera)
Maximum Focal Length (Telephoto):	51.2mm (equivalent of 320mm on 35mm film camera)
Macro Mode:	Yes
Minimum Focus Distance:	23.6 inches normal mode; 3.93 inches macro mode
Exposure Settings:	Auto exposure using multiple area or spot metering Exposure compensation +/- 2EV adjustable in 1/3 steps; auto bracketing; exposure lock
Minimum Aperture:	f/7.1
Maximum Aperture:	f/2.8
Minimum Shutter Speed:	1/1000 second
Maximum Shutter Speed:	8 seconds
White Balance:	Auto TTL; manual presets for daylight, overcast, tungsten, and fluorescent
ISO Equivalencies:	100, 200, 400
Removable Memory Included:	SmartMedia card 16MB
Power Source:	2 CR-V3 lithium batteries, or 4 AA alkaline, Ni-MH, lithium or NiCd rechargeable batteries Optional AC power adapter AA alkaline batteries

Flash Characteristics:	Auto flash, red-eye reduction, fill-in, slow shutter synchronization, flash off
Connections:	USB,video
Image Formats:	JPEG, TIFF, DCF, digital print order format
Video Capture Format:	QuickTime Motion JPEG
Video Capture Resolutions:	320×240, 160×120 ppi
Frames per Second:	15
Maximum Video Length:	Information not available
Size:	4.23×3×3.05 inches
Weight:	11.1 ounces
Other Features:	12-second self-timer Noise reduction DPOF (digital print order format) LCD playback: index display, up to 3× enlargement, slide-show, scene rotation Movie playback: normal, reverse, frame-by-frame Date/time record Image effects: black and white, sepia, resize to portable file size for e-mail or the Web, sharpness, contrast Scene program (landscape-portrait, sports, portrait)
Included Software:	CAMEDIA Master Software 4.0
Included Components:	Auto-connect USB cable NTSC video cable Carrying strap Lens cap and retainer cord 2 CR-V3 lithium batteries 16MB SmartMedia card

Fujifilm FinePix F402

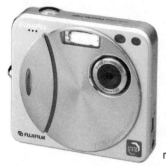

If you're easily boggled by the latest technology, put on a seat belt before playing with a Fujifilm FinePix F402. The light, slim, shirt pocket-size camera is packed with some of the most gee-whiz technology to hit digicams. The CCD imager has only 2 megapixels but uses Fujifilm's 3rd Generatiuon Super CCD Technology to create a larger capture area and create a resolution equal to that from an ordinary 4 megapixel camera. It saves images to an xD-Picture Card, about the size of a penny, but available now in sizes up to 128MB and theoretically capable of holding 8 gigabytes. The xD is also super fast, allowing you to unleash a torrent of picture taking. If the F402 doesn't boggle you, you're unbogglable. **Street price: $260-$303**

Number of CCD pixels:	2.11 megapixels (4 megapixel resolution)
LCD Screen Size:	1.5 inches
Viewfinder:	Real-image optical
Optical Zoom:	0×
Digital Zoom:	3.6×
Lens:	Fixed
Focus Features:	TTL autofocus contrast type Single focal length equivalent of 39mm wide angle on 35mm film camera
Minimum Focal Length (Wide Angle):	Does not apply
Maximum Focal Length (Telephoto):	Does not apply
Macro Mode:	Yes
Minimum Focus Distance:	1.6 feet normal mode; 0.2 feet macro mode
Exposure Settings:	Autoexposure; 64-zone TTL metering
Minimum Aperture:	f/8
Maximum Aperture:	f/3.2
Minimum Shutter Speed:	1/2000 second
Maximum Shutter Speed:	1/2 second

White Balance:	Automatic, plus manual presets for shade, fluorescent (daylight), fluorescent (warm white), fluorescent (cool white, incandescent
ISO Equivalencies:	200, 400, 800, 1,600
Removable Memory Included:	xD-Picture Card 16MB
Power Source:	NP 40 battery or AC-5V adapter
Flash Characteristics:	Autoflash, red-eye reduction, forced flash, suppressed flash, slow synch
Connections:	USB
Image Formats:	JPEG
Video Capture Format:	AVI
Video Capture Resolutions:	320×240; 160×120 ppi
Frames per Second:	10
Maximum Video Length:	240 seconds at 160×120
Size:	3×2.7×0.9 inches
Weight:	4.4 ounces, excluding battery
Other Features:	10-second self-timer LCD single-frame playback with 14.4 zoom; 9 multi-frame
Included Software:	FinePix Viewer DP Editor Apple QuickTime 5.0 ImageMixer VCD for FinePix
Included Components:	16MC xD-Picture Card Li-ion batter NP 40 Hand strap USB cable AC power adapter/battery charger

Canon EOS 1Ds

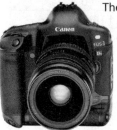

The EOS-1Ds is Canon's newest professional SLR. It's the first Canon digital SLR with a sensor which captures a full 35 mm frame, using a CMOS sensor like that found in the EOS-D30 and D60. This 11 mega-pixel camera packs a big punch. It also packs a big pricetag.
Street price: $7,050-$7,999

Number of CMOS pixels:	11.1 megapixels
LCD Screen Size:	2 inches
Viewfinder:	TTL
Optical Zoom:	Lenses sold separately
Digital Zoom:	Lenses sold separately
Lens Mount:	Camera body only; Canon EOS EF Mount
Focus Features:	CMOS sensor
Minimum Focal Length (Wide Angle):	Lenses sold separately
Maximum Focal Length (Telephoto):	Lenses sold separately
Macro Mode:	Lenses sold separately
Minimum Focus Distance:	Lenses sold separately
Exposure Settings:	Exposure bracketing with -3EV to +3 EV in 1/3 EV or 1/2 EV Steps
Minimum Aperture:	Lenses sold separately
Maximum Aperture:	Lenses sold separately
Minimum Shutter Speed:	1/8000 seconds
Maximum Shutter Speed:	30 sec + Bulb
White Balance:	8 positions, manual preset, 3 memories
ISO Equivalencies:	100-1250 50 with Custom Function 3-1
Removable Memory Included:	None
Power Source:	NI-MH battery pack
Flash Characteristics:	Hot shoe and sync; no built-in flash

Connections:	Firewire
Image Formats:	JPEG, RAW
Video Capture Format:	Continuous drive for JPEG stills
Video Capture Resolutions:	Information not available
Frames per Second:	3 fps in continuous drive
Maximum Video Length:	10 JPEG or RAW
Size:	6.1×6.2×3.2 inches
Weight:	55.9 ounces
Other Features:	Camera body only 21 Custom functions and 26 Personal functions 6 metering options Enlargement mode on LCD Can shoot in RAW and JPEG simultaneously Can use RemoteCapture to record images directly to computer remotely
Included Software:	EOS Digital Solutions Photoshop LE
Included Components:	Ni-MH Pack and charger Interface cable DC coupler kit Strap and hand strap

Olympus Camedia E-20n

The 5 megapixel resolution and super-fast shutter speed make the Olympus Camedia E-20 a top performer, especially in its price range. Olympus uses TruePic technology for superior color even at lower resolutions. It was chosen by *PC World*, *PC* magazine, ZD-Net, Digital Focus, and the Technical Image Press Association as one of the top digital cameras. **Street price: $890-$1,699**

Number of CCD pixels:	4.92 megapixels
LCD Screen Size:	1.8 inches
Viewfinder:	SLR optical viewfinder Full information displays for mode, aperture, shutter speed, spot metering, center-weighted metering, flash Viewfinder shows focus
Optical Zoom:	4x
Digital Zoom:	No
Lens:	Aspherical multi-coated ED glass Fixed; 62 mm lens thread for extension lenses
Focus Features:	Dual infrared and passive TTL system autofocus (contrast detection system) Manual focus using lens ring
Minimum Focal Length (Wide Angle):	9mm (equivalent of 36mm on 35mm film camera)
Maximum Focal Length (Telephoto):	36mm (equivalent of 140mm on 35mm film camera)
Macro Mode:	Yes
Minimum Focus Distance:	24 inches normal mode; 8 inches macro mode
Exposure Settings:	Multi-Pattern metering system Center-weighted metering Spot metering Programmed auto exposure, aperture priority, shutter priority, manual image adjustment modes Contrast: low, normal, high (user selectable in menus) Sharpness: soft, normal, hard Exposure bracketing with -3EV to +3EV in 1/3 EV Increments
Minimum Aperture:	f/11
Maximum Aperture:	f/2.0

Minimum Shutter Speed:	1/18000 second
Maximum Shutter Speed:	60 seconds + Bulb
White Balance:	Auto white balance; 7 presets from 3000K to 7500K plus manual one-touch
ISO Equivalencies:	Auto or selectable 80, 160, 320
Removable Memory Included:	SmartMedia 16 MB included; it has dual card slots for SmartMedia, CompactFlash Type I and II; and IBM Microdrive hard drive
Power Source:	2 lithium battery CR-V3, or 4 Ni-MH, Ni-Cd, or alkaline batteries (alkaline for emergency only) Optional LBS30 or LBS32 LiPo battery with grip kit
Flash Characteristics:	Auto-flash, red-eye reduction; fill-in, slow synchronization (first-curtain synchronization), second-curtain synchronization, forced on, or external (with Olympus synch)
Connections:	USB, video output
Image Formats:	JPEG, RAW, TIFF, EXIF, (DCF: "Design rule for Camera File system"), DPOF (direct to printer)
Video Capture Format:	No true video capture
Video Capture Resolutions:	No true video capture
Frames per Second:	2.5 fps burst mode (no true video capture)
Maximum Video Length:	4 images
Size:	5.1x6.3x4.1 inches
Weight:	37 ounces without batteries
Other Features:	LCD displays one to nine frames, slideshow, histogram Wide-angle and telephone lens converters option to enhance zoom characteristics Date and time stamping
Included Software:	Adobe Photoshop Elements Camedia Master 4.0
Included Components:	32mb SmartMedia Card Ni-MH battery pack and charger Wireless remote USB cable Video cable

Nikon D100

The Nikon D100 is intended as a direct competitor to the Canon EOS D60, and it definitely makes for a difficult choice. The 6.1 megapixels will certainly get the job done. The camera's ergonomics make it comfortable in the hand and easy to control, with features aplenty. **Street price: $1,539-$1,945**

Number of CCD pixels:	6.1 megapixels
LCD Screen Size:	1.8 inches
Viewfinder:	TTL, built-in diopter adjustment
Optical Zoom:	Lenses sold separately
Digital Zoom:	Lenses sold separately
Lens Mount:	Camera body only, Nikon F Mount
Focus Features:	CCD Sensor, AutoFocus
Minimum Focal Length (Wide Angle):	Lenses sold separately
Maximum Focal Length (Telephoto):	Lenses sold separately
Macro Mode:	Lenses sold separately
Minimum Focus Distance:	Lenses sold separately
Exposure Settings:	Center-weighted, spot metering Exposure bracketing with 1/3, 1/2, 2/3 or 1 step Exposure compensation +/- 5 EV in 0.3 or 0.5 EV steps
Minimum Aperture:	Lenses sold separately
Maximum Aperture:	Lenses sold separately
Minimum Shutter Speed:	30 seconds
Maximum Shutter Speed:	1/4000 second
White Balance:	Auto, 6 manual settings, preset
ISO Equivalencies:	200-1600
Removable Memory Included:	CompactFlash
Power Source:	Li-ion batteries
Flash Characteristics:	Built-in pop-up flash or hot shoe Front curtain, rear curtain, red-eye, slow, red-eye slow
Connections:	USB
Image Formats:	JPEG, TIFF, RAW
Video Capture Format:	None
Video Capture Resolutions:	None
Frames per Second:	3 fps continuous drive

Maximum Video Length:	None
Size:	5.7×4.6×3.2 inches
Weight:	24.7 ounces without battery
Other Features:	Camera body only Voice memo Self timer
Included Software:	Nikon View 5.1
Included Components:	Information not available

Fujifilm FinePix S602 Zoom

The FinePix S602 Zoom owes its 6 pixels to a 3rd generation Super CCD sensor with advanced signal processing. This means better color reproduction and high sensitivity, resulting in high resolution images. **Street price: $749**

Number of CCD pixels:	6 megapixels
LCD Screen Size:	1.8 inches
Viewfinder:	TTL
Optical Zoom:	6x
Digital Zoom:	4.4x
Lens Mount:	Fixed
Focus Features:	AutoFocus, AF area focus, manual
Minimum Focal Length (Wide Angle):	Equivalent of 35mm on 35mm film camera
Maximum Focal Length (Telephoto):	Equivalent of 210mm on 35mm film camera
Macro Mode:	Yes
Minimum Focus Distance:	1.6 feet in normal mode; 4 inches in super-macro mode
Exposure Settings:	Multi, spot, averaging +/- 2.0 EV in 1/3EV steps
Minimum Aperture:	f/11
Maximum Aperture:	f/2.8
Minimum Shutter Speed:	15 seconds
Maximum Shutter Speed:	1/2000 second
White Balance:	AutoFlash, 7 positions, and manual
ISO Equivalencies:	160, 200, 400, 800, 1600
Removable Memory Included:	SmartMedia 16 mb
Power Source:	4 AA alkaline batteries
Flash Characteristics:	Hot shoe
Connections:	USB
Image Formats:	JPEG, TIFF
Video Capture Format:	AVI

Video Capture Resolutions:	Information not available
Frames per Second:	30 fps
Maximum Video Length:	Information not available
Size:	4.8×3.2×3.8 inches
Weight:	17.6 ounces
Other Features:	5 frame continuous shooting Audio recording and voice capturing CompactFlash or SmartMedia
Included Software:	FinePix Viewer DP Editor Apple QuickTime 5 VideoImpression Adobe PhotoDeluxe HE 4.0
Included Components:	16mb SmartMedia card USB cable Video cable Shoulder strap Lens cap holder

Sony Cyber-shot DSC-F717

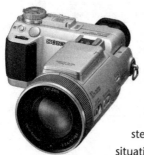

Combining point-and-shoot convenience with a host of manual photographic controls, this camera is sure to inspire digital photographers to expand creativity and get better results. Armed with high-quality Carl Zeiss optics, ISO sensitivities of 100/200/400/800, and shutter speeds of up to 1/2000 second in auto mode, the DSC-F717 produces stellar results, even in the most demanding of shooting situations. **Street price: $699-$999**

Number of CCD Pixels:	5.24
LCD Screen Size:	1.8 inches
Viewfinder:	TTL
Optical Zoom:	5x
Digital Zoom:	2x
Lens Mount:	Fixed
Focus Features:	5 area multi-point AutoFocus Hologram low light laser assist focus ring
Minimum Focal Length (Wide Angle):	38mm
Maximum Focal Length (Telephoto):	190mm
Macro Mode:	Information not available
Minimum Focus Distance:	Information not available
Exposure Settings:	Multi-segment, center weighted, spot 3 shot bracketing 1/3, 2/3, 1 EV steps Exposure compensation +/- 2EV in 1/3 EV steps
Minimum Aperture:	f/8.0
Maximum Aperture:	f/2.0
Minimum Shutter Speed:	30 seconds
Maximum Shutter Speed:	1/1000 second
White Balance:	3 Positions plus manual
ISO Equivalencies:	Auto, 100, 200, 400, 800
Removable Memory Included:	Memory Stick 32 mb
Power Source:	InfoLithium M series battery

Flash Characteristics:	Pop-up Pre-flash metering, red-eye hot shoe
Connections:	USB
Image Formats:	JPEG, TIFF
Video Capture Format:	MPEG
Video Capture Resolutions:	160×112, 320×240
Frames per Second:	16 fps
Maximum Video Length:	Information not available
Size:	6.4×4.9×2.7 inches
Weight:	23.2 ounces
Other Features:	Voice memo E-mail/text still image mode
Included Software:	Pixela ImageMixer USB driver
Included Components:	32mb Memory Stick InfoLithium M series battery AC adapter A/V output cable USB cable Shoulder strap Lens cap with strap

Nikon Coolpix 5700

The powerful 5 megapixels of the Nikon Coolpix 5700 allow you to print images as large as 16x20 inches. The 8x optical zoom of the Nikkor lense provides crisp, clear images. Two extra-low dispersion (ED) elements minimize chromatic aberration, and the macro mode allows for shots as close as 1.2 inches.

Street price: $799-$1,199

Number of CCD pixels:	5.0 megapixels
LCD Screen Size:	1.5 inches
Viewfinder:	Electronic ViewFinder (EVF)
Optical Zoom:	8x
Digital Zoom:	4x
Lens Mount:	Fixed
Focus Features:	Contrast detect TTL autofocus
Minimum Focal Length (Wide Angle):	35mm
Maximum Focal Length (Telephoto):	280mm
Macro Mode	Yes
Minimum Focus Distance:	1.2 inches in macro mode
Exposure Settings:	Multi-area or spot Aperture and shutter priority Exposure bracketing 3 or 5 within +/- 2 EV steps Exposure compensation +/- 2 EV in 1/3 EV steps
Minimum Aperture:	f/8
Maximum Aperture:	f/2.8
Minimum Shutter Speed:	8 seconds
Maximum Shutter Speed:	1/4000 second
White Balance:	5 modes, white balance bracketing
ISO Equivalencies:	100, 200, 400, 800, Auto
Removable Memory Included:	CompactFlash 32mb
Power Source:	Li-ion
Flash Characteristics:	Pop-up; auto, flash cancel, slow sync, red-eye
Connections:	USB

Image Formats:	JPEG, TIFF, RAW
Video Capture Format:	QVGA
Video Capture Resolutions:	Information not available
Frames per Second:	15 fps
Maximum Video Length:	1 minute
Size:	4.3×3.0×4.0 inches
Weight:	16.9 ounces
Other Features:	Best shot selector Enlarged playback RAW playback Histogram indication
Included Software:	NikonView 5 ArcSoft software suite
Included Components:	32mb compact flash card Li-ion battery and charger Lens cap and strap A/V cable USB cable

Canon EOS D60

The Canon EOS D60 is the successor to the EOS D30. Canon listened to the photographic community when increasing pixels to 6.3 megapixels while retaining a continuous mode of 3 fps in 8 shots. **Street price: $1,819-$2,499**

Number of CCD pixels:	6.3 megapixels
LCD Screen Size:	1.8 inches
Viewfinder:	TTL
Optical Zoom:	No
Digital Zoom:	No
Lens Mount:	Camera body only; Canon EOS EF Mount
Focus Features:	1-shot autofocus, manual focus, 3 focus points
Minimum Focal Length (Wide Angle):	Information not available
Maximum Focal Length (Telephoto):	Information not available
Macro Mode:	Information not available
Minimum Focus Distance:	Information not available
Exposure Settings:	Shutter or aperture priority Exposure compensation +/- 2 EV in 1/2 EV or 1/3 EV increments
Minimum Aperture:	Information not available
Maximum Aperture:	Information not available
Minimum Shutter Speed:	30 seconds
Maximum Shutter Speed:	1/4000 second
White Balance:	7 settings: auto, daylight, cloudy, tungsten, fluorescent, flash, manual
ISO Equivalencies:	100, 200, 400, 800, 1000
Removable Memory Included:	CompactFlash 16mb
Power Source:	Li-ion
Flash Characteristics:	Auto pop-up, red-eye reduction Hot Shoe
Connections:	USB
Image Formats:	JPEG, RAW
Video Capture Format:	None
Video Capture Resolutions:	Information not available
Frames per Second:	Information not available
Maximum Video Length	Information not available

Size:	5.9×4.2×3.0 inches
Weight:	27.5 ounces
Other Features:	3fps Continuous Mode (8 shots) 14 custom functions 38 settings Remote control
Included Software:	RAW image converter ZoomBrowser EX Photo record Remote capture PhotoStitch
Included Components:	Li-ion battery pack and charger

Kodak DCS 14N

The latest digital camera entry from Kodak was released in February 2003. The Kodak DCS 14N offers a whopping 13.7 megapixels. And the image sensor is the same size as a frame of 35mm film. The Nikkor AF mount accepts a wide range of lenses. This top-of-the-line camera body uses a Firewire connection.
Street price: $4,000

Number of CMOS pixels:	13.7 megapixels
LCD Screen Size:	Information not available
Viewfinder:	TTL
Optical Zoom:	Lenses sold separately
Digital Zoom:	Lenses sold separately
Lens Mount:	Camera body only Nikkor AF mount
Focus Features:	Autofocus
Minimum Focal Length (Wide Angle):	Lenses sold separately
Maximum Focal Length (Telephoto):	Lenses sold separately
Macro Mode:	Lenses sold separately
Minimum Focus Distance:	Lenses sold separately
Exposure Settings:	3D matrix, averaging, or spot +/- 3EV in 1/2 EV steps
Minimum Aperture:	Information not available
Maximum Aperture:	Information not available
Minimum Shutter Speed:	30 seconds
Maximum Shutter Speed:	1/4000 second
White Balance:	Auto
ISO Equivalencies:	80-640
Removable Memory Included:	Information not available
Power Source:	Kodak Li-ion battery
Flash Characteristics:	Pop-up or hot shoe
Connections:	Firewire
Image Formats:	JPEG, RAW
Video Capture Format:	No
Video Capture Resolutions:	None
Frames per Second:	None
Maximum Video Length:	None
Size:	5.2×6.2×3.5 inches
Weight:	35.3 ounces

Other Features:	8-Frame, 1.7 fps continuous mode Voice annotations Extended range JPEG CompactFlash or MultiMedia card
Included Software:	Kodak professional DCR file format module
Included Components:	Information not available

Nikon D1X

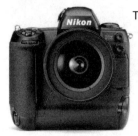

The D1X is based on the Nikon D1, which took the professional photography market by storm and had a huge influence on the price of professional digital SLR's. The D1X offers a respectable 5.89 megapixels and an improved user interface. It also offers selectable color profiles. **Street price: $2,920-$4,200**

Number of CCD pixels:	5.89 megapixels
LCD Screen Size:	2 inches
Viewfinder:	TTL
Optical Zoom:	No
Digital Zoom:	No
Lens Mount:	Camera body only Nikkor AF/F-Mount, D-type
Focus Features:	Autofocus
Minimum Focal Length (Wide Angle):	Lenses sold separately
Maximum Focal Length (Telephoto):	Lenses sold separately
Macro Mode:	Lenses sold separately
Minimum Focus Distance:	Lenses sold separately
Exposure Settings:	3D matrix, center-weighted averaging or spot Exposure compensation +/- 5 EV in 1/3 EV steps Exposure bracketing 2-3 in 1/3, 1/2, 2/3, or 1 EV steps
Minimum Aperture:	Lenses sold separately
Maximum Aperture:	Lenses sold separately
Minimum Shutter Speed:	30 seconds
Maximum Shutter Speed:	1/16000 second
White Balance:	6 Positions plus manual
ISO Equivalencies:	125-800
Removable Memory Included:	Information not available
Power Source:	Nikon EN-4 NiMH
Flash Characteristics:	Hot shoe and sync connector Front and rear curtain, red eye, slow, and red-eye slow
Connections:	Firewire

Image Formats:	JPEG, TIFF, RAW
Video Capture Format:	No
Video Capture Resolutions:	None
Frames per Second:	None
Maximum Video Length	None
Size:	6.2×6×3.3 inches
Weight:	42.3 ounces
Other Features:	9-image, 3 fps continuous mode 35 custom settings One-touch playback Enlarged playback
Included Software:	Nikon view browser
Included Components:	Neck strap Video cable Ni-MH battery pack and charger

Fujifilm FinePix S2 Pro

The Fujifilm FinePix S2 Pro is built on a Nikon body. It is the second generation Fujifilm SLR to utilize the Super CCD Sensor system. The 12 megapixels provide unparalleled clarity. The FinePix S2 Pro offers both USB and Firewire connectivity.
Street price: $1,770-$2,399

Number of CCD pixels:	12 megapixels
LCD Screen Size:	1.8 inches
Viewfinder:	TTL
Optical Zoom:	No
Digital Zoom:	No
Lens Mount:	Camera body only Nikon F mount AF-S mount
Focus Features:	Lenses sold separately
Minimum Focal Length (Wide Angle):	Lenses sold separately
Maximum Focal Length (Telephoto):	Lenses sold separately
Macro Mode:	Lenses sold separately
Minimum Focus Distance:	Lenses sold separately
Exposure Settings:	3D matrix, center-weighted averaging or spot Exposure compensation +/- 3 EV in 1/2 EV steps
Minimum Aperture:	Lenses sold separately
Maximum Aperture:	Lenses sold separately
Minimum Shutter Speed:	30 seconds
Maximum Shutter Speed:	1/4000 second
White Balance:	7 settings, plus manual
ISO Equivalencies:	100, 160, 200, 400, 800, 1600
Removable Memory Included:	Information not available
Power Source:	4x AA alkaline batteries, plus 2x CR123A lithium
Flash Characteristics:	Auto, on, off, red eye, slow sync
Connections:	USB and Firewire
Image Formats:	JPEG, TIFF, RAW

Video Capture Format:	No
Video Capture Resolutions:	Information not available
Frames per Second:	Information not available
Maximum Video Length	Information not available
Size:	5.6×5.2×3.2 inches
Weight:	30 ounces
Other Features:	7-Frame, 2fps continuous mode Dual slots for SmartMedia and IBM Microdrive Remote control Voice memo
Included Software:	Fujifilm FinePixViewer Fujifilm RAW Converter LE Adobe Photoshop Elements
Included Components:	USB cable IEEE1394 cable Video cable Shoulder strap 4x AA batteries 2x CR123A lithium batteries

aberration A distortion in an image caused by a flaw in a mirror or lens.

acquire A software menu selection to scan from within the program (if it is TWAIN compliant).

anti-aliasing A technique of blending variations in bits along a straight line to minimize the stair-step or jagged appearance of diagonal edges.

aperture The lens opening through which light passes expressed by a number called f-number (or f-stop). Typically, f-stops range from f-2 through f-32, although many lenses don't reach the extremes on either end. Each higher number represents an opening half the size of the previous number, f-2 being the largest and f-32 the smallest. The aperture is one of the key factors in an exposure setting.

array A grouping of elements, such as the rectangular array of photodiodes that make up the digital film that captures an image.

artifact An unwanted pattern in an image caused by the interference of different frequencies of light.

autofocus A lens mechanism that automatically focuses the lens, often by bouncing an infrared light beam or sound waves off the subject matter.

automatic exposure A camera mode that adjusts the aperture and shutter speed to the proper exposure based on direct readings of a light meter.

automatic flash An electronic flash that measures the light reflected from a subject and varies the length of the flash for proper exposure.

back-lit A setting that illuminates the subject from behind.

bayer pattern A distribution of red, green, and blue filters on an image sensor that provides twice as many green filters as red and blue because of the eye's sensitivity to shades of green.

bit depth The number of bits–0s and 1s in computer code–used to record, in digital image situations, the information about the colors or shades of gray in a single pixel, which is the smallest amount of information in a graphic image. Using 24-bit color, each pixel can be set to any one of 16 million colors.

bitmap An image represented by specific values for every dot, or pixel, used to make up the image.

BMP file A Windows file type that contains a bitmapped image.

bracket A burst mode that, as a safety precaution, shoots extra exposures that are normally one f-stop above and below the exposure indicated by the light meter reading.

brightness The overall light intensity of an image. The higher the brightness, the lighter the image.

burst mode The ability of a camera to take several pictures one after another, as long as the shutter button is depressed.

calibrate Adjust the handling of light and colors by different equipment, such as cameras, scanners, monitors, and printers so that the images produced by each are the same in brightness, hue, and contrast.

CCD raw format The uninterpolated data collected directly from the image sensor before processing.

charge-coupled device (CCD) An image sensor made up of millions of photodiodes, transistors that convert light energy to electrical energy, and transmit the electrical charges one row at a time.

chroma A quality of color combining hue and saturation.

clipping The loss of color information above or below certain cutoff values.

CMOS image sensor An image sensor similar to a CCD created using CMOS technology. CMOS stands for complementary metal-oxide semiconductor.

color, additive A system such as printing that creates colors by combining the absorption abilities of four basic colors: cyan, yellow, blue, and black. See Color, subtractive.

color balance The overall accuracy of the hues in a photograph, particularly with reference to white.

color depth The number of bits assigned to each pixel in the image and the number of colors that can be created from those bits. See bit depth.

color, subtractive The creation of colors in cameras, monitors, and scanners by combining the effects of pixels colored red, blue, and green, usually referred to as RGB. See color, additive.

color temperature The "warmth" or "coolness" of light, measured in degrees kelvin (K). Midday daylight is about 5,500K. Light bulbs are about 29,000K— more orange or warm. Color temperature is important to color balance.

compact memory A form of flash memory using a microchip.

compression, lossless File compression scheme that makes a file smaller without sacrificing quality when the image is later uncompressed. ZIP and GIF files use lossless compression.

compression, lossy A file compression scheme that reduces the size of a file by permanently discarding some of the visual information. JPEG is the most common lossy compression form for graphics.

continuous tone An image, such as a film photo, that has a gradual range of tones without any noticeable demarcation from one to the other.

contrast The difference between the dark and light areas of an image.

depth of field The area between the nearest and farthest points that are in focus through a camera lens. Depth of field increases at smaller lens apertures.

dithering The process of creating different colors by placing dots of black, cyan, yellow, and magenta ink near each other in different combinations.

dots per inch (dpi) A measurement of resolution used for scanning and printing.

dynamic range The range of the lightest to the darkest areas in an image. Also known as Dmax or density range. See histogram.

exposure The amount of light used in a photograph, based on the aperture and how long the shutter stays open.

exposure compensation The ability to automatically change exposure by one or two stops to lighten or darken the image.

fill flash Flash used to fill shadows caused by overall bright lighting.

fixed focus A lens made to permanently focus on the most common range, from a few feet to infinity. The focus is usually not as sharp as that obtained with a variable focus lens.

flash memory card A card containing chips that store images using microchips instead of magnetic media.

focal length The distance, in millimeters, from the optical center of the lens to the image sensor when the lens is focused on infinity. Long focal lengths work like telescopes to enlarge an image. Short focal lengths produce wide-angle views.

gamma A mathematical curve created by the combined contrast and brightness of an image. Moving the curve in one direction makes the image darker and decreases the contrast. Moving the curve in the other direction makes the image lighter and increases the contrast.

gamut The range of colors a device captures or creates. A color outside a device's gamut is represented by another color within the gamut.

grayscale At least 255 shades of gray from pure white to pure black that represent light and dark portions of an image.

histogram A bar graph showing the distribution of light and dark values throughout a photograph, roughly equivalent to a photo's dynamic range.

hot shoe A clip on the top of the camera to attach a flash unit.

IEEE 1394 A personal computer port capable of transferring large amounts of data, often used to upload graphic and video files. Known as i.Link on Sony systems and firewire on Apple computers.

image sensor A microchip that records images by converting the scenes light values into an electrical current that travels to a memory chip to be recorded as digital values.

intensity The amount of light reflected or transmitted by an object with black as the lowest intensity and white as the highest intensity.

interpolation A process used in digital zooms and digital darkrooms to enlarge images beyond the maximum size represented by the number of pixels making up the image. Interpolation creates the new pixels needed to increase the size by guessing what light values they should have based on the values of the real pixels that would be next to the new ones. See Zoom, digital and Zoom, optical.

ISO A number rating indicating the relative sensitivity to light of an image sensor or photographic film. Faster film (higher ISO) is more sensitive to light and requires less exposure than slower film does.

jaggies The stair-step effect in diagonal lines or curves that are reproduced digitally.

J-peg, JPEG, or JPG A popular digital camera file format that uses lossy compression to reduce file sizes. Developed by the Joint Photographic Experts Group.

lag time The time between when the shutter button is pushed and when the camera makes the exposure.

long lens Telephoto lens.

lossless See compression, lossless.

lossy See compression, lossy.

macro mode A lens mode that allows focusing on objects only inches away.

megapixel An image or image sensor with about 1 million pixels.

memory stick A flash memory storage device developed by Sony.

metering, center-weighed Reading light intensity with an emphasis on an area in the center of the viewfinder's frame.

metering, matrix A light meter reading produced by reading the light from several areas throughout the frame.

metering, spot A light reading taken from a narrow area in the center of the frame.

midtones Light values in an image midway between the lightest and the darkest tones.

MPEG A digital video format developed by the Motion Pictures Expert Group.

noise A random distortion in an analog signal causing snow or dark flecks throughout an image. It can be caused by electronic noise in the amplifiers, nearby electrical spikes, or other random electrical fluctuations.

normal lens A lens with about the same angle of view of a scene as the human eye, about 45 degrees.

optical character recognition (OCR) A scanning technology that recognizes letters and translates them into text that can be edited on screen.

photodiode A transistor made of materials that react to being exposed to light by generating a proportional electrical current.

pixel Picture element, the smallest individual element in an image.

pixelization An effect caused when an image is enlarged so much that individual pixels are easily seen.

PPI (pixels per inch) A measurement of the resolution of an image based on the number of pixels that make up an inch.

preview screen A small LCD screen on the back of the camera used to compose or look at photographs.

red-eye An effect that causes eyes to look red in flash exposures, caused by light reflecting off the capillary-covered retina.

red-eye reduction mode A mechanism that fires a preliminary flash to close the iris of the eye before firing the main flash to take the picture.

resolution The sharpness of an image, measured in dots per inch (dpi) for printers and pixels per inch (ppi) for scanners, digital cameras, and monitors. The higher the dpi or ppi, the greater the resolution.

resolution, interpolated A process that enlarges an image by adding extra pixels whose color values are calculated from the values of surrounding pixels.

RGB The color system used in most digital cameras, where red, green, and blue light is captured separately and then combined to create a full color image.

saturation The amount of color in a specific hue.

sharpening A function in digital darkroom software, some cameras, and some scanners that increase the apparent sharpness of an image by increasing the contrast of pixels that lie along the border between light and dark areas in the image.

short lens A wide-angle lens, one that includes more of the subject area.

shutter The device in a camera that opens and closes to let light from the scene strike the image sensor and expose the image.

shutter-priority mode An automatic exposure system in which you set the shutter speed and the camera selects the correct aperture (f-stop) to make an accurate exposure.

shutter speed The length of time during which the camera shutter remains open. These speeds are expressed in seconds or fractions of a second, such as 2, 1, 1/2, 1/4, 1/8, 1/15, 1/30, 1/60, 1/125, 1/250, 1/500, 1/1,000, 1/2,000, 1/4,000, 1/8,000. Each speed increment halves the amount of light.

SmartMedia A form of flash memory on a microchip.

tagged image file format See TIFF.

threshold A color or light value of a pixel before software or a camera does anything with the pixel's information. For example, blue values might be substituted with red values, but only if the blue pixels have an intensity within a certain range of values. The higher the threshold, the fewer pixels affected.

thumbnail A small image that represents a bigger version of the same picture, usually linked on a Web page.

TIFF A popular lossless image format used in digital photography.

TWAIN An industry-standard method for application software, such as word processors, to access a scanner directly to scan images for that application's documents.

upload Sending files from a device, such as a digital camera or memory card, to a computer.

variable focus A lens whose range of focus can be changed from close-up to a few feet to infinity.

viewfinder, optical A separate window that shows what would be included in a photograph, but only approximately.

viewfinder, single-lens reflex Viewfinder whose image comes directly through the same lens that will be used for taking the picture.

viewfinder, TTL (through the lens) A viewfinder that looks through the lens to use the same image produced by the lens to create a photograph.

white balance An automatic or manual control that adjusts the brightest part of the scene so it looks white.

white point The color that is made from values of 255 each for red, blue, or green in a camera's sensor image, a monitor, or a scanner. On paper, the white point is whatever color the paper is.

wide-angle lens A lens with an angle of view between 62 and 84 degrees.

zoom, digital A way of emulating the telephoto abilities of a zoom lens by interpolating what new pixels would look like based on the values of pixels next to the artificially generated pixels. See interpolation.

zoom lens A lens that lets you change focal lengths on the fly.

zoom, optical A method that changes the focal length of a lens to change its angle of few from wide angle to telephoto. Optical zoom is preferable to digital zoom.

Links

Here are some sources on the web for digital camera, imaging, and photography terms.

- **www.shortcourses.com/choosing/glossary/19.htm** Thorough glossary to accompany online tutorials.

- **www.anweb.co.uk/I_04_d4/d4d12.htm** Glossary of photographic terms.

- **www.dpreview.com/learn/Glossary/** Excellent glossary with helpful illustrations.

- **http://divemar.com/divermag/archives/dec96/glossary.html** Underwater photography terms.

- **http://electronics.cnet.com/electronics/0-1629008-7-2643634.html** CNET's glossary of digital photography.

- **www.scanneroutlet.com/faq.htm** Useful frequently asked questions on Scanner Outlet's web site.

- **www.microtekusa.com/glossary.html** Glossary of terms from scanner- maker MicroTek.

Index